The
CAMCORDER
handbook

Malcolm Squires

HEADLINE

A QUARTO BOOK

Copyright © 1992 Quarto Publishing plc

The right of Malcolm Squires to be identified as the author of the work has been asserted by him in accordance with the Copyright, Design and Patents Act 1988.

First published in Great Britain in 1992 by HEADLINE BOOK PUBLISHING LTD

First published in paperback in 1994 by HEADLINE BOOK PUBLISHING LTD

10 9 8 7 6 5 4 3 2 1

778·599.

British Library Cataloguing-in-Publication Data

Squires, Malcolm
 Camcorder Handbook: Creative Course in the Skills of Home
 Video-making. Featuring Specially Developed Video Projects
 to Help Put Theory into Practice
 I. Title
 778.59 O747-278-58X - 1442.

ISBN 0-7472-7858-X

This book was designed and produced by
Quarto Publishing plc
The Old Brewery
6 Blundell Street
London N7 9BH

Senior Editor Cathy Meeus
Editors Louise Bostock, Helen Douglas Cooper,
Jonathan Hilton, Susan Ward
Editorial Consultants Peter M. Brown, Steve Fletcher
Picture Managers Rebecca Horsewood, Sarah Risley
Picture Researchers Susan Berry, Michele Faram
Senior Art Editor Philip Gilderdale
Designer Nick Clark
Illustrators Graham Rosewarne, Guy Smith
Photography Sharp Studios, Tim Hill, Ian Howes,
Martin Norris, Phil Starling, Paul Walker, Jon Wyand
Publishing Director Janet Slingsby
Art Director Moira Clinch

Special thanks to Brigitte Squires, Neal Cobourne and
David Kemp.

Typeset in Great Britain by Typestyles (London) Ltd., Harlow.
Manufactured in Hong Kong by Regent Publishing Services Ltd.
Printed in Hong Kong by Leefung Asco Printers Ltd.

HEADLINE BOOK PUBLISHING LTD
A Member of the Hodder Headline PLC Group
Headline House
79 Great Titchfield Street
London W1P 7FN

Introduction

There's never been a better time than the present to take the plunge and start making your own home videos. The newest camcorders are lighter and easier to carry around than their predecessors, while their capacity to "think for you" means that you can spend less time worrying about technology and more concentrating on good video-making. And the equipment is becoming more and more affordable as well. A sophisticated 1990s-style camcorder, with all the gadgetry you're ever likely to need, is now well within the reach of the average family budget. The new videotapes last for an hour or more, while the abundance of editing and titling equipment now available, even at the low end of the price scale, means that it's easier to make superb videos.

So, you've bought your first camcorder, loaded it with tape, and started to take your first shots. What do you need to know next? How do you plan your shooting and edit your tapes to make something enjoyable that you and your family will want to view over and over again? What do you need to know about continuity and sound?

These are just some of the questions my students frequently ask, which is why I've planned this learn-as-you-shoot course. Step-by-step and stage-by-stage, I've tried to develop a positive, nontechnical, and above all, enjoyable guide to the tricks and skills of creative video-making, so that by learning the basic do's and don'ts in this book, you'll be able to create tapes that are polished and entertaining. What I've tried to avoid is the kind of abstract technical detail that non-professionals simply don't need to know. My guiding principle was to make THE CAMCORDER HANDBOOK as practical and as confidence-building as I could, so that, when you have read it, you'll really look forward to getting out there, shooting whatever you want to shoot, and feeling justifiably proud when you screen the results.

What it comes down to, really, is thinking through what you're aiming for and how to achieve it and going on from there. This rule applies to whatever you decide to shoot — and, of course, there's scarcely a facet of life that doesn't lend itself to video filming. Just look around you, and you'll see literally hundreds of opportunities to try out your new techniques and develop your own video style.

So let's raise the curtain and get on with the great video show...

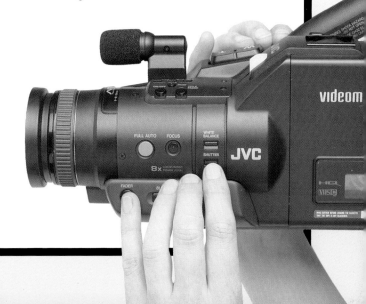

Contents

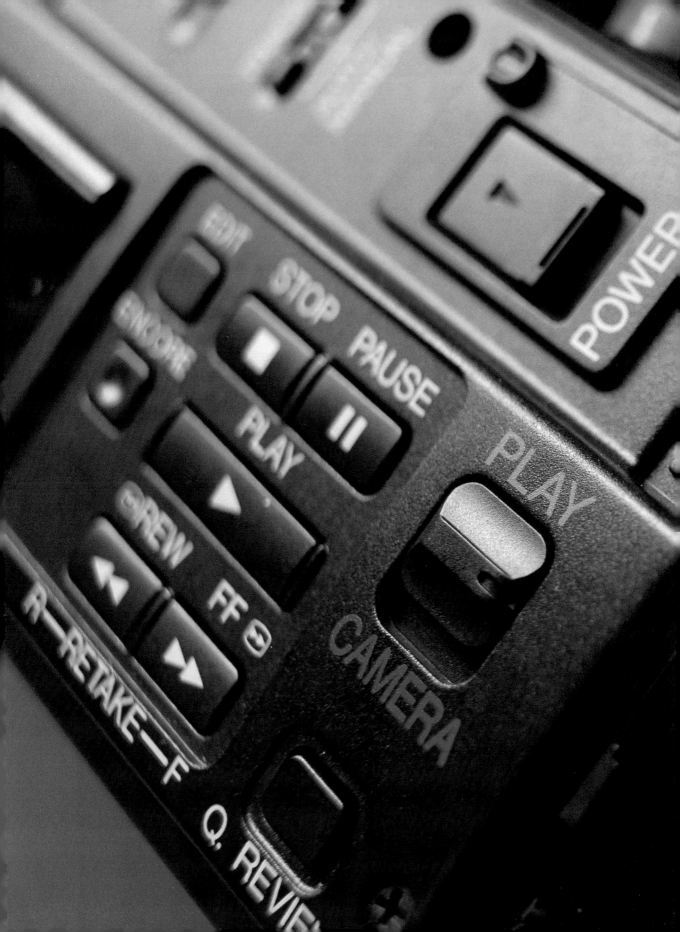

Getting started

Getting started

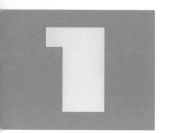

The selling point of many modern camcorders is that they are "auto-everything" – exposure, white balance, focusing, sound-recording level, and so on. The danger is that it is all too easy simply not to bother experimenting with the manual overrides usually provided to discover exactly what the creative potential of the machine actually is. Perhaps the reason for this is because you are not certain what these controls do, and why.

The object of this first chapter is to get you up and running and confident with a camcorder. An explanation of what a camcorder is and how it works, what the controls do and when they should be used, is followed by a discussion of the different types of camcorder and tape "formats" – what they can mean to you in terms of convenience, ease of use, or special features.

A prerequisite for any photographic medium is light. As we all know, light levels fluctuate throughout the day, as well as from season to season. Camcorders have sophisticated exposure-compensating controls to cope with this but, when used on manual settings, they open up a whole range of creative possibilities. Not only light intensity, but also the colour of light changes, a fact that sometimes needs to be compensated for when moving from daylight to indoor lighting. This leads on to a section covering differing approaches to working in these two light sources, and how to modify or supplement the effects of each.

Capturing the moving image is only half of the camcorder story: the other half is sound. Sound is often overlooked as being just "anything that happens to be going on" picked up by the microphone. You could, as with exposure, simply leave sound recording on automatic, but this is a very hit-or-miss approach. In the same way that images can set a mood, weave an atmosphere, or help to enrich the story-telling, so a good soundtrack can often add an all-important extra dimension. The two sides of making a video – vision and sound – are inseparable. The more you understand about the relationship between the two, the better the likely outcome of your efforts. This part of the book eases you into the subject area by explaining some of the important aspects of sound and how they can be used to best effect.

At key points throughout this chapter, special exercises have been included. These are designed to take you through a real-life application of the point being made to make sure you fully understand the how, why, and when of that particular aspect of the technique.

▶ **FIRST SHOTS** *The prospect of a holiday abroad is often the spur to a first camcorder purchase. Tourist locations around the world are full of travellers recording highlights of their visit. These first ventures into video-making needn't be a succession of wobbly, erratically composed sequences. Even a few hours spent mastering the basic controls of your machine will get you started on the right track for producing a creditable video.*

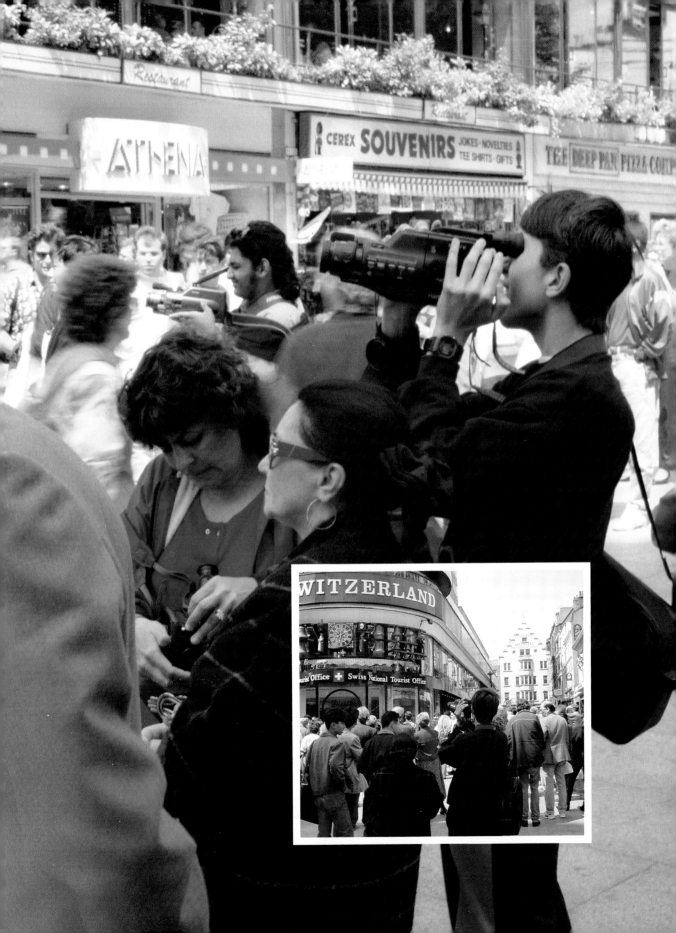

Since this book takes the form of a school, and the chapters lessons, it should not be too elementary to begin at the very beginning. What, exactly, is a camcorder?

First of all, the name itself is short for camera-recorder. It works by means of a sensing device, which converts a moving image seen through a focused lens into a series of electronic signals. These signals, in turn, are transmitted onto a tape. At the same time, the

- **What is a camcorder?**
- **Summary of functions**

The camcorder

THE MICROPHONE *The camcorder's own microphone provides adequate sound recording for most purposes. It is omnidirectional – that is, it can pick up sound from any direction, not just from the direction in which it is pointing. Some camcorders have a high/low switch that you can use to increase the recording sensitivity.*

accompanying sounds, picked up through a built-in microphone, are also transmitted as electronic signals and imprinted onto the same tape.

Large camcorders are carried on the shoulder, whereas the increasingly popular smaller camcorders are hand-held in front of the face. The size of the camcorder is determined by the size of the videotape that it takes, with different tape formats suitable for different purposes. It is important that your camcorder and VCR (video cassette recorder) take tapes of the same format, or can be adapted to take them (see Format options, page 14).

There are two ways of playing back a recorded tape. It can be played back in a VCR and watched on an ordinary television set. Alternatively, on some models, it can be played back in the camcorder itself, while you watch it in the viewfinder. On these models the viewfinder is electronic (like a television screen), whereas models that only record have a simple viewfinder like that of a stills camera.

A number of camcorders have the capacity to record at two different speeds, standard speed (SP) and long-playing speed (LP). Although long-play is economical because it allows you to fit more material on to a tape, it cannot provide the same image quality as standard play.

THE LENS *The standard lens of the camcorder has a zoom mechanism that allows you to move in for a close-up or pull back for a wide-angle shot without changing your position. With some camcorders you can replace the standard lens with a substitute.*

FULL AUTO BUTTON *This resets all controls to automatic.*

FADER BUTTON *This fades the picture at the beginning or end of a scene.*

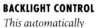

BACKLIGHT CONTROL *This automatically adjusts the exposure to compensate for the silhouetting effect of a dark subject in front of a bright background.*

AUTOMATIC FOCUS OVERRIDE *This control allows you to focus manually.*

WHITE BALANCE CONTROL *Setting this correctly allows you to compensate for the colour bias that occurs in different kinds of light.*

CASSETTE HOUSING *This model takes VHS-C cassettes. The housing is opened by the eject button on the back panel.*

▼ **VIEW FROM BEHIND** *From top left to bottom right, you can see the following controls: the memory button, which allows you quickly to locate specific points on a tape; the tape counter reset button; the standard/long play selector, which enables you to double the time available on your tape when long play is* selected; an alarm button that alerts you when recording starts and ends; tape rewind and fast forward controls; quick review function. On the far left, the record and play indicator lights can be seen. The power on and cassette eject buttons are on the far right.

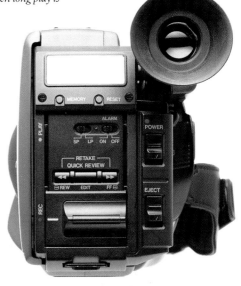

DATE/TIME CONTROL *This allows you to superimpose the date and time over a corner of the frame.*

MANUAL IRIS CONTROL *The amount of light entering the camcorder can be adjusted by this control.*

SHUTTER SPEED SELECTOR *This controls the time during which light is allowed to enter the camcorder.*

▲ **ZOOM** *The powered zoom control consists of a rocker switch marked at either end W (wide-angle) and T (telephoto). Most camcorders have a fixed speed zoom control, although some models allow you to* increase the speed of the zoom with increased pressure on the rocker. On this camcorder title-creating functions are also located on the top of the camcorder.

There is a right camcorder for every video enthusiast. Your choice has probably been made on the basis of the way in which you intend using it. A camcorder that is primarily for capturing holidays and recording important family events for posterity is likely to be a light, mobile machine with perhaps only a few additional features. However, a machine for making high-quality structured and edited films needs to have more sophisticated fea-

- **Tape formats**
- **Camcorder formats**
- **Low band and high band**

GETTING STARTED

Format options

tures and will be correspondingly larger and heavier. It will probably cost as much as three times more than a smaller amateur camcorder.

One of the key considerations affecting the size and portability of a camcorder – as well as the picture quality of your videos – is that of the tape format. There are six formats currently on the market. VHS, VHS-C, Super VHS, Super VHS-C, Video 8, and Hi-8. Betamax, a format used by some older VCRs, is not used in modern camcorders.

Video formats fall into two groups, low band and high band. In practical terms the difference between the two is that the high-band formats provide a much sharper picture, and the colours bleed into each other less. This is because in the high-band formats the electrical signals that carry brightness are different from those that carry colour. When a low-band tape is played back these two electrical components are blended together and passed along a single wire, which degrades the quality. On a high-band system the brightness and colour are processed separately, which helps to eliminate colour bleed. High-band systems also eliminate the irritating herring-bone or moiré patterns that appear on patterned subjects and small details. Because of the difference in quality, high-band format camcorders are markedly more expensive than low-format ones.
LOW-BAND FORMATS Standard VHS, VHS-C and Video 8 are low-band formats. VHS is the most common format for pre-recorded tapes.

TABLE OF FORMAT OPTIONS

When choosing a camcorder, the first decision you will have to make is that of format. The six formats listed below are currently on the market. Another format Betamax was popular in the home video market some years ago. However, in the context of video-making it is now obsolete and Betamax recorders are no longer made.

	Pros	Cons
Standard VHS (Low band)	Good quality picture Sound recorded on separate track for easy editing	Bulky and heavy
VHS-C (Low band)	Compact Good quality picture	Needs adaptor for playing on standard VCR
Super VHS (High band)	Excellent picture quality Hi-fi sound	Bulky Cannot be played back on low-band (standard) VCR
Super VHS-C (High band)	Compact Excellent picture quality Hi-fi sound	Cannot be played back on low-band (standard) VCR
Video 8 (Low band)	Compact Good quality picture Hi-fi sound	Tapes not compatible with VHS VCRs
Hi-8 (High band)	Compact Excellent picture quality Hi-fi sound	Tapes not compatible with VHS VCRs

▼ SIZE INCOMPATIBILITY

As you can see from the life-size picture shown here, there is considerable difference in the cassette sizes of the VHS (rear), Video 8 (middle), and VHS-C (front) formats. It is largely the size of cassette that determines the size of the camcorder needed to house it. Some people prefer the weight and bulk of a machine needed for a full sized VHS cassette, since it may actually help them to avoid camera shake when hand-holding the camcorder. These cassettes also give a longer recording time. For others, lightness and portability may be important considerations and so they are prepared to compromise on the length of recording time.

► VHS-C ADAPTOR

To play back a VHS-C cassette via a standard VHS home recorder, you generally need to use an adaptor (pictured here). Machines are now beginning to appear, however, that will accept both sizes of cassette.

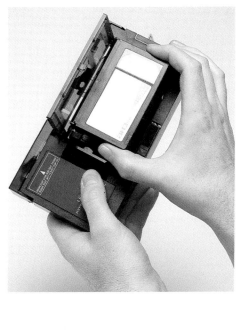

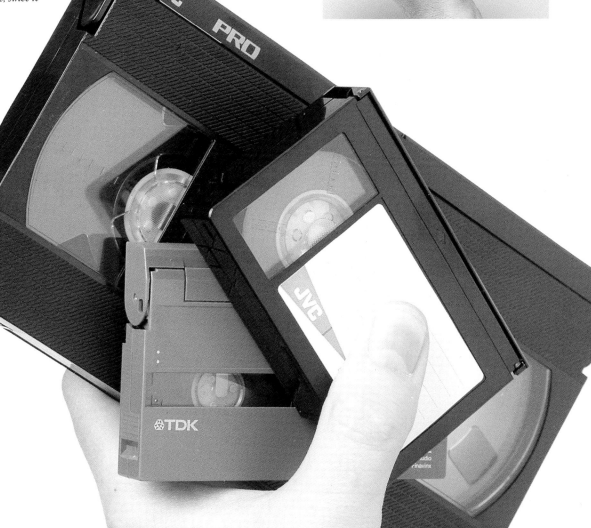

VHS uses ½in (12.7mm) tapes, which give up to 3 hours of recording/playing time at standard speed. The picture quality is good, the sound less so, but this system has the advantage that the sound is recorded on a separate track, which makes editing easier. VHS cassettes are large, so the camcorders are bulky to carry around.

VHS-C is similar to VHS but is more compact. The tapes normally give 30 minutes of playing time, and can be played back on standard VHS equipment using a special adaptor. Because the cassettes are small, the camcorders are smaller and lighter than standard VHS, making them very popular.

Video 8 is the smallest format. It uses ¼in (8 mm) tapes, and the camcorders are small and light. The picture quality is good, and the sound quality is very good. The tapes cannot be played in a VHS recorder, but can be played directly into the TV from the camcorder. Alternatively the tapes can be copied onto VHS format.

HIGH-BAND FORMATS Super VHS and Super VHS-C are the same size as VHS and VHS-C respectively, but the picture quality and equipment have been improved. They also have hi-fi sound. They cannot be played back on a low-band (ie standard VHS) VCR, although they can be copied on to low band for replay without loss of quality. They are at their best, however, when played back through a Super-VHS equipped TV set, producing pictures and sound that approach professional television quality. Hi-8 is the same size as Video 8, but again the quality of pictures and sound is much higher.

▶ **VHS-C** *This format is a response to the public's desire for smaller, more compact camcorders – the C stands for "compact." VHS-C machines use the same tape as their larger cousins but housed in a smaller cassette. The sacrifice here is recording time, which is only 30 or 45 minutes, compared with three hours with full-sized VHS. Picture quailty is as good as VHS and Video 8, but sound reproduction is not up to the standard of Video 8. Unless you have a VCR machine that accepts the mini cassette of the VHS-C camcorder, you will need to use a special adaptor (see page 15).*

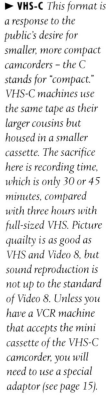

LOW BAND VS. HIGH BAND *Of the two format categories, high band is the more expensive, but it offers enhanced picture quality if you have high-band playback equipment.*

Another major advantage of high band tapes is that they can be copied through several generations with much less loss of quality than would be the case with low-band tapes. This is a definite plus if you wish to copy tapes for family and friends, or if you intend to edit, because this can involve copying.

▼ VIDEO 8

This is now the most popular camcorder format, and it is often referred to simply as 8mm. In terms of picture quality, there is not much between Video 8 and VHS or VHS-C – sound reproduction on Video 8, is however, far superior. Video 8 cannot be played back via an ordinary VCR machine. Dedicated 8mm playback machines are available, but they are expensive. To view Video 8 images you need to connect the camcorder directly to the television set.

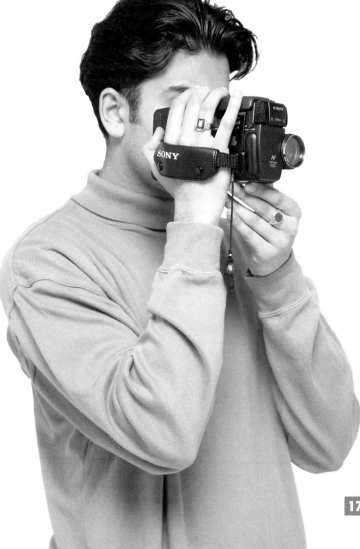

You've bought your camcorder, fitted new batteries, and inserted a clean tape. Now you're ready to go and shoot your first video. At this point it's well worth taking a little time to consider an obvious but fundamental element of successful video technique – how to support the camcorder to prevent it shaking.

SUPPORTING THE CAMCORDER Quality video depends on a motionless, steady, well-supported camcorder that can be panned or tilted with

- **From turning it on to shooting a take**
- **Camcorder support, exposure, focus**

Using the camcorder

a smooth movement when required. The way in which the camcorder is supported is one of the major contributing factors in producing a professional-looking end result.

Television studios use heavy pedestals, dollies, and booms to carry their cameras, minimizing vibration and erratic movement. Even on location, cameras are usually mounted on tripods. Only on occasional instant hard-news shoots are the cameras shoulder-mounted, and even then viewers usually see only a few seconds of that footage. Until recently, camcorders echoed the design of these shoulder-mounted news cameras. The public's desire for smaller and lighter camcorders eventually produced units held in front of the face like a still camera. This means that it is certainly more convenient to take a camcorder on holiday, but it is very difficult to obtain really steady shots without at least a shoulder brace. Of all the options for supporting a camcorder for stationary work, the tripod is the most popular (see Accessories and equipment, pages 162-8).

However, even without any additional equipment, you can reduce camcorder movement by adopting a firm, well-balanced stance and by taking advantage of available fixed surfaces, such as tables and walls, to provide additional stability. The choice of position depends on the type and size of camcorder.

SETTING EXPOSURE The next step is to set the camcorder controls for the lighting conditions with which you will be working. There are

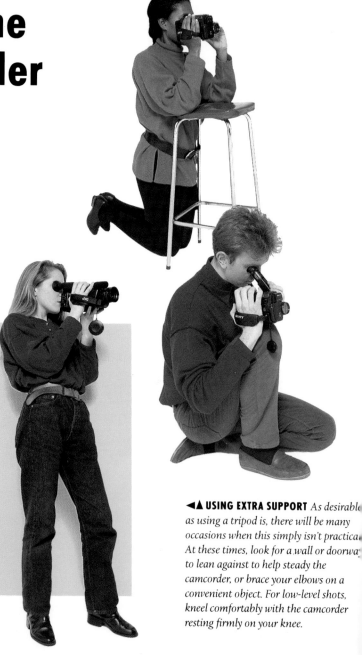

◀▲ USING EXTRA SUPPORT *As desirable as using a tripod is, there will be many occasions when this simply isn't practical. At these times, look for a wall or doorway to lean against to help steady the camcorder, or brace your elbows on a convenient object. For low-level shots, kneel comfortably with the camcorder resting firmly on your knee.*

► **CORRECT POSTURE**
When hand-holding a camcorder, stand comfortably with your elbows tucked into your body to brace the recorder. Your shoulders should be relaxed and your elbows not so tight that minute muscle tremors are set up, since these will translate to shaky pictures. For short sequences, a two-handed grip on the camcorder is best.

▼ **ONE-HANDED GRIP**
For lengthy sequences, a one-handed grip may be most comfortable. Support your elbow with your free hand.

► **LEGS AND FEET**
Stand with your legs slightly apart and spread your body weight evenly between them. Lock your knees, without tensing them, to help transform your body into a stable platform. If you want to pan from this position, then swivel the top half of your body only, moving from the hips, and leave your legs and feet motionless.

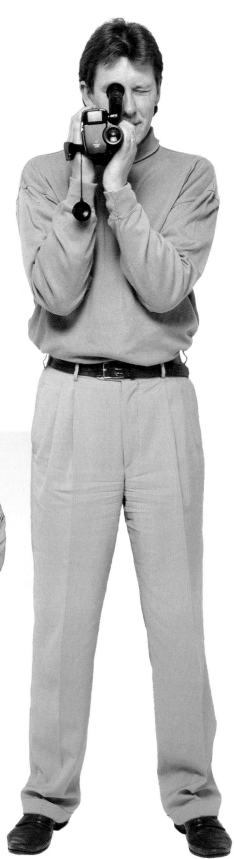

SHOOTING PROCEDURE
- *Switch on*
- *Insert tape*
- *Support camcorder*
- *Set colour balance*
- *Set shutter speed and aperture*
- *Zoom in to focus*
- *Frame the shot*
- *Start shooting*

with which you will be working. There are three settings that you need to consider: the white balance (or colour balance), the shutter speed, and the aperture size. The first, the white balance switch, should be set to match the type of light prevailing – either indoor or outdoor. On some camcorders, prevailing light is monitored electronically and adjusted automatically. The colour of light is discussed in more detail on pages 24-5.

Most camcorders set the exposure automatically. However, the shutter speed control available on some types of camcorders regulates the length of time that the light is allowed to enter the camcorder; it operates in conjunction with the aperture setting to give the correct exposure. For a fast-moving subject in normal lighting conditions, choose a fast shutter speed to keep the image from blurring when played back and paused to freeze frame the action.

The aperture is the adjustable hole set behind the lens and in front of the sensor. It governs the amount of light falling on the sensor. A built-in automatic exposure meter controls the set of blades that expand or contract to open or narrow the aperture; the meter responds to the prevailing levels of light. The size of the aperture also controls the

TIPS *For successful videos follow these basic rules.*
- *Have a clear idea of what you want to achieve with each take before you begin to shoot.*

- *Plan the take carefully, so that it has a clear beginning and end.*

- *Hold the camcorder completely still. Let any movement take place within the frame.*

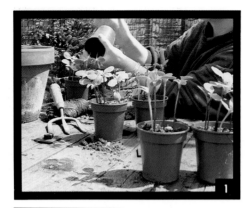

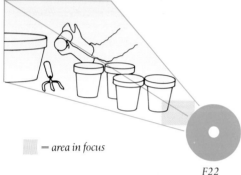

= area in focus

F22

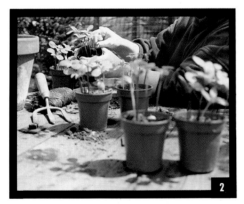

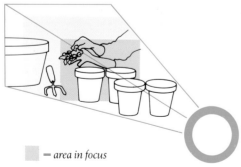

= area in focus

F1.4

◄ **DEPTH OF FIELD**
Camcorders with manual aperture control will have an aperture setting ring on the lens marked with f-numbers. The thing to remember is that the smaller the f-number the larger the aperture and the shallower the depth of field. In other words, changing from f11 to f8 widens the aperture and thus reduces the depth of field. In the examples presented here, the same scene has been shot with the lens set to f22 (1) and f1.4 (2). In the first image, depth of field is extensive, and everything from the near foreground to the far distance is sharp. In the final version, you can see the area of sharp focus is limited to the hands.
Also notice that depth of field extends roughly one-third in front, and two-thirds behind, the point of true focus.
The other factors that affect depth of field are focal length (see Zooming, page 64-5) and subject distance from the camcorder. The closer the subject to the lens, the shallower the depth of field at any given aperture or focal length.

depth of field – that is, the distance between the nearest and farthest points in the shot that are in focus. The smaller the aperture size, the greater the depth of field, and vice versa. Some camcorders have a manual aperture override that allows you to set the aperture yourself, in order to produce the depth of field you want.

COMPOSING AND FOCUSING You have dealt with your white balance and the exposure; now put your eye to the viewfinder and compose your shot. Use the viewfinder to frame the scene, concentrating on your principal subject and excluding distracting surrounding objects. (See Composing the shot, page 56-7). Remember that home-use camcorders produce the best and sharpest images while filming in close-up or telephoto mode. More distant, generalized scenes do not show up well on the small screen of a TV set. Though your camcorder will have an automatic focus facility, you may well decide to focus manually. Apart from anything else, this saves battery life. If you do take this option, use this valuable trick of the trade: zoom in close, focus, and then zoom back to frame your shot. If you do not do this, the focus may well drift as you zoom in or out during the take. You are now ready to begin shooting.

As your filming becomes more sophisticated, you will need to alter the focus continuously, using the zoom (too little of the zoom is better than too much) and altering the manual aperture to suit changing lighting conditions. Like playing the guitar or the piano, the coordination needed to do this only comes with practice.

SHOOTING Broadly speaking, there are two approaches to videomaking. If you press the on-off button frequently as you film the action – selecting what to film, filming it, and then pausing when nothing worth recording is happening – you are said to be editing in camera. Providing that you are careful in your choice of shots and timing, you may well produce a video that requires little editing. If you decide on the point-and-shoot method, that is, shoot virtually everything that you see in order to record the maximum amount of material, your video will almost certainly need editing afterward. Your choice of approach will largely depend on the nature of your subject and the predictability of the action.

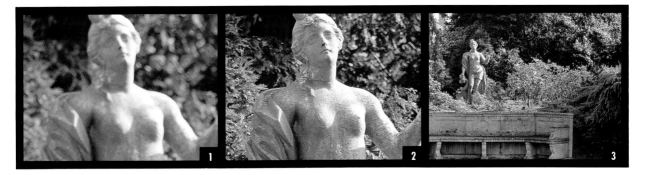

▲ **MANUAL FOCUSING** *To focus the camcorder manually, it helps to have the largest possible image in the viewfinder (1). First, zoom in to the closest focal length setting and adjust the lens focus control until the image appears sharp (2). You may have to move through the point of best focus before deciding. Next, zoom back until the framing is correct for the wider-angle view you have determined to start the sequences (3). Now you can start filming, knowing that your image will remain sharply focused when you zoom in again on the subject.*

ANALYSING YOUR SUBJECT *A useful feature found on some camcorders is an exposure lock. In subjects where there are deep shadows and very bright highlights, as in the landscape (right), the camcorder is not able to record detail in both at the same exposure settings. You will have to zoom in on the area that must be correct so that it completely fills the frame, and then engage the exposure lock. This fits the settings to suit that part of the scene. Next, zoom out again to frame the image for the take, and start recording. If you locked the exposure controls for a bright area of the scene, then the shadows will be underexposed. If you set the exposure for the shadows, the highlights will be overexposed.*

Dark shadow – no detail

Medium light – underexposed

Bright sunlight – correctly exposed – lots of detail

► **BACKLIGHTING** *The problem of backlighting occurs when the subject is between the camcorder and the light source. The metering system "sees" all this light and reduces the aperture. In the process, however, the subject is rendered as a silhouette (1). To overcome this, some camcorders have a backlight control. This opens up the aperture by a predetermined amount (2). Some models also have a manual aperture option, which will allow any amount of compensation (3).*

Few optical instruments are as efficient in low light as the human eye. But, in fact, the camcorder comes close; it surpasses even the best still camera in its capacity to cope with poor lighting conditions. Its sensitivity to low light means that, roughly speaking, if you can see it, the home video camcorder can film it.

CONTRAST While camcorders work exceptionally well in conditions ranging from dim rooms to bright sunlight, like still cameras,

- **Understanding lighting**
- **Contrast**
- **Low light**

Light levels

they have trouble with contrast – scenes combining elements in deep shadow and in strong light. Though the human eye can accommodate a contrast range of 100 to 1 (that is, when the brightest element is 100 times brighter than the darkest part of the scene) – some beach or snow scenes can reach contrasts of 500 to 1 – the camcorder can register a level of contrast only as high as 30 to 1. In high-contrast situations where there is no possibility of controlling or adjusting the contrast. Details in the shadows melt into black, while details in the highlights disappear into white.

WORKING IN LOW LIGHT LEVELS Even though camcorders can film adequately in low light, it is at the cost of quality. You will notice that both colour depth and image sharpness suffer. A grainy or sandy effect is often apparent on-screen. These are all results of the much-reduced signal-to-noise ratio. As with sound, if the recording level is very low, background interference intrudes. In sound recording this manifests itself as a hiss; "picture noise" appears in the form of visual grain, murky colours, and reduced sharpness.

Some types of camcorders have a gain-up switch that should be used in very poor light conditions. This facility amplifies the voltage produced by the light falling on the camcorder's image sensor, and so increases the apparent brightness of the picture. But even so, there is a cost in diminished sharpness.

LIGHT RATING *The video industry uses the common shorthand of light rating, measured either in foot candles – the light value of one candle at a distance of one foot from the flame – or, more usually, the metric equivalent measured in lumens per square metre, called "lux". One foot candle roughly equals 10 lux.*

Most video camcorders can record an adequate image if the brightness of the supplied light is 10 lux or more – a light too dull to read by. Many of the most up-to-date machines will record in light as low as 4 lux.

The illustrated scale (right) shows the lux ratings of a selection of lighting conditions.

Bright sun
50,000–100,000

Hazy sun
25,000–50,000

Overcast
2,000–10,000

Typical office
200–300

Typical living room
50–200

Sunset
1–100

Well-lit street at night
10–20

Dimly-lit street
at night
less than 1

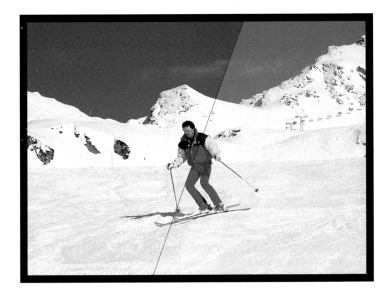

▲ ANALYSING THE LIGHT – HIGH CONTRAST *In a snow scene such as this, there is a risk that the combination of extreme whites and maximum blacks will produce a contrast range that a camcorder simply cannot cope with, and the image may show a loss of detail at both ends of the scale. Most autoexposure systems will "see" all the reflected light from the snow and sky and close the aperture down, turning your subject into a silhouette (as in the top left segment). A possible solution is to use backlight control to at least salvage the main subject (as in the bottom right segment).*

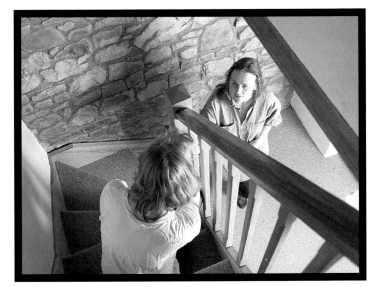

▲ ANALYSING THE LIGHT – LOW CONTRAST *In a low-contrast scene such as this, a lack of peak whites and rich blacks, results in an image that appears dull, grey and a little lifeless. By way of compensation, however, the camcorder should have little trouble in recording subject detail at both extremes of what contrast is present.*

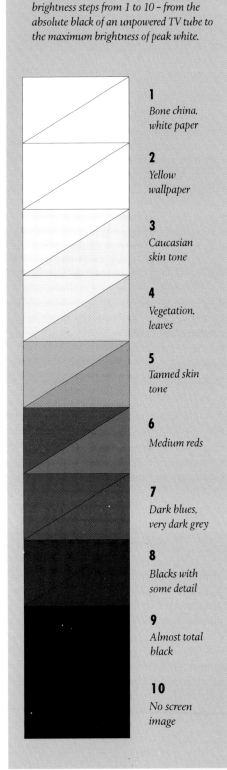

THE GREY SCALE *The grey scale is a scale used in video to designate a range of brightness steps from 1 to 10 – from the absolute black of an unpowered TV tube to the maximum brightness of peak white.*

1
Bone china, white paper

2
Yellow wallpaper

3
Caucasian skin tone

4
Vegetation, leaves

5
Tanned skin tone

6
Medium reds

7
Dark blues, very dark grey

8
Blacks with some detail

9
Almost total black

10
No screen image

23

The transparent colourless brightness we call light is actually a mixture of equal quantities of three colours – blue, green, and red. Increase or decrease the amount of any one or two of these components and the light takes on a colour or cast. Conversely, blackness – or total darkness – is the absence of these colours. In order to get the most from your video camcorder, it is necessary to understand these principles and to appreciate

- **The characteristics of daylight and artificial light**

The colour of light

that the colour of outdoor light is constantly shifting and changing around us.

Most people are unaware of how colours change as time passes during the day and as we move from place to place, though an experienced artist, photographer, or filmmaker recognizes these changes instantly. The most dramatic outdoor changes take place during sunrise and sunset, when the colour content of the light becomes predominantly yellow and red. From around two hours after sunrise to about two hours before sunset, the colour of daylight remains fairly constant. Both photographs and videos made during this period show little colour cast. Bright sunshine bathes the subject in light with a warm, yellow bias, while on heavily overcast days, coldness is imparted by a noticeable blue cast.

SETTING THE CAMCORDER FOR COLOUR High-quality camcorders can compensate well for the variation in light colour bias. Nevertheless, even if your camcorder has an automatic setting, it is best not to rely on it. Most machines have two to three positions on the white balance control: outdoors, indoors, and – optionally – automatic. The most advanced have an additional position for fluorescent lighting, to adjust for the green cast caused by this type of light.

Setting the control for either indoors or outdoors is self-explanatory. But if you have a mixture of light sources, it is then that the automatic setting comes into its own; when

▶ **LIGHT THROUGH THE DAY** *The pictures here illustrate the type of changes in colour rendition you could expect in subjects lit by the sun at different times of the day and in different weather conditions. (1) At noon on a sunny day, the light will have a high yellow content, and skin tones will appear bright and pleasant looking. (2) On a dull, overcast day, the light will have a high blue content, and skin tones could appear decidedly sickly. (3) Misty or foggy weather creates a broadly similar effect as overcast weather. (4) In the late afternoon, the sun creates a slightly yellow-orange colour cast as it sinks low in the sky. (5) With the sun below the horizon, what little light there is changes more to blue.*

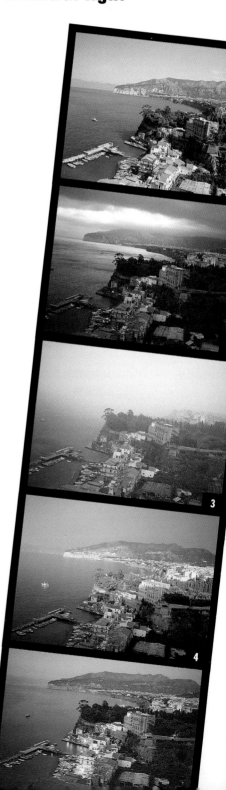

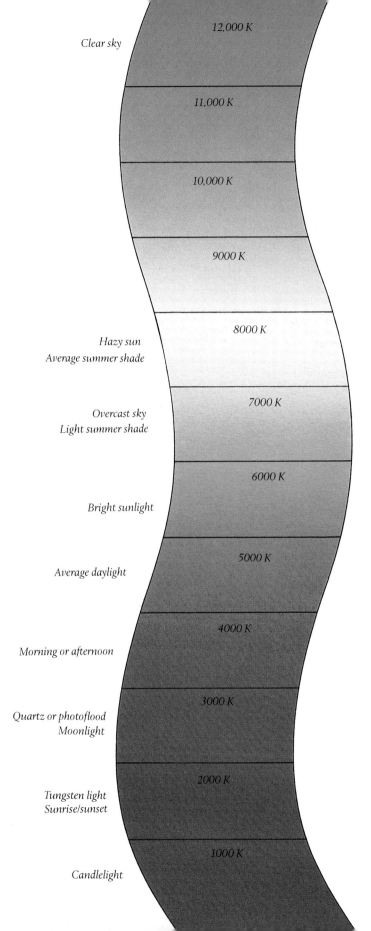

Clear sky — 12,000 K

11,000 K

10,000 K

9000 K

8000 K — Hazy sun / Average summer shade

7000 K — Overcast sky / Light summer shade

6000 K — Bright sunlight

5000 K — Average daylight

4000 K — Morning or afternoon

3000 K — Quartz or photoflood / Moonlight

2000 K — Tungsten light / Sunrise/sunset

1000 K — Candlelight

LIGHT vs SOLID COLOUR *Every videomaker should have a basic understanding of the principles of colour. The first, perhaps startling, fact is that the rules of optical colour, or the light spectrum, are quite different from those of solid, or pigment, colour. The three primary pigment-colours as used by artists, for example, are red, blue, and yellow; those of the optical spectrum are blue, green, and red – with yellow formed by an equal mix of red and green. The science of light is quite complex, so a textbook on colour aimed at photographers and filmmakers would be a useful addition to your bookshelf.*

this is set the camcorder will do its best to find the optimum balance for the scene being recorded (see also Indoor light, page 28).

Older video cameras and modern professional models need a preliminary fix on white, to set the camcorder for further recording. In order to do this, the viewfinder should be pointed at something white – a wall or a large object – while depressing the white balance button for several seconds. This reads the colour as white and thereafter sets other whites as good whites. Some camcorders are now supplied with a white balance lens cap to facilitate easy adjustment of the white balance. The setting is lost, however, every time the camcorder is turned off or if the colour of the light source changes.

◄ COLOUR TEMPERATURE
Colour temperature is a convenient way of describing the colour content of various light sources. It is measured in degrees Kelvin, although the degress sign is always omitted. To understand how it works you need to remember that the redder the light the lower its colour *temperature. Therefore, tungsten light sources (about 2000 K), which are deficient in blue wavelengths (and thus appear more orange) have a lower colour temperature than, for example, daylight (5000 K), which is high in blue wavelengths.*

25

Now we move to the widest stage available to the home videomaker – the Great Outdoors – with lighting courtesy of Mother Nature. But that can cause its own problems. Outdoor lighting conditions are normally difficult to control and manipulate. The contrast between light and dark either is too strong or so dull that everything looks flat. Shadows are necessary to emphasize shape, form, and texture, and are essential to give depth and visual

- **Making the most of natural light**
- **Using reflectors**

Using light outdoors

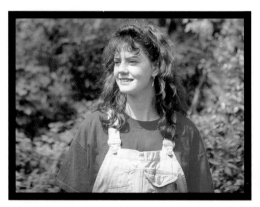

richness to your two-dimensional video. But when sunlight is too bright the shadows become harsh; if the day is overcast, little or no shadow is present.

So what can you do to better the chances of a good sequence? In some cases the easiest option is to move the subject indoors, but most live events render that impossible. Remaining outside restricts you to a stark choice – you can either arm yourself with a range of equipment designed to manipulate existing light, or you must make the most of careful camera positioning. The manipulation of lighting falls into two categories: additive and subtractive lighting. Additive lighting relies on the use of additional lights or reflectors; subtractive lighting, which is covered below, relies on clever use of shade or the use of screens or diffusers.

SUBTRACTIVE LIGHTING The larger the group or more spontaneous the action, the more difficult it will be to arrange or organize the

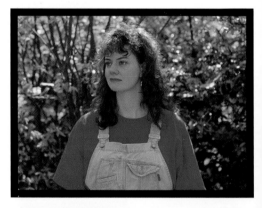

EXTERIOR LIGHTING CONTROL
Always remember you have two means of adapting outdoor lighting:

Additive lighting *Adding light to parts of the scene with artificial lights or reflectors.*

Subtractive lighting *Removing or lowering light intensity with screens or diffusers.*

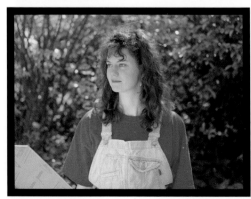

players. In the case of major outdoor events – like race meetings, football games; or trips to the beach or mountains – harsh shadows will not affect your wide, establishing shots. However, when you move in for close-ups of people and details, shadows may intrude noticeably. If it is possible to move the subject(s) into the shade for the close-ups, try doing so. Your camcorder aperture will adjust automatically. The colours in your establishing shots will be sharp and vibrant – the result of the bright sunlight – so when you cut to the close-up shaded shots, the fact that they are a little bluer should not matter too much. By using reflectors (see Adding light, page 30) you may be able to reflect additional light back into the shaded areas.

DIFFICULT LIGHT CONDITIONS When you have your camcorder set on automatic, the size of the aperture is controlled by a built-in exposure meter. This responds to the level of the prevailing light. However, no one should rely on automatic setting one hundred percent of the time. There are occasions when the camcorder's built-in exposure meter can be fooled by light conditions and will consequently miscalculate the aperture opening.

Placing your subject in front of a sunny window or a white wall will confuse the light meter of the most sophisticated camcorder. The exposure meter will respond to the bright background by automatically reducing the aperture size. Therefore only a small amount of light is allowed to fall on the sensor. Any areas that are shaded – such as the subject's face –

◄ SUBJECT IN BRIGHT SUNLIGHT *In this first shot, notice the overall warmth of the colours, and also how the contrast between highlights and shadows has created a generally sharp, crisp image. On the negative side, the shadows around the eyes are unattractive.*

◄ SUBJECT IN SHADE
By moving the subject into shade just a few feet from where the image above was taken, you can see how both highlights and shadows have moderated. Contrast is reduced and it is possible to see more detail overall.

◄ INTRODUCING A REFLECTOR *Shooting in the shade, but using a reflector to put back some of the "sparkle", is the best lighting option in these circumstances. Lightening the face produces a more attractive result.*

TACKLING PROBLEMS WITH NATURAL LIGHT

Low light *Use the gain-up switch.*

Bright background *Use manual aperture setting to over-expose the main subject* or *Use the backlight control switch.*

Strong contrast *Change the angle to cut deep shadows out of shot; move subject into the shade; use manual aperture setting; use the backlight control button.*

WORKING WITH BACKLIGHTING
This exercise is designed to help you learn how careful use of the camcorder controls can help you overcome the problem of strong light behind your subject.
● *Ask a helper to stand outside in front of a brightly lit white wall.*
● *When you look through the viewfinder as you start to record, you will notice that your subject's skin tone appears too dark.*
● *If you have a manual aperture control override, gradually open the aperture as you record, until the skin tone appears correctly exposed.*
● *If your camcorder has only a backlight control switch, first record the scene with the switch off, and then with it turned on.*
● *When you play back you will notice that as skin tone is corrected, the white wall becomes over-exposed. In most cases this is an acceptable trade off.*
It is also useful to compare the settings required for correct skin tone in the above sequence with those required for the same subject in the same lighting levels against a dark background.

will appear as black silhouettes, and all detail will be lost. Relatively unimportant areas, on the other hand, like the brightly lit background, will be clear and sharp. Unless you want to create this effect, this type of lighting is unlikely to produce a video most of your friends would enjoy!

By using your machine's manual override, however, you can deliberately overexpose the whole picture. This will render detail in the shaded subject area correctly, and though the less important background will be too bright, it is an acceptable solution. If you do not have manual aperture override, use the backlight control switch to adjust the exposure. This switch increases the aperture size by a set amount to provide a more balanced picture.

We all know how the colour of clothes and furnishings can change when taken from the well-lit interior of a house or store into the clear sunlight of a doorway or window. The colour of light from light bulbs and fluorescent tubes is quite different from that of daylight, and this affects your video pictures. You must be sure to set the camcorder to the correct type of light before you start taping. Quite apart from the direction from which

● **Using available light sources**
● **Coping with mixed light**

Indoor light

your light is coming and its relative hardness or softness, the most important aspects of concern when taping a video indoors are overall brightness and the number and mix of the light sources you are using.

OVERALL BRIGHTNESS Although the relative brightness of modern home lighting and the increased sensitivity of the newer camcorders means that more than reasonable results are usual when filming home videos, they can be improved still further by increasing the light supply. In most situations this can be done quite easily.

Increasing the strength of domestic light sources is the most obvious first step. Professionals carry a range of 100- and 150-watt household bulbs, together with adaptors for bayonet and edison-screw fittings, to be used on ordinary table and standard lamps. Never, under any circumstances, use photoflood bulbs in domestic lamps.

By bringing in more lights, by positioning them carefully, and by using spotlights and ordinary lamps for directional lighting, you can brighten indoor light to a great degree. Additional lighting treatments for higher quality videos are covered on pages 30-3.

MIXED LIGHT SOURCES In interior shots, the main problem is usually caused by mixed lighting. A scene may be lit by a mixture of outdoor light (blue), tungsten light (yellow), and fluorescent tubes (green). This cocktail of colours can result in a bizarre cast on the

1

3

THE COLOUR OF INDOOR LIGHT *Every type and intensity of indoor illumination has its own colour, temperature and coloration. Video tape will, however, record these different colours and produce images with distinct casts unless you adjust the "white balance" on the camcorder to compensate. On modern models, the white balance adjusts automatically as you move from one type of lighting to another, but no camcorder can cope with competing casts from different sources. In the images here, you can see (1) a figure lit by daylight with the camcorder set to record indoor light. The blue cast is the result of the camcorder boosting the blue content to compensate for tungsten's deficiency in these wavelengths. In the next image (2), a photoflood is the main lighting and the camcorder has been set for daylight. The result is a more yellow colour cast. In the next version (3), fluorescent lighting, even with the camcorder set for indoor light, produced a green cast, while in the final image (4), domestic tungsten gives an overly warm, unnatural colour effect.*

exercise

USING THE WHITE BALANCE *The object of this exercise is to demonstrate how the use of the white balance control affects the colour quality of your recordings.*

● *Record an outdoor scene with the white balance set for indoor light.*
● *Then shoot a further sequence with it set for outdoor (natural) light.*
● *Next go indoors and record a sequence lit by artificial light, making sure that all natural light is excluded. Make sure that the white balance is set for outdoors.*
● *Finally, record a last sequence, this time with the white balance set for indoor light.*

When you compare these test sequences you will clearly see that the indoor shots with outdoor settings are too yellow, and that the outdoor footage shot as for indoor lighting have a blue cast.

scene. The best way to solve this problem is to change the colour of the light source(s) to match one another as much as possible. You can set the camera for indoor (tungsten) lighting and put yellow Cellophane sheets over the windows to remove the blue content of the daylight. Or you can set the camera for daylight and put blue Cellophane sheets in front of the indoor light sources to remove the yellow content of the light. If the scene is predominantly lit by fluorescent tubes, you can fit a magenta filter over the camcorder lens or cover the tubes with magenta-coloured Cellophane to cut out the green cast.

Some camcorders have an automatic colour balance control that gives you an effective compromise when subjected to mixed lighting. Such balance controls are usually quite effective, but generally it is better to modify the colours of your light sources.

If you wish to extend your creative options beyond what is possible with simple domestic lighting or natural light alone, you may consider investing in some specialized video lighting equipment. For most people some home-made reflectors and no more than three video lights are sufficient to provide a wealth of new lighting possibilities.

REFLECTORS On big-budget movies, the lighting teams use extremely bright, large units,

- **Creating a lighting setup**
- **Power outputs**
- **Lighting effects**

GETTING STARTED · Adding light

powered by big generators and with the output of military searchlights. For lower-budget film and video productions, reflectors are more generally used.

Reflectors can be positioned outdoors or indoors, and partnered with natural or artificial light. They redirect light to fill in the shadows, to create a more even spread of light, and to produce backlighting. Although photographic companies produce a variety of reflectors, they are very easy to make yourself. Leading lighting professionals often adapt household materials, such as white polystyrene sheets, aluminum cooking foil, white linen bedsheets, and so on, to their own individual reflector designs, and use them to bounce back both sunlight and artificial light. Video needs relatively soft light, with low levels of contrast to give good detail in both the highlights and shadows. This requires a lot of bounced rather than direct light.

Most reflectors are silver or white. While silver surfaces are generally more reflective, they can reflect the blue of the sky, producing a cold colour cast. White reflectors give a warmer, more natural colour to the scene. Gold reflectors are occasionally used to warm up skin tones, particularly when there is little natural yellow in the light source.

VIDEO LIGHTS Video lights come in a range of sizes, styles, and power ratings, and there are three basic types to choose from – professional video lights, domestic fan-cooled video lights

▲ **REFLECTORS**
Reflectors – easily made at home with foil or white card (above right) – will produce soft, sympathetic lighting without completely losing its directional qualities as in the shot above.

▶ **CEILINGS AND WALLS** *When filming indoors you will often have the opportunity to bounce light off nearby walls or a low ceiling. This gives a soft, directionless lighting effect. You need to take care, however, to use a white- or neutral-*

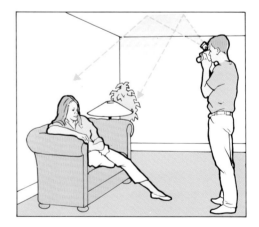

coloured surface, since the light will pick up a cast from any surface it is bounced off.

VIDEO LIGHT OUTPUTS

The table below summarizes the light output provided by a selection of additional light sources.

Quartz halogen video lights	*up to 2000 watts*
Sungun *(hand-held, battery-powered light)*	*250 watts*
Electricity supply-powered video lights	*500-2000 watts*
Battery-powered video lights	*40-100 watts*
Photoflood lights	*500 watts*
Photographers' lamp	*250 watts*
Domestic security lights *(patio-type outdoor security lights adapted for video use)*	*500 watts*

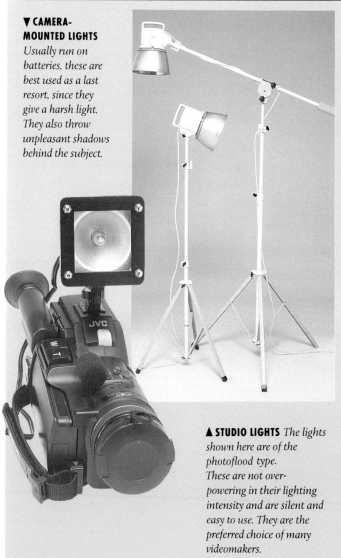

▼ CAMERA-MOUNTED LIGHTS
Usually run on batteries, these are best used as a last resort, since they give a harsh light. They also throw unpleasant shadows behind the subject.

▲ STUDIO LIGHTS *The lights shown here are of the photoflood type. These are not over-powering in their lighting intensity and are silent and easy to use. They are the preferred choice of many videomakers.*

and photofloods. You should consider your needs carefully, since a comprehensive lighting setup can cost as much as your camcorder.

Professional video lights are quartz halogen lamps of between 500 and 1000-watts. Quartz halogen domestic fan-cooled video lights house one or two 1000-watt tubes. They have a colour temperature of 3200K, which is similar to domestic tungsten lighting. Safety glasses, which also act as diffusers, are fitted over the bulbs, and many have barn-door flaps that control the direction of the light. The better models also have a facility for fitting filters and diffusers.

Photographers' photoflood lights use edison-screw tungsten photoflood bulbs of 275 or 500 watts. They have a colour temperature of 3400K, notably higher than domestic tungsten lighting. They cast an even illumination over a wide area and give soft-edged shadows.

The best way of using video lights is to bounce the light off white walls or a ceiling. However, this is not always practical. If a room has coloured walls, the colour will be reflected in the video footage. And many buildings have ceilings that are too high or darkly painted for light to bounce off them. In these circumstances you will need to point lamps directly at the subject. If they are too powerful, however, they may cause discomfort and squinting. At a distance of 3 to 10 yards, direct 500-watt

LIGHTING AND SAFETY *Although there are many different light sources, all possess one common characteristic: they produce heat. The strength of the heat given off from photographic and video lamps means that the lampholder itself becomes very hot. Touching the casing of a video lamp can cause a severe burn. If the lamp is placed too near wallpaper or any flammable material it could catch fire.*

Quite apart from the danger caused by overheating, any electrical appliance can be dangerous, perhaps lethal, if it has a faulty connection. Fuses of the correct rating should be fitted, and connections and wiring regularly checked. Leads should not be left lying across floors when they are not in use, and when they are needed they should be taped down with gaffer or packaging tape.

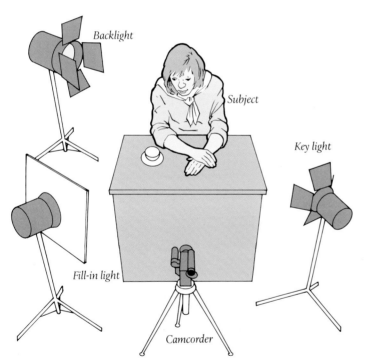

Backlight

Subject

Key light

Fill-in light

Camcorder

lights are quite sufficient for most purposes; 1000-watt lights could be too bright. On the other hand, 500-watt lamps may not be quite bright enough to be bounced off walls.

THE THREE-LIGHT PROTOCOL Consider, for a moment, two types of normal daylight. On a bright, clear day the sun acts in a similar way to a directional spotlight, creating harsh lighting and deep, long shadows. This is particularly noticeable when filming scenes involving people. Strong sunlight imparts unpleasant highlights to light-coloured clothing and exaggerates facial features – noses appear longer and eyebrows cast shadows.

In contrast, a cloudy, overcast day throws few shadows. Video pictures taken on such a day are flat and two-dimensional.

The camcorder aperture must try to find a happy medium between these extremes. Some controlled shadow is necessary, since shadow provides one of the prime visual indicators registering depth in a scene. For several decades, the three-light protocol has been the answer to the problem. By using three artificial light sources, still and movie camera operators attempt to create the ideal light setting, with just the right amount of shadow detail, a compressed contrast range, and an effective use of directed light.

The three-light protocol was first used by portrait photographers intent on establishing, by careful use of lighting, the best effect of mood, shape, form, and isolation from background. It is difficult to employ the three-light protocol for moving subjects and it is most useful in lighting individuals talking to the camera, or people involved in interviews, discussions, or static groups.

LIGHTING MOVEMENT The lighting of moving subjects must always be a compromise. In most shots, action begins with a stationary subject who goes through the movement and becomes stationary again. In this situation you should be able to light the beginning and end of the shot carefully, deciding on one of two options for the central section. Either allow motion to take place under available light, or wash the scene with a high-output general lamp or lamps. Although you will want to move the camera while filming, never move the lights. The movement of the shadows would look quite bizarre.

THREE-LIGHT PROTOCOL SETUP

First place the key – or main – light at an angle of 45° to the subject. It creates a triangle of light whose borders are shadows cast by the nose, eyebrows, and the side of the face. Next set up the fill-in light on

the opposite side of the subject. The fill-in light should be half the brightness of the key light, or, if equal in brightness, it should be positioned behind a diffuser or be placed twice as far away. It lightens the shadows cast by the key light.

Finally mount the backlight behind the subject. It will cast highlights on the background and/or the subject's hair.

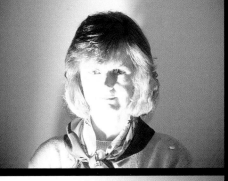

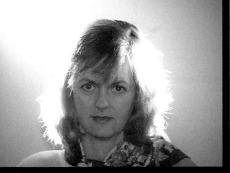

Rim lighting *The subject is lit from behind with two lights - one on each side. The subject is also lit from in front by a light, or in this case, a reflector.*

Under-lighting *in which the subject is lit from below, is used to create an eerie or supernatural effect. Much used in the theatre and in horror movies, this lighting effect is produced by positioning the light well below the height of the subject's face and pointing up at it.*

Halo lighting *uses a single light behind the subject. There is also light from in front provided by a reflector or an additional light.*

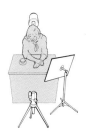

Butterfly lighting *If you have only one lamphead available, place it close to the camera and slightly behind it at a height of about 8ft. This avoids the problem of the shadow of the nose that would be created by a light from the side.*

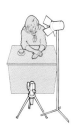

Silhouette lighting *in which the subject is lit from behind only, is often used in news and current affairs programmes to conceal the identity of the subject.*

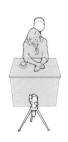

◄ **LIGHTING EFFECTS**
The diagrams and their associated images here give a good indication of how to achieve certain lighting effects. These are a guide only, however, since much depends on the power output of your lighting unit, the proximity of any reflective surfaces, and the size of the subject in the viewfinder. Experiment with any of the setups by introducing coloured, patterned, or semi-opaque materials over some of the lighting heads.

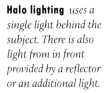

One of the most common mistakes of the novice videomaker is that of concentrating on the visual aspects of recording to the exclusion of the sound elements. Somehow, the auditory components – whether voices, music, or background noises – are expected to be picked up at the same time as the images, without any effort on the part of the camcorder operator. However, good sound reproduction makes an important contribution to the

- **An introduction to sound and acoustics**
- **Hard and soft sound**
- **Modifying acoustics**

The basics of sound

overall immediacy and interest of any video recording. Whatever control you can exercise, however, will be primarily on the surroundings, rather than on the functioning of the machine itself.

EMITTING AND RECEIVING SOUND Sound travels out from its source in waves. The concept is easier to understand if you compare it to the vibration sent through the water when a stone is thrown into a pond. The ripples radiate out from the source in a regular pattern. The number of waves leaving the sound source per second is called the frequency, calibrated in Hertz (Hz). Thousands of Hertz are known as kiloHertz (kHz). The strength or push that gets the sound waves moving away from the source is measured in watts (w).

Sound waves are absorbed by some materials, such as carpets, clothing, and curtains, and bounce off hard, smooth surfaces. The way in which sound is heard depends not only on the volume of the sound but also on the way in which some of it is absorbed or reflected by the immediate environment. In technical terms, sound is referred to as either hard (reflected) or soft (partially absorbed). Sing in your bathroom and the effect will be completely different from that achieved when you sing in your living room. Engineers go to great lengths to get the balance or mixture of incident, or non-reflected, sound and reflected sound just right.

Although the ear is trained from birth to

▶ **HARD AND SOFT ROOMS** *Both the structure of the room and its furnishings and contents affect the characteristics of the sound you are recording. Carpets, soft furniture, wall hangings, drapes and so on all tend to muffle and deaden sound waves and produce a "soft" sound. Polished floors, bare walls, uncurtained windows, and wooden surfaces all reflect sound waves back and give a "hard" sound quality. The room shown here, with its soft furnishings and drapes, would produce a soft sound.*

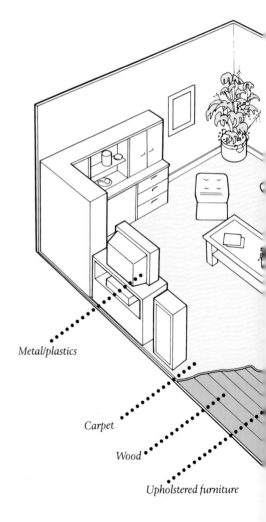

Metal/plastics

Carpet

Wood

Upholstered furniture

exercise

CREATING HARD AND SOFT ROOMS *In this exercise you will learn to distinguish the differences between sounds recorded in "hard" and "soft" rooms. You will need an audio-cassette recorder and some music tapes. Use the camcorder to record the music and perhaps also your own voice in as many of the following places as you can:*

● *An empty garage.*
● *A bathroom with bath mats and towels in place.*
● *A bathroom without any soft furnishings.*
● *A living room.*
● *A carpeted bedroom.*

When you play back, you will notice how the reflective surfaces in the hard rooms create an echo effect that is reduced in the presence of sound-absorbent soft furnishings.

distinguish between a main source of sound and all other impinging sonic reflections, a microphone cannot do this. So unless you take care when making a video, the recording can contain a jumble of conflicting sounds.

Because it is easier to add sound components than to take them out, sound studios are designed to give what is known as a dead response. In most cases the recordists use absorbent materials, such as mattresses, cardboard egg-cartons or corrugated cardboard to lose any echo. In the home, a living room with pleated curtains, a carpet, and lots of soft furnishings would present the domestic equivalent of a dead room.

THE EFFECTS OF ACOUSTICS Sound quality can be affected by echo and reverberation. When sound is reflected, there may be a short period of silence before the sound returns once, clearly and distinctly – this is an echo. Echoes are a particular problem in buildings such as cathedrals where both the stone walls and furnishings are reflective. In such circumstances sound may have several echoes, each of which may take seconds to return. This is an extreme example of "live" or hard sound.

In the case of reverberation, the sound comes back repeatedly, at shorter and shorter intervals, until it dies away or decays. Reverberation has been cultivated as a technique at pop concerts and a reverb unit is useful in audio-processing for amateur videos. You may wish to recreate the effect of the voice coming over the public address system of a large outdoor event, for instance. A single microphone fed through a reverb, used with an audio-dubbing camcorder, would achieve this.

FREQUENCY To understand and use sound effectively, you also need to have some knowledge of frequency levels; these affect the pitch of sound. Most adjustment and manipulation of frequency levels is done during editing. While some microphones have limited frequency controls (called roll-off), generally speaking, during video filming you have enough to do to control the incoming pictures accurately without having to worry about sound levels as well. For this reason, most camcorders automatically control the amount of sound being recorded and have no extra sound control facilities.

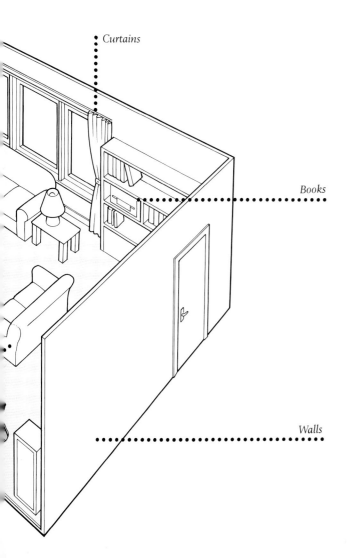

Curtains

Books

Walls

Normal video sound is recorded in much the same way as it is on an audio cassette – the sound signals are translated into magnetic pulses on the tape. This is called linear sound recording and differs from pure audio recording only in that with an audio recorder you record sound over the whole tape, whereas video sound uses only a thin strip down the edge, the rest of the tape being reserved for pictures. Stereo video recordings have two

- **How the camcorder picks up sound**
- **Choosing the right microphone for the job**

Recording sound

sound strips on the tape – one strip for each channel.

HI-FI SOUND Like everything else in the video field, sound-recording techniques are undergoing continual improvement. Recent developments for VHS and Super VHS formats include hi-fi or DM (depth multiplexed) sounds, while Video 8 and Hi-8 have benefited additionally from PCM (pulse code modulated) sound. It is worth pausing here to clarify our terms. The description *hi-fi*, in particular, can be confusing, since in the past video recorders were marketed as such because the normal linear-type sound was improved slightly. This older, so-called hi-fi bears no resemblance to the newer hi-fi methods of sound recording described here.

In hi-fi (DM) recording, the sound is recorded over the whole tape area. This results in far better sound reproduction quality – in fact, it is almost as good as compact disc sound. Because true hi-fi is so new, the manufacturers realize that many people, when buying the new hi-fi camcorders, will only have standard linear VCRs, which are unable to play back hi-fi sound. Therefore, all current hi-fi camcorders are also fitted with standard linear sound recording and playback.

The additional option of hi-fi sound has caused much confusion within the industry. Obviously it is a great step forward to have improved sound, but since some camcorders and VCRs have it and others do not, you need to

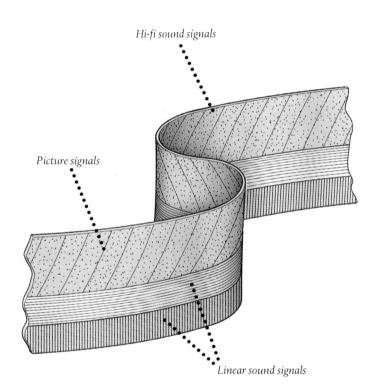

Hi-fi sound signals

Picture signals

Linear sound signals

HOW SOUND IS RECORDED *The majority of camcorders record linear sound – that is, the sound signals are carried on a separate part of the tape from the pictures on two adjacent strips* *(one for each stereo track). Hi-fi sound, which is available on an increasing number of machines, is recorded all over the picture area of the tape. Because this sound information is mixed with the picture* *signals, hi-fi sound – unlike linear sound – cannot generally be removed after recording.*

take particular care when purchasing equipment to mix and match a video setup.

At present one major drawback is that hi-fi sound cannot be removed from the tape, or have sound dubbed onto it, without destroying the pictures. Only one very expensive amateur VCR is available that can insert pictures onto a hi-fi track.

Whatever type of camcorder you have, the simplest way of recording sound is to use the on-camera mike to record live sound onto the video tape at the same time as the pictures. This is known as synchronized sound. Sound quality can often be enhanced by using an accessory microphone (see page 39), which cuts down on camcorder handling noise. Another sound recording option is to add sounds recorded at other times – for example, commentaries or music – at the editing stage (see Wild track sound, page 42).

MICROPHONES The microphone is an instrument that turns sound waves into an electrical signal. The signal can then be passed through a wire to a recording mechanism and onto a tape. Unfortunately, most microphones fitted

to camcorders are not as good as separate accessory microphones.

Most, but not all, camcorders are fitted with a socket to allow the use of an accessory microphone. However, there are two points to keep in mind when deciding whether or not to buy one. First, while the microphone should be out of shot during filming, it must still be as close as possible to the source of the sound. This is not always possible if it is attached to the top of the camcorder. Second, there is a range of microphone types, each suitable for a different job.

The main way to improve sound is to use an accessory microphone connected to the camera by about 20 feet of cable, positioned on a stand. While this setup is useless in mobile situations, nevertheless, even when filming large events, a microphone with three feet or so of cable used with a stand will vastly improve the quality of the sound and exclude any camcorder-handling noises.

MICROPHONE MECHANISMS There are two basic types of microphone: the dynamic microphone and the Electret condenser type.

THE RIGHT MICROPHONE *The choice of the appropriate microphone for the job is one of the key factors in producing a good-quality sound track. Here the wedding videographer has decided to use an off-camera microphone, placed near to the altar, to record the vows – arguably the part of the video in which sound quality is most vital. For other parts of the wedding celebration the on-camera mike would be adequate.*

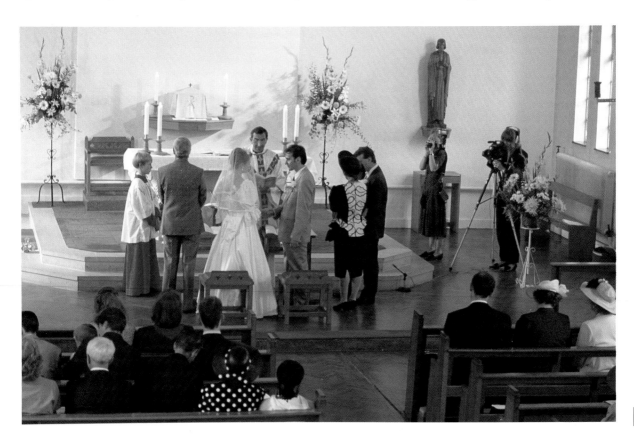

Dynamic microphones are good general-purpose microphones that work well even with a long cable. Microphones of this type do not require a battery. Electret condenser microphones are more sensitive and make use of an additional battery to amplify the sound signal. They do not, however, tolerate cable lengths of longer than about 60 feet.

POLAR PATTERNS The polar pattern of a microphone describes its directional response, that is, the extent to which it picks up sound evenly from different directions. There are three types of polar patterns: omnidirectional, cardioid, and shotgun.

An omnidirectional microphone picks up sound evenly from all directions. It is good for recording general background and atmospheric sound tracks. Most built-in camcorder microphones are omnidirectional.

The cardioid (or unidirectional) microphone picks up sound mainly from in front, and a little from the sides – generally including the picture area – so that incidental noise is reduced. The cardioid microphone is a good general-purpose microphone and is particularly suitable for recording sound at events such as conferences.

The shotgun microphone is very directional. It picks up almost no side sound and definitely no back sound. It is especially useful for interviews, and for recording speakers from a distance.

OTHER TYPES OF MICROPHONES The Lavalier clip-on microphone solves all the problems of getting the microphone close to the speaker. Although of the sensitive Electret condenser type, its small size and the fact that it is clipped to a tie or lapel means that it can only be used with a static subject. It is not suitable for recording groups of people, as each person needs his own microphone. The results have to be fed into the camcorder using a mixer. On the plus side, the Lavalier clip-on is high quality at a low price.

The radio microphone normally comes with both a larger omnidirectional version and a Lavalier. It is sometimes supplied simply as a transmitter/receiver with no mike. Radio microphones, cheap ones in particular, are unlikely to produce sound recordings of a high enough quality.

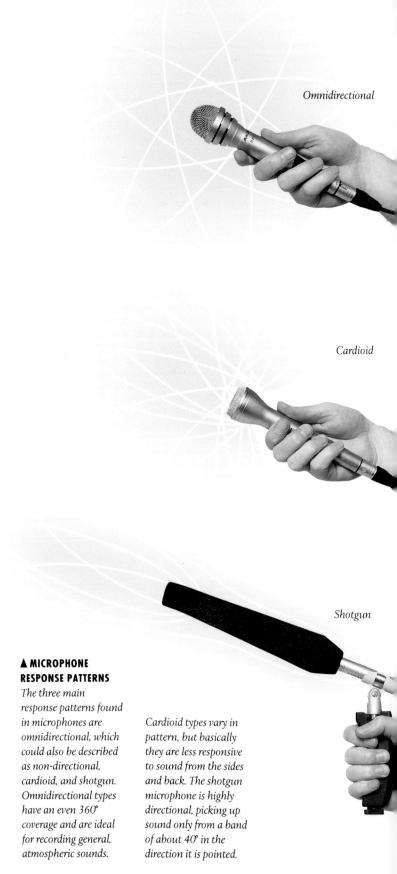

Omnidirectional

Cardioid

Shotgun

▲ MICROPHONE RESPONSE PATTERNS
The three main response patterns found in microphones are omnidirectional, which could also be described as non-directional, cardioid, and shotgun. Omnidirectional types have an even 360° coverage and are ideal for recording general, atmospheric sounds.

Cardioid types vary in pattern, but basically they are less responsive to sound from the sides and back. The shotgun microphone is highly directional, picking up sound only from a band of about 40° in the direction it is pointed.

WHICH MICROPHONE FOR WHICH JOB?

Single person *clip-on, cardioid, omnidirectional*
Two people *cardioid, shotgun*
Group *cardioid*
Subject at a distance *shotgun*
Crowd *omnidirectional, cardioid*
Background *omnidirectional*
Moving subject *radio*

POSITIONING THE MICROPHONE

Attaching the microphone to a lightweight boom allows you to position it above the sound. If you need both hands for the camcorder, then consider using a small, portable microphone stand, which is fine for a static sound source. For best voice quality, use a personal microphone, or a Lavalier, which clips on to the speaker's clothing near the mouth.

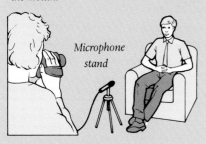

Microphone stand

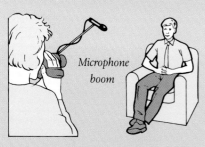

Microphone boom

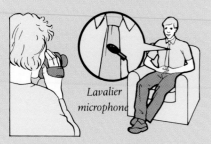

Lavalier microphone

▶ **USING MIKES** *Good microphone technique means getting the mike as close to the sound source as possible. This may involve hiding an off-camera mike within a prop, such as a vase, or attaching it to a boom (you can improvise with a broom handle) and enlisting a helper to hold it out of the shot as shown here.*

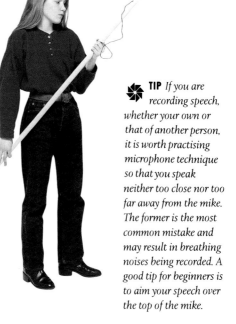

✦ **TIP** *If you are recording speech, whether your own or that of another person, it is worth practising microphone technique so that you speak neither too close nor too far away from the mike. The former is the most common mistake and may result in breathing noises being recorded. A good tip for beginners is to aim your speech over the top of the mike.*

exercise

RECORDING WITH BACKGROUND SOUND *The object of this exercise is to gain a practical understanding of how to control sound. You will need two people to hold a conversation, an off-camera microphone, and a radio tuned in to a station broadcasting speech rather than music.*

● *Using the camcorder's built-in microphone, record your subjects in conversation together with the radio playing in the background. Ask them to pause from time to time so that you can only hear the radio.*
● *Repeat this exercise without the radio.*
● *Now use an off-camera microphone to record the conversation first with the radio in the background, and second without the radio. Set up the microphone so that it is close to your subjects. When listening to your tapes, notice how the unwanted background noise intrudes and disrupts the main sound track. Notice also how the background noise appears to get louder when the speakers pause, as a result of the camcorder's automatic gain mechanism. In most cases the sound track obtained with the off-camera mike will make the background sound less obtrusive and give the speaker's voices more depth.*

There are a number of ways in which you can monitor level and quality of sound as you record it. On some camcorders you can check the VU (volume unit) meter on the side of the machine or the LCD (liquid crystal display) arrays in the viewfinder. Alternatively you can use headphones or link the camcorder to a vision monitor watched by a helper.

In reality, checking the VU meter while filming is extremely awkward, because you are

- **Checking sound quality**
- **Background noise**
- **Reducing unwanted noise**

Monitoring sound

too busy with your eye to the viewfinder. Situations in which you are using a tripod are a little easier, but it still means a break in watching the action. For this reason, most people use headphones.

If you decide to rely on headphones, you must exclude as much environmental sound as possible that is not being picked up by the microphone. In this respect the hearing-aid type of earpiece usually supplied when you buy your camcorder is virtually useless. Personal stereo headsets are a little better. But the best answer is the larger, ear-enclosing headphones, which are not expensive. Be careful to ensure that the impedance rating is correct for your camcorder when you purchase headphones. Around four to eight ohms is normal. If in doubt, consult your video sales shop, even if you are planning to purchase the headset from somewhere else.

Many video camcorders automatically adjust the sound recording level. This can be annoying because in quiet passages between desired sounds, the audio circuit of the camcorder will hunt for any sound and will amplify unwanted background noise until a loud sound nearer the microphone brings the level back to normal. Top-of-the-line camcorders avoid this problem since they are equipped with hi-fi sound. This means that, in addition to better sound pickup, they are also manually adjustable, and can be monitored by observing the VU meters or LCD arrays.

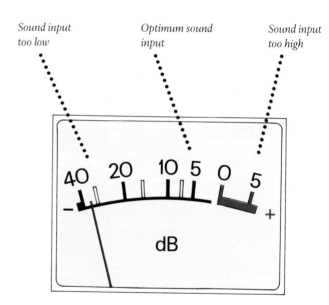

Sound input too low *Optimum sound input* *Sound input too high*

▲ VU METERS *Good-quality sound depends on the strength of signal coming into the system matching the recording medium's ability to record it, too little, and tape hiss becomes apparent, too much, and the tape will become overloaded and distort. To help you monitor this aspect of* *recording camcorders have a VU meter that registers, either as a swinging needle across a scale of values or a light display, the quantity of sound picked up by the microphone.*

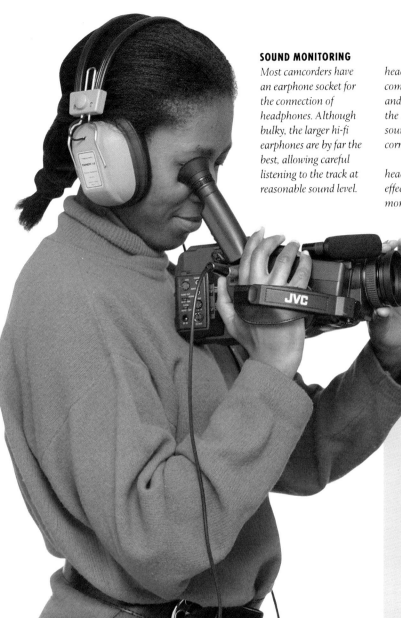

SOUND MONITORING

Most camcorders have an earphone socket for the connection of headphones. Although bulky, the larger hi-fi earphones are by far the best, allowing careful listening to the track at reasonable sound level.

Walkman-type headsets are a compromise. Lighter and more portable than the hi-fi version, their sound transmission is correspondingly poorer.

Hearing-aid type headsets offer the least effective method of monitoring sound.

However, they are useful when travelling, since they are the most portable of the three earphone types.

Camcorders that record a hi-fi stereo sound track have either a pair of VU meters to monitor the adjustable recording levels, or they have an LCD array of lights to indicate the levels.

PROBLEMS HEARD IN SOUND RECORDINGS

Distortion This is caused by extra, unwanted frequencies or over-modulation of the sound. It cannot be cured once it is recorded.

Noise Disturbing background sounds are recorded by every camcorder to some degree. A partial solution is to use an accessory microphone close to your sound source.

MONITORING BACKGROUND SOUND Continual and careful monitoring of background sound throughout filming is a must, in order to achieve sound continuity. Naturally you will be alternating between pause and record as you collect your stream of moving images, but don't forget that as you take a pause from recording, you are cutting the sound as well as discontinuing the picture.

In most general filming situations this is relatively unimportant, since when you turn on your camcorder again the background environmental sound will seem to have been continuous. If you are recording a scene where there is background music, however, you will be chopping from one song to another when you pause from filming – the lack of continuity will also be apparent if people are speaking. In addition, cities and towns often have aircraft or other traffic noise in the background that will also cut inconsistently. Always remember, therefore, not to interrupt everyday sounds with a deafening silence. For example, if an aircraft flies overhead when you are filming a scene, let the sound die away completely before you switch off.

Most of us have seen documentaries – or even fictional accounts – about the making of motion pictures. One scene is bound to feature a camera tracking shot, with a large microphone suspended over the actors. This microphone is recording dialogue into a tape recorder. It will later be added to the film when that is edited.

The separate sound recording is known in movie and professional video circles as the

- **Recording background sound and sound effects**
- **Synchronizing sound to pictures**

Wild track sound

wild track. In the case of film, the wild track is recorded on either an optical or a magnetic sound strip. Most videomakers use wild track sound, not as the main sound track, but as a way of adding extra sound effects or general, non-specific, atmospheric, or background sound that they have recorded separately, onto films at the editing stage. This also often helps to make editing cuts less obvious. (For more information on editing your sound track, see Editing sound, page 92).

The portable tape recorder used most often by professionals is a sophisticated reel-to-reel machine called a NAGRA. But a portable domestic audio cassette player is an adequate alternative. And don't forget that you can use your camcorder as an audio recorder even if you don't want to record pictures.

The time-honoured way of synchronizing sound to pictures is by using a clapperboard at the beginning of each take. The editor, spooling through the visual tape in slow motion, hits the pause button just as the arm of the clapper hits the slate. The editor then listens to the audio tape and pauses at the same moment as the sound of the click of the arm hitting the slate. Both tapes can then be set in motion exactly synchronized. Affordable electronic time-code systems are now appearing on the market to simplify the matching process, and soon some home-computer systems will also be able to do this.

▲ CLAPPER-BOARD
Clapper-boards are available from any good video accessories store. They are excellent devices for marking the beginning of a take – all the relevant information being written in the spaces provided. The clapper is *important when synchronizing images and separately recorded sound. Once you have the visual image of the clapper striking the board coinciding with the sound of the clapper striking, you know you have perfect synchronization.*

SOUND EFFECTS *Quite apart from the general background sounds that you can collect with an audio recorder, you can have fun manufacturing your own sound effects using household objects. In fact, purpose-made sound effects are often more satisfactory than recording live sounds during filming and can add greatly to the individuality of your video recordings. Most of these effects can also be produced by a helper standing near the mike – but out of shot if you don't want to get involved in sound editing. You may also record sound separately from your pictures for background commentaries. If you want to use commercially recorded music on your home video, you will need to check out the law as such recordings are normally protected by copyright.*

RECORDING YOUR OWN SOUND EFFECTS

Foghorn *Blow gently across the top of a bottle half-filled with water.*

Thunder *Blow gently over the top of the microphone, or wobble a piece of tin sheet.*

Rainfall *Run sugar down a paper tube placed close to the microphone.*

Shortwave radio reception *Play two identical recordings very slightly out of step.*

Horror/space effects *Reverse the sound on the tape recorder. This can be done with voices or music.*

Voice on the telephone *Speak into a headphone plugged into the microphone socket of the camcorder or VCR.*

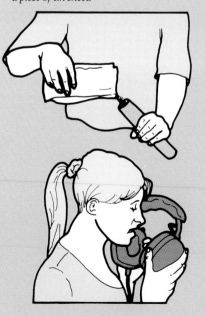

▲ **SYNC SOUND RECORDING** *If you intend to record a lot of wild sound in which lip-sync is important, then it may be worth investing in this type of audio cassette recorder, which has a third track that carries a special sync pulse. During the editing process, the sync pulse locks the video and sound together to ensure perfect synchronization. If this aspect of video-making is not important to you, then you can use any good-quality cassette recorder to record a sound-track or sound effects.*

Walking in snow *Scrunch up a half-filled bag of flour near the microphone.*

Mastering shooting technique

Mastering shooting technique

Most film-makers work within a set of rules and conventions when creating a film story. These rules and methods, which started in the days of hand-cranked cameras and silent images, have evolved to form a set of techniques accepted by both film- and videomakers and us, their audience, as an effective way of communicating certain ideas, emotions, concepts, and so on. An example of this is something seen in virtually every piece of moving imagery: the notion that the audience will accept a sequence of scenes as being connected in both time and place (unless there is evidence to the contrary). How many times have you seen a close-up of a character's face staring intently at something, followed by a shot of the scene or object the character is surveying? It does not matter that the second scene could have been filmed weeks later and a thousand miles away – the convention is understood and the connection made.

If you are able to make this type of connection when you plan your tape, then you have to know in advance the type of material you will need. The alternative is to leave it to chance and hope that something usable turns up. The former approach means thinking ahead. Such planning does not have to be elaborate, require any particular skill, or take much time; it all depends on the type of video you are making. A panoramic sweep across some beautiful stretch of countryside as part of your holiday tape might only require that you take note of where the pan should begin and end in order to avoid some unsightly feature

appearing in shot. If, on the other hand, you are making a mini-drama or a documentary, you will have to take planning through a series of stages, slowly refining and polishing the content, before starting any recording.

Perhaps the hardest concept to get across to camcorder users is the need to limit camera movements – a moving camera coupled with a moving subject can become an unwatchable experience. Planning a shot in advance so that the camcorder is stationary and the lens set to frame everything necessary for that scene is often a better option than an unplanned camera movement that draws attention to itself. This concept, that the camera remains "invisible", is often the key to successful videomaking. Yet this idea shouldn't inhibit you from aiming for a wide variety of shots in your videos. Understanding how to maintain the balance between visual interest and discretion in your camerawork is a vital skill.

As in the first chapter, this section contains specially designed exercise boxes to encourage a more practical approach to some of the trickier techniques.

► **EXPLOITING THE MEDIUM** *Successful videomaking is more than simply understanding your camcorder controls. Once you have gained confidence with the basics, you will be ready to embark on an exploration of the* *variety of techniques that mark out the best videos. For example, you will learn how to pan, choose the best viewpoint, capture movement, and how to plan your approach to obtain professional-looking results.*

Pre-production planning is the secret to making a coherent, well-presented film. All professionals are vitally aware of this and they employ a production team to make the early stages of organizing a film or video creatively efficient and cost-effective. You may think that for a home video of a party, wedding, or sports event, planning is either unnecessary or unmanageable. Good planning at the outset is far more likely to create a watchable, story.

● From idea to script

Pre-production planning

The style and amount of preplanning depends largely on what you are recording. A wedding, for instance, offers only one chance to record key moments, such as the exchange of vows, the throwing of the confetti, or the speeches. On the other hand, if you are producing a business video to promote a machine your company wishes to sell to clients, you may have an opportunity to film the subject in several locations and from many angles. Even though you expect to film several takes in order to select the best at the editing stage, you should decide what you want from each shot before you start recording. As you become more accomplished, you are likely to notice an increasing number of creative possibilities and options. In time, you will develop a professional technique and your video recordings will reflect your personal style.

No two film directors are exactly alike. John Ford, for instance, often shot only one take before moving on to the next scene. He believed that spontaneity develops if the actors know that they are expected to get it right the first time. Woody Allen is known to film take after take until he feels he has got the scene just right. Despite their different techniques, however, all directors underline the need for careful planning.

From the most humble story to the most elaborately structured film, the planning begins with an idea for a story. Before proceeding on his hunch, the filmmaker must answer two

THE MAGAZINE OF CALIFORNIA

GOLDEN STATE

HISTORIC LEXINGTON VIRGINIA

VIRGINIA-NORTH CAROLINA

BLUE RIDGE Parkway

HISTORIC LEXINGT...
In Virginia's Beautiful Shenando...
The Home of Robert E...
and Stonewall Jacks...

SAFETY NEEDS YOUR HELP!
Protect the Park and your Lif
Don't Litter, Drive Friendly

ISSUED BY
NATIONAL PARK CONCESSIONS,
Blue Ridge Parkway Operations
Route 1, Box 286
LAUREL SPRINGS, NORTH CAROLINA 286
919-372-4499

▲ **BACKGROUND RESEARCH** *This family have decided to video their move from Cape May on the East Coast, to Santa Barbara in the West. On the way they will stop off at various towns and national parks. Planning a video of places that you have never visited before* *would be impossible without background research. Useful information can be gained in advance from tourist guides and brochures.*

▼ THE INITIAL OUTLINE

Although not giving any details of the form, structure, or content of a video production, the initial outline, such as the one below, is nevertheless an important part of the pre-planning process. Its primary function is to set the broad parameters of the proposed video, sorting out coherent start and end points, and a sketchy notion of what lies in between. It also helps to translate the initial jumble of ideas into written form, from which it can be developed and refined.

questions: does the central theme entertain, and does it teach? Every film, to be any good, must entertain. If it also teaches, albeit unintentionally, that is even better.

Before beginning a film or video, four documents are usually produced – an outline, a brief, a treatment, and a script. Some projects demand several types of scripts. Depending on the type of film, a storyboard may also be drawn up. Even a simple video of a children's party can benefit from preparing one or two of these documents.

THE OUTLINE The outline takes the form of a single, short piece of text, no more than a few paragraphs long, that describes the concept of the story cut to its barest bones. The other three stages build on the base laid by this initial outline.

THE BRIEF The first stage in formulating a brief is to decide what and who exactly the video is for. Videos rarely stand in isolation. They nor-

PREFILMING CHECKLIST

1 *Check the availability and positions of electrical outlets.*

2 *Visit the location: determine the position of the sun during the shoot; do a sound check for unwanted background noise; review the parking situation; insure the security of equipment if you are temporarily off-site. Check weather forecast.*

3 *Obtain any necessary permissions.*

4 *Inform everyone involved of the location, time, and duration of filming.*

5 *Write down your ideas for camera-shooting angles in your script.*

6 *Arrange for any props or scenery to be on-site on time.*

7 *Check through your equipment list to ensure everything is there and in working order. This applies to smaller cables, plugs, etc.*

8 *Ensure that all batteries are fully charged.*

9 *Assign jobs and positions to helpers so that they know exactly what they should be doing during the shoot, and where.*

10 *Check that your tape stock is sufficient and accessible.*

Go West Young Woman !

Not just me, but Jerry, the kids, furniture, carpets, clothes, potted plants, just about everything we've accumulated in the past 12 years – except the kitchen sink. Video to start with lots of footage of Cape May on the East Coast. Want to show the best of the place we've lived in all these years, the house, inside and out, just as it normally looks (maybe a bit tidier than normal); packing, the furniture truck arriving, house emptying out bit by bit – sad, forlorn. Truck pulls away. We shut the door on the past and start the journey into the future.
Major stopovers heading west: Washington, Blue Ridge Mountains, Nashville, Memphis, Hot Spring, Santa Fe, Grand Canyon, Las Vegas, and finally arriving at our destination – our new home in Santa Barbara. It's a trip of a lifetime, and I want video coverage of the lot !

▼ **THE SHOT LIST** *After producing an outline and doing some background research, it is possible to start making a shot list. In this case, the shot list is simply a list of ideas of how to approach filming the various situations that the family is likely to encounter on their journey, with notes on equipment.*

Scene 21

First glimpse of the Pacific - trip nearly over!! Lots of coverage of Santa Barbara-type architecture to contrast with Cape May shots earlier on.
ber; must get close-up of town sign

Scene 22

Go West Young Woman!

Opening titles Background to titles - long, panoramic shot of Atlantic around cape May (remember: polarizing filter). Title of video "Go West Young Woman!"

Scene 1 Atlantic Ocean, seafront, typical colonial-style architecture.

Scene 2 Our house - lots of external footage and details, especially attic window where the kids used to play.

Scene 3 Planning the move. Family conference around table, with map showing route. (Remember: need microphone stand for live sound. Rostrum shots of map, Realtor's details and picture of the new house.)

Scene 4 House is empty now. Tour of empty rooms. Finish on lined-up suitcases waiting by the front door - door is open.

Scene 5 The loaded car with family inside ready to go. The departure, neighbors waving goodbye.

Scene 6 Arrive at first stopover - Washington. Good close-ups of Stars and Stripes. Monuments: White House, Senate Building. Lots of good family shots.

Scene 7 Arrive Nashville! Coverage of clubs, bars featuring Country
Try to tal

Scene

▼ **THE STORYBOARD** *In this case, the videomaker was in a position to make storyboards only for those sequences at the start and end of the video, in places that she had knowledge of.*

▼ **THE TREATMENT** *After the outline and the brief have been completed, it is useful to write out a full treatment, especially for complicated videos such as this one. The treatment brings together all the previous ideas, to give an idea of the type of video being made, and to outline elements of narrative, dialogue, etc.*

Go West Young Woman! TREATMENT

The video story records the family's move from our home in Cape May, on the East Coast, to Santa Barbara on the West Coast. We have decided to make stopovers to take in some of the sights on the way, so the video can show the trip almost like a road movie. We must plan the trip precisely, so that we can break the journey in convenient spots without causing too much delay. I want to show the essence of each place we visit, but in a fairly concise way. I therefore have to know beforehand exactly what I am looking for, but I must also have the flexibility to allow for the unexpected. Having looked through a few travel guides I have prepared a quick shot list for one or two of the locations, with notes on sound. I hope to bump into some colorful characters on the way, and footage of them should liven up the video.

In terms of shots, I must remember to include close-ups of state and town signs. I could also use the realtor's details of the new house. Here and there I would want to include the date - perhaps by showing somebody reading a paper and then going into close-up so that the date becomes visible. Also shots of booking offices and banks with a date-sign showing could serve the same purpose. I must also make sure to include shots of the family while traveling. For coherence, I want to record the Stars and Stripes here and there, as we cross the country, and perhaps some shots of fastfood stores that can be found everywhere.

As far as equipment is concerned, I want to keep things simple, for obvious reasons. I am not taking a hard camcorder case, but a soft bag that does not attract too much attention to itself. I have also decided not to take a heavy tripod, but a monopod only, along with the shoulder brace. At times, I may have to rely on walls for stability

Go West Young Woman

Opening titles over long slow pan across the Atlantic from Cape May. Polarizing filter.

The house. Zoom in on attic window. Show kids leaving out and waving.

Tou...
hou...
dow...
doe...
ta...

◀ **ROUTE MAP** *A useful extra aid to planning in this case is a route map, which shows all the stopovers on the way. The numbers marked onto the map are added to the shot list in order to locate each scene quickly on the map.*

mally fit with activities such as a training course, a sales presentation, sporting or recreational pursuits, or, of course, family events. They are often used together with other materials, such as photograph albums, textbooks, and diaries. A brief generally consists of several pages discussing the viability of the idea, the way in which the video is to be used when complete, and observations and notes about the target audience.

THE TREATMENT The treatment is a distillation of the ideas and information contained in the outline and the brief. The treatment is not in-

tended to be a detailed plan. It explains the way in which the video is going to be presented and the way in which it is going to attract and hold the audience's attention. It clarifies the story, explains the focus of each scene, and gives an indication of dialogue, details of characters, subplots, and so on. It also describes the look, style, and mood of the overall production. An abbreviated treatment will clarify your ideas and improve the prospects of even the simplest home video.

THE SCRIPT The script sets out the dialogue and actions of the proposed film or video, as well as the location. You should also make a note on the script of the type and angle of the shots required for every piece of action or dialogue, and exactly where each shot begins and ends, including all zooms, pans, and tracks.

For a multi-location video, a shooting schedule might be necessary. This divides the script into convenient shooting sessions. The shooting schedule should list the scenes to be shot at each location, the time involved, the equipment and props required, and the participants needed.

For specialized home videos, an elaborate script is probably quite unnecessary, but the discipline of thinking through an outline, treatment, or both can produce a list of ideas, aims, and cautions that will prove very helpful during filming.

THE STORYBOARD This is probably the most useful planning document for inexperienced videomakers. It consists of frame-by-frame sketches that indicate the content of each scene and the way in which it will be shot – that is, shot type, angles, and so on. Accompanying notes can be used to describe what you are trying to achieve in each shot as well as sound notes. You do not have to be a great artist to produce a useful storyboard since it is generally only for your own reference. The advantage of this kind of document is that it helps you to visualize not only individual scenes but also the overall pace of the action and atmosphere of your planned video.

exercise

ASSESSING LOCATIONS *The object here is to develop your skill at judging the potential of various locations, looking particularly at the position of the sun, and to train yourself to plan around the facilities available at each location. You will need a notebook, a compass and a small still camera.*
● *During the course of a week or longer, carry these items around with you. Note any places that you visit that you think could provide useful video locations.*
● *At each location note the time of day and the position of the sun. Use your compass to check the north-south orientation. Draw a small sketch map to help you record this information.*
● *Take photos of the key elements of the location, and make descriptive notes, including distance from facilities such as electricity supply, shops, etc.*

Even if you do not plan to use this location for a shoot, you will have been able to practice some useful planning and observation skills.
You will also have the beginnings of a useful location file.

A good video is not just a series of actions. It must progress seamlessly through a variety of sequences, telling the story visually. Smooth transitions between shots and scenes are achieved through a clear understanding of the way in which a video is created, using the basic building blocks of frame, take, and scene.

Everyone knows that there is no such thing as moving film. Hold up a portion of celluloid cut from a roll of film and you will see

- **Telling a story in images**
- **Creating tension**
- **Making changes in pace**

Narrative techniques

a series of similar, although slightly different, still pictures, or frames. By a trick of the mind known as persistence of vision, these pictures seem to move – as long as the frames flash before the eyes at a speed no less than 25 frames per second, the memory will cause the pictures to blur together. So a filmed sequence should be thought of as a series of still shots. For your own easier understanding of the medium, try to think of a video as sequences of shots that move the story along.

The frame is the smallest unit in videomaking. Each time the start button of the camcorder is pushed, a take begins, recording a series of frames. It ends when the camcorder is switched into pause or off. The length of the take will depend upon your judgement. Where possible, several takes are usually recorded, one after the other, so that the best can be selected for final use. To identify these takes, professionals use a clapperboard. This has the production's name, the take number, and the scene number written on it and is recorded at the start of each take. The clapperboard also has an important role in synchronizing picture and sound (see page 42). The action being filmed is called a scene, and it is made up of many takes. Every videomaker should keep a written log sheet of takes.

WAYS OF TELLING A STORY Like the novelist or journalist, the videomaker can assume an objective or subjective approach to story-telling. Normally, the audience watches a video

▲ **1** *This video story opens with a long shot of a girl. At this stage, the audience knows nothing about her or what she is doing there.*

▲ **2** *Next, there is a cut to a medium shot showing her looking at her watch. This tells the audience that time is important to her for some reason.*

▲ **5** *This cut to a close-up of the girl's face makes the link in the audience's mind between her and the previous shot of the hurrying boy.*

▲ **6** *Cut back to the hurrying boy. The alternating shots, girl/boy/girl/boy, firmly establish a relationship between them and that they are both reacting in the same time frame and to the same set of circumstances.*

CHANGING SHOTS FOR NARRATIVE EFFECT

From long shot to mid-shot	*Concentrates the audience's attention on a smaller area of interest.*
From close-up to mid-shot	*Reduces tension by pulling back and including more of the scene.*
Insert	*A shot of something included in the master shot, but taken from a different angle, and inserted into the master shot at the editing stage.*
Cutaway	*A shot of something not covered in the master shot but relevant to it; implies a connection between two otherwise unrelated sequences.*
Reaction	*Filmed after the master shot and inserted later; shows a character's reaction to the action or event.*

▲ **3** *The scene now cuts to a big close-up of the watch face. The audience is now in no doubt that time is crucial to the storyline.*

▲ **4** *The cross-linear narrative is now introduced. The boy's obvious haste connects him to the idea that time is important.*

▲ **7** *The girls turns to wave. Because the narrative has successfully established the idea that she is waiting for the boy, the audience will know that he has arrived at last.*

▲ **8** *The final shot of the confrontation between them brings both strands of the story together and confirms the purpose of the previous shots.*

objectively, that is, as nonparticipants. They are aware that they are spectators, or observers, removed from the scene. But when they are drawn into viewing a video subjectively, they become part of the action, members of the cast. This is achieved by moving the camera in the way that one of the participants might move, perhaps to look over someone's shoulder, to show a big close-up of a newspaper at normal reading distance, or a drawer being opened, displaying its contents.

As well as choosing to adopt an objective or subjective approach, you can also decide between telling the story in a logical sequence or using cross-linear narration. This is a popular modern convention of storytelling in which the film cuts between two events that at first appear unrelated. There is no dialogue to link them together, and no obvious reason to connect them; but in time, the audience begins to fathom the purpose of the implied connection. The technique can be used effectively to add interest to the film.

CREATING TENSION AND PACE To produce scenes in which the sense of drama is progressively heightened, increase the number of shot changes and shorten them correspondingly to build up the tempo. The crescendo effect should reach a climax when the action or drama is at its peak.

The pace of a film can be varied in other ways too. Inserts, cutaways, and reaction shots can all compress time or action. If you have shot sufficient material, you can use cutaways to intensify the sense of time passing during a sequence. Combined with rapid changes of shot, this has the effect of building up tension.

✿ **TIP** *Remember that video films are actually made up of a succession of still pictures, with sound added. Try to see your videos as a series of scenes linked together by continuity of purpose and plot. In the beginning, you will find it easiest to visualize each scene as a still picture, with the movement taking place within the frame. A storyboard will make the process of visualization easier.*

Like most other divisions of media and communications, video has a special language and vocabulary – one it largely shares with the cinema. Chief among the terms are those used to define shot size, usually used in connection with people, though they can be used for objects as well. Shot size determines how large the characters and objects featured in each frame will appear, as well as how much of them we will see. Mastery of the use of these

MASTERING SHOOTING TECHNIQUE

Types of shot

six sizes is an important part of storytelling; the choice of shot controls what we are allowed to know about a subject in a given scene, and it can also exercise a powerful effect on our emotional response to it.

The following terms and abbreviations to describe shot sizes have now become standard.

Very long shot	V/L
Long shot	L/S
Mid-shot	M/S
Close-up	C/UP
Big close-up	BC/U
Extra-big close-up	EBC/U

In video shorthand, a scene in which two people appear is called a 2-shot, or 2S, a scene with three people is a 3S. More than four people and you are back to the normal descriptions – family, group, team, crowd, and so on. Several other phrases are used in videomaking, particularly in writing a script or shot list. The following are among the most common and useful.

Establishing shot A shot showing the whole area in which the action will take place. It is used so that the audience can understand where the story is located. For instance, if you wanted to show that the sitting room in which your dialogue takes place is situated in a tower block, you would start with an exterior view showing the block (the establishing shot) before cutting to the room.

USING DIFFERENT SHOTS

Type of shot	What it is	When it is used
Very long shot	Panoramic shot of scene.	Big master shot. Can convey sense of isolation by setting small human figure in vast landscape.
Long shot	Includes all the important features of a scene.	Conveys information. Master or establishing shot. Establishes relationship between subject and environment. Only big gestures are visible.
Mid-shot	Reveals expression but does not focus on one subject.	Establishes interplay between two characters.
Close-up	Concentrates on a face or detail of a scene.	Reveals character and feelings.
Big close-up	Focuses on part of the subject's face (such as the eyes) or hands.	Creates a shock effect.
Extra-big close-up	Focuses on a minute detail often to the extent that you cannot recognize the object.	Creates a sense of mystery and surprise once the entire subject is disclosed.

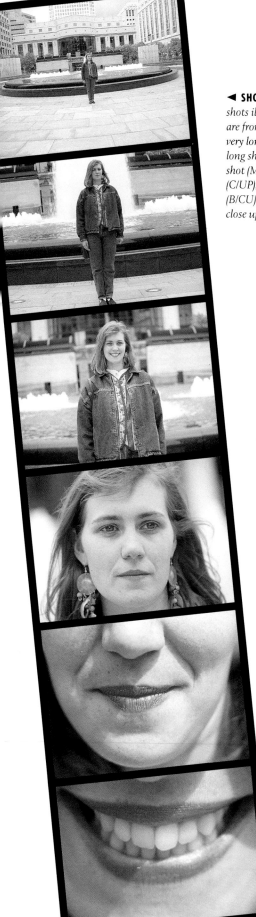

◄ **SHOT TYPES** *The shots illustrated here are from top to bottom: very long shot (V/L); long shot (L/S); mid-shot (M/S); close-up (C/UP); big close-up (B/CU); and extra-big close up (EBC/U).*

Re-establishing shot This is used to introduce a new character. Suppose you shot some footage of two teenagers fixing the engine of a car. You might start with both of them walking up to the car (the establishing shot), cut to some 1-shots of each, and then to an EBC/U of a hand putting a spanner onto a nut. If your next shot was a mid-shot of a new character, your viewers would get a surprise. If instead you pulled back for a re-establishing shot, showing the person walking up to the car and the two teenagers, you have effectively prepared the viewer for a more intimate shot of the third character.

Lose the... Reframe the next shot to exclude the subject mentioned. If after a 3-shot you wish to exclude the father, you would write: "lose the father."

Lose focus on... In instances where there is little depth of field, it can be impossible to hold two subjects in focus who are at different distances from the camera. You have to decide to let one of them go out of focus.

Follow focus on... This person is to be kept in focus when the subjects move, to the exclusion of other objects or people.

Split focus A compromise shot that attempts to render two people as sharp as possible when the depth of field will not allow both to be in sharp focus.

Center up The main subject is to be dead center.

exercise

VARYING SHOT SIZE *In this exercise you will learn how varying shot size can add interest and pace to your video productions. You will need some actors. The action centres around a card or board game.*
● *Arrange your cast around the game and record an establishing shot at the start of the game that includes all the players the room.*
● *As the game progresses, record sequences at different shot sizes. Feature individual expressions with close-ups, show the game unfolding with mid- and long-shots, convey excitement and tension with extra big close-ups.*
● *Get a close up of the victorious player at the moment of triumph and finish by pulling back for a final shot of the entire scene.*
 When you review your tape note when changes of shot size have helped you to create the effect you wanted. Also note errors such as jump cuts when changes in consecutive shot sizes have failed to be sufficiently marked. (See also Continuity, page 68).

While we still call film-making a "new" entertainment medium, it has existed for a century. That has been more than enough time for all of us to have developed a set of conditioned expectations when we sit down in front of a motion picture or video screen.

There is a "grammar" of film-making, conventions which all video-makers should observe. For instance, while it is acceptable to cut through the chin of a big close-up, the same

- **Framing the subject**
- **Angles of view**
- **Creating a feeling of depth**

Composing the shot

is not true if you slice through the mouth. The image is unpleasing to our innate sense of balance. This rule of composition – and many others like it – have been passed to us from still photography, in which a small two-dimensional frame contains the images. The way in which the film-maker places the points of interest within the frame, together with those elements which lend depth and perspective, defines the visual appeal of any picture.

SOME GOLDEN RULES Our ideals of beauty and proportion predate the cinema and photography by thousands of years. The Ancient Greeks, in designing their large and spacious buildings, devised a set of rules, which they called the Golden Mean, otherwise known as the rule of thirds. This postulates that if you divide a rectangular frame into thirds vertically and horizontally, and place your subject on any of the intersections, the resulting image will look harmonious and restful. A subject placed in the center of the frame, on the other hand, will produce a dull and unmemorable picture. It pays to remember this concept when framing your own video shots.

The eye prefers to travel from left to right when viewing a scene, because of the way in which we have been taught to read. If a pictorial element, such as a road, river, fence or railway line, appears to be going somewhere, the eye will follow it. If it leads to something of interest – particularly if it leads from left to right – the viewer will feel a sense of satisfac-

▲ **THE RULE OF THIRDS** *This rule of composition can often be useful when you want to draw attention to the subject or to some specific part of a scene. If you imagine that the frame is divided into thirds, horizontally and vertically, then anything positioned at an intersection of thirds is given additional emphasis. In this shot the figures are grouped around such an intersection.*

ALTERNATIVE COMPOSITIONS

Undertaking this exercise enables you to become familiar with the rule of thirds and the different composition options that it offers. You will need a helper for the second part of this exercise.

● *Choose a location that offers you a clear view of the horizon plus one other key point – a tree or building – in the middle distance.*

● *Frame and record a shot in which the sky occupies two thirds of the viewfinder, and in which the key point is situated one third of the way into the frame from the left, and one third from the bottom.*

● *Next give the sky only one third of the frame area, and place the key point one third into the frame from the right and one third down from the top.*

● *Take a front-on head-and-shoulder shot of your helper, starting with the head touching the top of the frame and gradually tilting the camcorder to allow more headroom, until the composition looks "right".*

● *Finally, try one sequence looking up at your subject, and another looking down. When you review each of these sequences, you will soon appreciate how angle and composition affect the viewer's response to identical subject matter.*

tion. Lines such as these that lead into the picture will also create a sense of depth.

Filming people presents specific problems. You need to give your subjects looking and moving room; they should be positioned to one side of the frame so that there is space for them to look or move into. This is where the rule of thirds comes in; it will help to maintain good balance between subject and space in the frame. If your subjects appear to be moving out of the screen at either side, the effect will be unattractive. Remember, too, never to cut your subjects at natural joints such as elbow, knees, waist and neck. If necessary trim your shots midway between these points. The hands should be either fully in shot or completely out.

▲ ALLOWING WALKING SPACE *In the sequence above, a natural-looking result has been created by placing the figure to one side of the frame so that she has plenty of room to walk into shot.*

▲ SYMMETRICAL COMPOSITION *With the subject and the horizon placed centrally, this composition contains little emphasis.*

▲ HIGH HORIZON *The major emphasis has been given to the foreground. The placement of the figure to the left of the frame allows her to be seen in the context of her surroundings.*

▲ LOW HORIZON *Here the sky occupies the top two thirds of the frame. This low viewpont, in which the figure is seen against the dominant sky, isolates her visually from the landscape.*

▲ CREATING A VISUAL RELATIONSHIP *The addition of a second figure, demonstrates how using the rule of thirds allows you to frame a dynamic composition.*

▲ CREATING DEPTH

One way to create a feeling of depth in a two-dimensional image is to lead the viewer's eye into the frame. In the first image here (top), the use of a wide-angle shot has increased the size of the woman while diminishing the size of the house behind. This in itself helps to establish the distance between them. Then, as she turns in the second frame (centre), the eye travels past her and seeks out what she is looking at. In the final image, taken with a telephoto setting, depth is no longer so important since we all recognize this building as the object of her attention.

CREATING DEPTH In viewing a real scene, the human eye feeds the mind with quasi-instantaneous judgements which help us to perceive and appreciate depth. These decisions are based on information in the scene, including shapes, colours, textures, forms, patterns and shadows. Since a video is flat and two-dimensional, it stands to reason that the more of these elements you can incorporate into your shots, the more living and three-dimensional your images will look.

Just because you are restricted to a camcorder instead of a multi-thousand pound movie camera, don't bar yourself from using accessible tricks of the trade. In big-budget movies, whole streets are often wetted down to bring up their surfaces and to create reflections of colour. Mist or smoke can also help to give an impression of depth. There is no reason why these natural elements should not be used to good effect on a smaller scale in amateur pop and drama videos.

ANGLE OF VIEW When you film a weddding or football game, for example, you may have little or no say in what actions are taking place. But you still have certain prerogatives of the director. One of these is establishing your point of view – and this can be largely accomplished by your choice of camera angle.

Video allows you to focus the viewers' attention on what you want them to look at. You can do this partly through the type of shot you take. Only in establishing and wide-angle shots can the whole scene be viewed, and then fine detail is likely to be lacking. You will probably find that you will shoot most scenes in either mid-shot or close-up. In this way you conceal much of the setting, helping to concentrate the audience's attention on the main subject. The other way in which you can control the viewer's attention is through the camera angle.

The power of angles has been exploited by movie-makers for many decades. Not only can you manipulate *what* you want your audiences to see, but also *how* you want them to see it. The most obvious use of angles and framing is in hiding distractions, but angles can also be used to increase or reduce emphasis. Low angles exaggerate height, give importance and speed up motion, while high angles appear to reduce the stature of subjects and slow down action.

◀ **HIGH ANGLE** *The angle at which you choose to shoot is important to the impression you convey to the audience. Here, a high-angle shot has been used to diminish the stature of the subjects. In a different context, however, it could also be used to imply that they were being secretly observed by a third party. High-angle shots also tend to slow down the action.*

▶ **LOW ANGLE** *A low-angle shot such as this carries with it certain implications. Depending on the context of the rest of the scene, it could be used to indicate menace, as here, or to imply that this is somebody to look up to, thus increasing the person's status. Low-angle shots also tend to speed up the action.*

You can provoke different emotional responses if you "look up" at a person from those that you elicit when you "look down" on them. When watching a video, your viewers will feel a sense of superiority if the camera is held high over the subject. Conversely, a low angle will give your subject stature and dominance, and will lend excitement to any action. Side angles, which create diagonal lines across the screen, help to give depth and perspective.

To round off, here is one last Golden Rule. Every time you pause in filming, take the next shot from a different angle. It should also be a different size – *follow a mid-shot with a long shot or a close-up, not with another mid-shot.* A take that is only slightly different from the preceding one will appear to "jump" at the edit point. This is known as a jump cut, *a mistake to be avoided at all costs.* A complete change of viewpoint and size will give a much more polished result. After too much camera movement and too much use of the zoom, jump cuts are probably the most common mistake made by amateurs.

Panning is another film convention that is now shared with the newer medium of video recording. The term describes the movement of the camcorder, from a fixed position, to take in a wide scene. Although in theory it sounds easy, good panning is, in fact, very difficult. Maintaining a smooth, continuous movement requires a steady pair of hands, while the decision *when* to elect for a panning shot demands discipline from the videomaker.

- **Establishing shots and following movement**
- **Mobile panning**

Panning and tilting

Many people overdo the number of pans in any one video sequence, believing that video filming is primarily concerned with camcorder movement. Careful use of the pan adds interest and information to the video, but it must be used in moderation.

Use a panning shot to establish the location of a scene, to relate one part of a scene to another, or to follow movement. At the beginning of a film, or when showing a change of location, you want to show the audience where the action is taking place. If, for example, you are on holiday and you want to show your hotel, your room, the swimming pool and the bar, you may want to start with a general view of the hotel's exterior, establishing the scene of the action. It may not be possible to move back far enough to include the whole hotel in one static shot. You are left with two choices, a series of static, photo-type shots breaking up the hotel into several parts -- or a pan.

Whenever possible, you should use a good video tripod with a fluid head (see Equipment and accessories, page 162) If this is not possible and you have to hold the camcorder, careful body posture and support are essential. On rare occasions, you may attempt a mobile pan. This is more difficult to handle because, in addition to panning, you are moving from point A to point B. When done well it makes a highly interesting camera movement, but it takes practice.

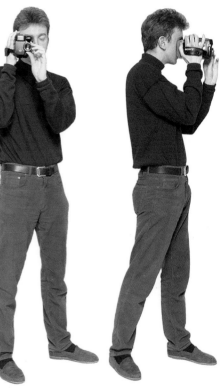

▲ **CORRECT STANCE FOR PANNING** *Before starting a pan, first establish the start and end points — the image you want to show at the beginning of the pan and that at its conclusion. If the pan will include objects at different distances from the camcorder, switch* the autofocus off and focus manually to prevent annoying shifts of focus during the camera movement. You will have the best chance of a smooth pan if you adopt a relaxed stance with your legs slightly apart and your body weight distributed evenly between them.

Support the camcorder firmly and swivel from the hips. Never move or shuffle your feet during a pan, since this will inevitably result in camera movement and jerky images.

When a camcorder is panned over a static scene, such as a landscape, the pan can draw attention to itself. Use static pans as a last resort. On the other hand, following action with panning packs a much greater punch for the viewer. This is because attention attracted by the movement within the frame and the camcorder's movement goes virtually unnoticed. But this type of pan also benefits from a steady hand holding the camcorder.

In order to obtain good pans, particularly mobile pans, you should spend time practising your movements until they become second nature. However, always bear in mind that, as a rule, camcorders work best when they are static and the movement takes place within the picture area, not when the camcorder is itself in motion.

THREE SHOTS FOR THE PRICE OF ONE Professionals often hedge their bets when panning or tilting by going for three for the price of one. By holding the camcorder static before commencing the pan, panning, and then continuing the shot for a while when the camcorder has come to rest, you will end up with three possible options when editing. If the shot is left unedited, the audience can assimilate even more information and are not rushed into viewing a pan. In any case, always hold the shot for a short time at the beginning and end of a pan, so that the audience can take in the scene and orientate themselves.

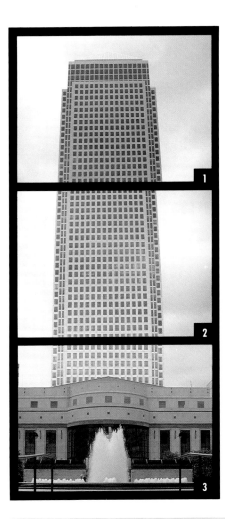

◀ **TILTING** *Tilting is a useful camera movement to reveal or exaggerate the height of a tree, cliff face, or, as here, a building. It is also excellent for drawing comparisons of size of different objects in a scene. The tilt represented by these images could start at the top of this office building (1) and slowly travel down its glass-and-concrete face (2), before coming to rest at the base of the building showing the fountain (3). Alternatively it could start at the bottom and move up. When a tilt includes the sky, use autoexposure or set the exposure for the start of the tilt (if tilting up) and let the sky overexpose.*

✿ **TIPS** *If you have decided to execute a pan, you must finish it before making a cut. Avoid at all costs jumping from an unfinished pan to a static shot.*
● *If, during a pan, you have decided that you do not want to use it, don't try to finish it quickly to get it over with. Exercise patience and finish it as you would have if you were happy with it. Use it as practice, if nothing else,* *although when you view the video at editing time, you may decide to keep it in.*
● *Keep horizontal lines horizontal and vertical lines vertical.*
● *When performing a hand-held pan, practice the swing before shooting. Swing your body a short way in the direction opposite to the pan before swinging back and starting to shoot. In other words, start to move before you start to shoot.*

exercise

PANNING *This exercise will help you to develop your skill in producing smooth and steady panning shots. You will need a camcorder and, if possible, a tripod.*
● *Position yourself a few yards from a street in a place that allows you a clear view of oncoming traffic. The object is to record vehicles as they come in to view, and to follow them in a smooth pan as they pass.*
● *Start your shot by holding the camcorder still and focusing on a selected car in the distance.*
● *Keep the car in shot as it moves toward you. You will need to swivel round at a speed that allows you to keep the car in shot.*
● *When you have panned round as far as you can, hold your position, and allow the car to move out of shot.*
When you have practiced several pans of this kind, try moving your position in relation to the street. You will notice that the closer you are to the moving object, the faster you will have to pan.

Tracking involves moving the camcorder parallel to the action; the term is also used to cover moving the camcorder toward and away from a stationary subject. This process is also known as dollying in and dollying out.

Tracking movements are used to follow action, to dramatize a moment, and to draw attention to or reveal a subject. Dollying in creates a more realistic effect than zooming, because it gives the effect of walking toward

- **Following the action**
- **Using a dolly**

Tracking

the subject. A slow, smooth dolly-in arouses interest and curiosity, as the camera slowly gains a more searching viewpoint.

On professional cinema and video productions, short lengths of miniature, narrow-gauge railway track are laid. The camera and its operator are seated on a platform that glides smoothly along the track. Obviously this kind of equipment is beyond the scope of the amateur. To perform the same job, albeit less smoothly, it is possible to purchase a Y-footed frame with castors to attach to the legs of your tripod. This accessory is also called a dolly. Provided that the surface you are covering is flat and smooth, such dollies can be used effectively.

Alternatively, you can obtain surprisingly good tracking shots using a wheelchair as long as it is fitted with large, bicycle-type wheels. If you opt for this solution, you will need an assistant to push you along.

The dolly, or an improvised alternative, needs to be pushed smoothly and quietly over an even surface. In addition, mark the beginning and end of the track with tape on the ground so that the shot you have planned has a neat start and finish to it. Use automatic focus initially, so that the lens adjusts as you move. You will need a lot of practice to adjust the focus manually while you track. Always use the wide-angle lens setting, so that the effects of vibration are less obvious. Never, never try to track using a telephoto lens.

TRACKING TECHNIQUES *For successful tracking shots be sure to:*

- *Set the lens to wide angle.*
- *Use automatic focus.*
- *Track over a flat surface.*
- *Walk the shot through several times.*
- *Move at a steady pace.*
- *Mark the beginning and end of the track with tape.*

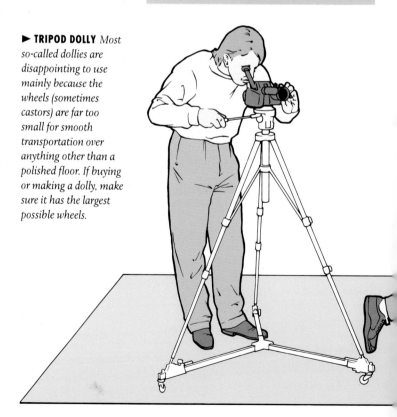

▶ **TRIPOD DOLLY** *Most so-called dollies are disappointing to use mainly because the wheels (sometimes castors) are far too small for smooth transportation over anything other than a polished floor. If buying or making a dolly, make sure it has the largest possible wheels.*

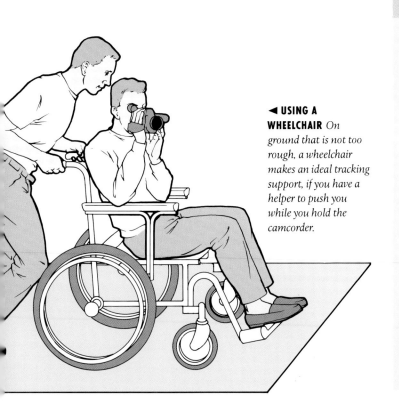

▲ THE TRACKING SHOT
The paved surface of this location demanded the use of a wheelchair for the tracking shot. Note here that because the couple are walking away from the fountain, and the camcorder also is being tracked back to maintain the same frame size of the couple, the foundation and general background diminish in size. The diagonal arrangement of the pictures here mimics the movement of both the camcorder and subjects.

◄ USING A WHEELCHAIR On ground that is not too rough, a wheelchair makes an ideal tracking support, if you have a helper to push you while you hold the camcorder.

exercise

TRACKING *The object of this exercise is to accomplish smooth hand-held tracking shots while on the move. You will need your camcorder, mounted on a dolly of some sort, and the help of a friend.*
● *Position your friend so that he is in mid-shot. Ask him to walk slowly toward you, talking to camera. As he approaches, dolly back so that he always remains in mid-shot.*
● *Next, position your subject at some distance from the camcorder. As he talks, slowly move toward him until he fills the frame.*
● *Finally, position yourself at some distance to the side of your friend. Ask him to walk ahead in a straight line, and move the camcorder in parallel, keeping him in mid-shot.*
With practice, you will begin to perform these different tracking movements smoothly and with a minimum of camera-shake.

The zoom lens is probably the most useful of all the innovative features that are now standard on video camcorders. Because of its variable focal length and the resultant variable angle of view, the zoom lens allows you to establish relationships between different elements in the scene by moving in and out. It can also be used to reveal detail or to emphasize particular parts of the subject. For example, you can go from a wide-angle shot of

Zooming

• Closing in and pulling out without changing position

a speaker and guests at a formal dinner, through to a mid-shot of the speaker, and then on to a close-up. The zoom is operated electronically by pressing the switch near the camcorder's on/off button, or by twisting the zoom range on the lens barrel.

USING THE ZOOM Zoom shots can start with a detail and zoom out to show the whole scene – this works particularly well at the beginning or end of a scene – or start with an inclusive shot and zoom in on a detail or on the central feature of a scene. Whatever your purpose in using the zoom, decide on the final shot first and compose it in the viewfinder before closing in on your subject, so that you know what you are aiming for. Always hold the shot at the beginning and end of a zoom so that a viewer can take in what is happening. Resist the temptation to zoom in and out of a scene to no particular purpose. You need to be totally committed before you begin a zoom, another reason for being clear in your own mind why you are doing the shot and for planning it carefully in advance. Once you have started a zoom, make sure you follow it through: if you change your mind halfway, the change will look like a jump cut.

The zoom lens creates an effect similar to dollying (see page 62). However, a major advantage is that a zoom is often a lot faster. Additionally, some camcorders allow you to alter the speed of the zoom as you record by increasing the pressure on the rocker switch.

▲ ZOOM AND PERSPECTIVE *These shots demonstrate what happens to the perspective of a shot when you use the zoom control to change focal length. Each time focal length was changed, the camcorder position was moved so that the couple were about the same size in the frame.*

In the first shot (above left), a wide-angle shot, the people seem large relative to the background building, giving rise to steep perspective. In the second shot (above centre), a medium shot, the increased focal length has enlarged the background, making it seem closer to the

exercise

USING THE ZOOM *Undertaking this exercise will make you more familiar with the working of the zoom control. You will need a camcorder and a tripod.*
● *Select an object such as a tree or a building, and position yourself at some distance away from it. Fix your camcorder on to the tripod.*
● *Before filming, zoom up and focus on the subject. Then back-zoom out to a wide angle.*
● *Start to film. Zoom in to a telephoto close-up of the subject, using your zoom's automatic rocker-switch.*
● *Repeat this exercise, this time using the pin on your lens barrel to perform the zoom manually. Try to be as smooth in your movements as possible.*
● *Next, discard the tripod and hand-hold the camcorder. Repeat both operations. At the end of each, continue filming in telephoto for a few seconds.*

When you zoom manually, you can alter the speed of the zoom to suit your requirements, although this does take some practice.

A slow zoom can be controlled so that the viewer is hardly aware of it happening. On the whole you should avoid zooming too quickly. Although occasionally a fast zoom can be put to good dramatic advantage, it has a disturbing effect – it tends to throw the subject matter at the viewer.

One disadvantage of zoom shots is that as you change focal length, the apparent perspective changes. In a scene that has some distance in it, the telephoto effect bunches together the various elements of the scene; objects in the background often appear larger and more dominating than they really are. This foreshortening effect is a result of the optics of the lens and does not apply to tracking shots. A very slow zoom, in which you also pan and/or tilt will, to some extent, distract from such distortion of perspective.

foreground. This effect is exaggerated in the third shot (above right), with the zoom now at its maximum extension. Perspective is much flatter and the detail of the background buildings is lost.

ZOOMING DO'S AND DON'TS

Do
● *Zoom with a purpose.*
● *Compose the final shot before starting to zoom.*
● *Zoom slowly. Practise slow, controlled zooms.*
● *Hold the image briefly at the beginning and end of a zoom.*
● *Combine the zoom with the movement of the subject to make it less obvious.*

Don't
● *Zoom in and out again during a scene.*
● *Use the zoom too often.*
● *Zoom very fast.*
● *Hesitate in the middle of a zoom, or change your mind halfway through it.*

Not every frame of a film, either in the movies or on video, is action-packed. Flat artwork, photographs, hand-painted animation cells, narrative text, and credits all require the use of a camera or camcorder mounted on a stand, or rostrum. This holds the picture-taking apparatus steady and at a reasonable distance from the material placed beneath. Two lights are usually attached to the rostrum to provide bright illumination.

● **Shooting static images and text**

Rostrum work

Rostrum stands need not be expensive. At its simplest, a camcorder mounted on a tripod and pointed at the ground will suffice, although as your skills develop you may soon wish for something a little more sophisticated. It is very easy to make a rostrum if you have any carpentry skills – a stand as simple as two wall-mounted shelving brackets would do. If you are going to use the rostrum often, you need to be able to run the camcorder up and down the column smoothly. Ensuring an even coverage of light is also important when undertaking rostrum work.

Several photographic manufacturers make camcorder rostrums. The low weight of camcorders means that a photographic copy stand is also ideal. It comes equipped with lights that take a variety of bulb types, usually Quartz halogen, the domestic filament variety, or even photographers' photofloods. All work equally well, provided you adjust the white balance controls of your camcorder appropriately before starting.

A set of supplementary, close-up lenses will prove useful when you use a camcorder for rostrum work. Most camcorders have a macro-facility for this type of work, but by using an inexpensive supplementary close-up lens instead, the zoom range is not disabled. Thus, despite the fact you are so close, you can still zoom in and out. This is a useful compositional aid; it allows you to crop to the section of the still picture that you want to show

▶ **FULLER INFORMATION** *Many documentary-type videos don't have as much impact as they might simply because they fail to inform the viewer properly of where the action is taking place. In this sequence of still images, a rostrum camera technique has been used to introduce a film about Crater Lake in Oregon. The first image is the relevant quadrant of the US – this helps to orientate the view broadly. Next, the lens zooms in, closer and closer, until the name Crater Lake is visible on screen, and finally cuts to the opening frame showing the lake itself. Video is not ideal for conveying a mass of small detail; so start to zoom in, or cut to, closer (and bolder) images and details as soon as possible.*

IMPROVISED ROSTRUM SETUP

The advantage of using a rostrum set-up along the lines of the one below is that you keep artwork or photographs pressed flat and parallel to the camera lens for filming. Any object with a tendency to curl can be pressed under a piece of clear glass. The lights positioned either side of the tripod need to be equidistant from whatever is being shot, their lighting heads must be at the same angle to the object, and the bulbs used must be of the same wattage. In this way, illumination across the object's surface should be even.

quickly and easily. It also can be helpful in providing an element of movement while filming a still scene.

If the zoom is rotated during filming, it should always take the form of a reveal rather than a conceal. In other words, you should zoom out from a close-up of a detail to expose more of your picture, holding or even increasing your audience's interest. If you zoom in, you will hide something a viewer has already seen, which they could find annoying. A zoom-in should be used only to highlight an important part of the image, and *only* when such emphasis is really necessary to get the message across.

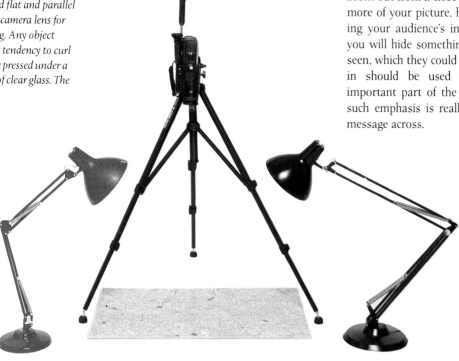

SUBJECTS SUITABLE FOR ROSTRUM WORK

Postcards

Paintings

Photographs

Maps

Charts

Newspaper cuttings

Book illustrations

Greeting cards

Diagrams

Certificates

Travel tickets

Brochures

Invitations

Small objects

Animation

Captions

Production credits

VIDEOING SLIDES *An inexpensive attachment into which you can insert slides is available for camcorders. It allows you to reproduce them either full-size or cropped, with little or no loss of quality.*

TIPS *If recording text, calculate how long to hold the shot by timing yourself as you read slowly.*

● *If the material being recorded reflects light, tilt it slightly, or use a polarizing filter.*

● *If the material being recorded is the wrong shape or proportions for the camcorder frame, mount it on a piece of card that matches the proportions of the frame.*

● *Pans should be very slow.*

Films and commercial videos are shot in sequences that maximize the use of sets and locations rather than in the order in which the scenes will eventually appear. On major productions a continuity person makes sure that, as the film crew and actors move from location to location, and from set to set, the things that need to remain consistent in successive scenes of the film do so. It would be ridiculous, for instance, to see an actor walk

Continuity

out of a house and get into a taxi with a three-quarter smoked cigar in his mouth, only to cut to the inside of the taxi and show a cigar that is only one-quarter smoked, and a tie which has mysteriously appeared around his neck. Food poses another major area of concern. A full plate cannot suddenly appear almost empty in the next sequence. These are all aspects of filming that are under the control of the continuity person.

But it is not just clothes and props that need to be monitored. When sequences that have been shot at different times are edited together, details of the background must be seen to remain the same, the actors must be in exactly the same positions in relation to one another, and their expressions must not change noticeably. Lighting and exposure must also remain consistent throughout a scene and, if you are shooting outside, you will certainly have to wait for the same time of day, and may even have to wait for several days for the same weather conditions.

So when you take a break during recording, or shoot out of sequence, you will need to make a note of all such important data at every cutting point. If you fail to do this, you will have problems with shots that don't intercut at the editing stage. A polaroid camera is very useful for making instant continuity notes; use a tape measure for taking down the exact distance between props and people on the set.

- **How to achieve continuity of appearance**
- **Controlling eyelines**
- **Continuity of action**

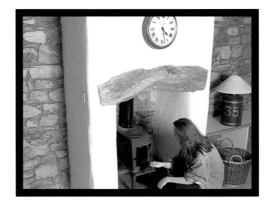

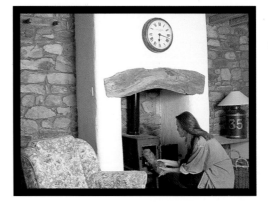

◄ **CONTINUITY ERROR** *Unless you want to convey the passing of time by showing a clock with a time later than that in a previous shot, you must ensure that the time on the clock matches in two supposedly successive scenes. In the images presented here, there is a second continuity error as well. The armchair has miraculously appeared in the second scene.*

Make sure that a change of angle between two scenes is decisive enough not to appear as a jump. This rule has been disregarded here, since the second scene has been shot from an angle only marginally different from that in the first.

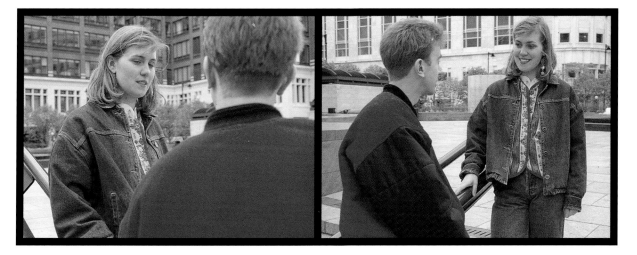

▲ CROSSING THE LINE

In the first shot (above left), the girl is on the left of the frame, while in the next (above right) she is on the right. Cutting from one to the other would cause an error known as crossing the line. If, in the first scene, you imagine a line running between the boy and girl, then the camcorder started recording from the left of it. If it had remained on that side of the line, no error would have occurred. However, for the second shot, it crossed to the right of the line and the problem you can see now ensued. If the camcorder had tracked left to right behind the boy, then the audience would have seen the shift in the geography of the shot as it crossed over the line and there would not appear to be a "jump" in the action.

 TIP For good continuity, monitor:

- The background
- Positions
- Expressions
- Clothes
- Makeup
- Props
- Weather

exercise

FILMING A CONVERSATION IN TWO TAKES

Practise this exercise to become familiar with camera-positions for interviewing. You will need a camcorder, a tripod, and two helpers.

● *Position your helpers so that they are facing each other, then film an establishing shot of the two together in profile.*

● *Cut, then move the camcorder to a position behind the left shoulder of the first person (person A, left), so that your shot shows the back of his or her head. Focus on the face of person B, who will start the conversation.*

● *When B has finished speaking, cut and move to a similar position behind the right shoulder of person B, so that you can film person A. Continue to alternate camcorder position as each person speaks.*

● *Now record footage of each person listening intently, from the same positions as before.*

When you view your footage you will notice that person B is always in the left half of the frame and that person A is always in the right half of the frame, preventing confusion.

▲ **USING BRIDGING SHOTS** *In track events or games such as football, where the direction of movement is vital to understanding the action, crossing the line from one side of the play to the other results in the direction of* *movement of the participants seeming to reverse itself. In these trotting scenes, for example, the horses in shot 1 are travelling right to left; in shot 2, left to right; and in shot 3 right to left again. If these were screened in this order, total* *confusion would prevail. To prevent this, use neutral bridging shots (here taken on the line of action itself from the back of a truck) to separate shots. The audience will then accept the apparent reversal of direction as being perfectly normal.*

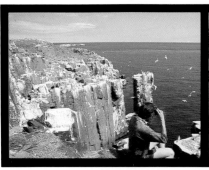

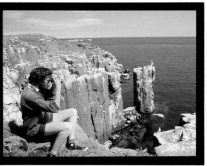

▲ **DISGUISING A JUMP CUT** *In much the same way as the bridging shots were used above in the trotting race sequence, a buffer shot has been* *used in this sequence of a rock climber to disguise a jump cut. One of the golden rules of film-making is to change the size of the shot as well as its angle* *if filming similar scenes or different takes of the same one. The two angles and shot sizes of the rock climber (shots 1 and 3) are sufficiently similar to draw* *attention to the cut if shown sequentially, so a cutaway of a seagull (shot 2) has been inserted between them.*

◄▼ USING EYELINES
This sequence is arranged diagonally to reinforce the direction of the eyeline. The first image (left) is the establishing shot, which shows both women and the setting. From this, it can be seen that the eyeline between the two links them together. In the next two images (below left and below), we see each of them in individual close-up. First the woman sitting on the steps is looking down from left to right, while the woman standing at the bottom in shot 3 is looking up right to left. By arranging the shots in this fashion, the eyeline established in the opening image is carried through the sequence.

 TIP *To avoid discontinuity:*

● *Match the height, lighting, and expressions of people.*

● *Make the change in the size and angle of the shots big enough to be obvious, but not so big as to create a jolt.*

● *Ensure that in a close-up the subjects are looking in the same direction as they are in the master shot.*

EYELINES When you are filming two or more people facing each other, the "eyeline" between them must be maintained, so that they continue to look at each other regardless of changes in the camcorder position. Draw an imaginary line between the subjects and do not cross this line with the camcorder when shooting the scene, regardless of which of the two or more you are filming. The only time you can cross the eyeline is when you are moving as you shoot or if you are inserting a neutral bridging shot. The latter is a shot of one of the subjects looking straight at the camera, in which no other direction is obvious.

CONTINUITY OF ACTION When shooting action sequences – for example, car racing – the movement must take place in the same direction from shot to shot, and the speed at which the action takes place must remain consistent. An imaginary line of action can be drawn through the scene following the direction of the action. All shots should be taken from the same side of this line unless you insert a neutral bridging shot .

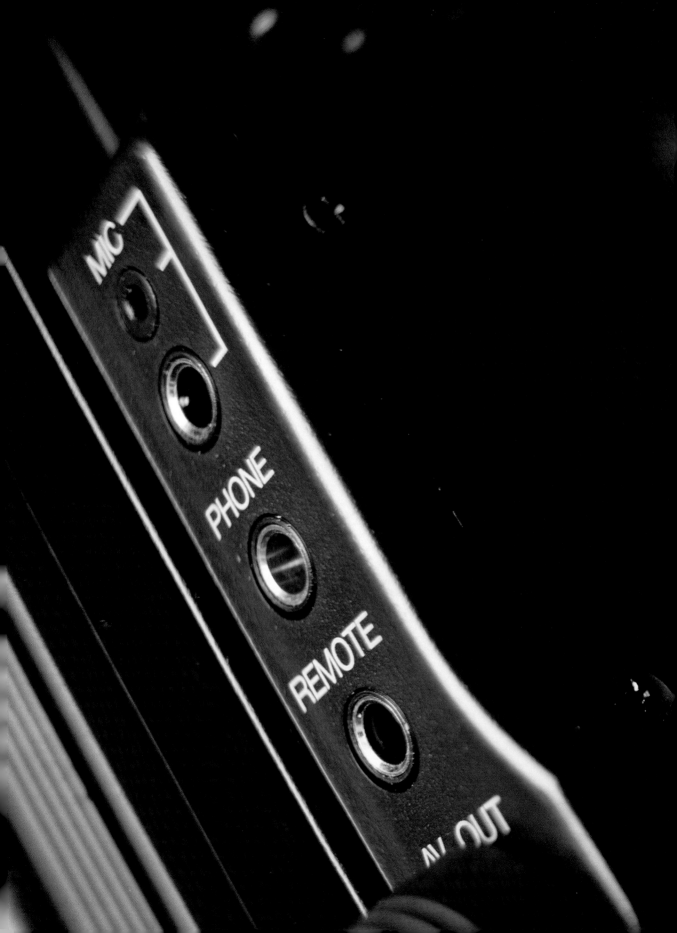

3

After the shooting is over

After the shooting is over

Many camcorder users never seem to get much beyond the "point, shoot, and file it" stage. This could be due to lack of time or perhaps the mistaken belief that videotape editing is too technical or requires expensive and specialist equipment. This is a great pity, since editing does not have to be over-technical, take up much time or involve much expense, and it can in itself become a very engrossing and rewarding pastime. And there is absolutely no doubt that a well-titled and edited video makes viewing far more appealing to a potentially wider audience than, say, the few individuals featuring in its production or to those who were present at the time the tape was shot.

Several years ago it was true to say that editing a domestic videotape was fraught with difficulty and, often, disappointment. Quality suffered badly in the transition, and obtaining a seamless join between scenes was next to impossible. Over the last handful of years, however, new generations of home-editing equipment have become available, and now the difficulty lies more in deciding which model to buy. A standard type of scene transition produced at the editing stage in movies and television dramas is known as a "lap dissolve", or "video mix", it is an extremely professional-looking effect that required, until now, the type of equipment that was well beyond the budget of even the most serious hobbyist. All this has changed, however, with the introduction of vision mixers within the range of many home videomakers. Quite apart from lap dissolves, the vision mixer is capable of a range of editing functions and sophisticated visual effects as well as having audio-mixing features as a bonus.

Despite the spectacular visual and audio effects now possible, or perhaps because of them, a cautionary word is appropriate. No amount of glossy electronic trickery can match the impact of a well-edited story that really captures the interest and attention of the viewer. It is not necessary to have the resources of a Hollywood director to make a good video. What you do need is a good storyline, a clear idea of how you want to tell that story, both in terms of visuals and sound, and a few basic skills and disciplines so that you can translate that concept into a reality. These are the components dealt with in this chapter of the book.

▶ **A POLISHED RESULT**
You have recorded those special events on videotape. What next? For the increasing number of video enthusiasts who are interested in video-editing, the post-production part is as challenging and creative as recording the events in the first place. How do you decide which shots to use and which to leave out? Which is the best order in which to arrange your narrative? Can editing help overcome shooting errors? Once you have some understanding of these editing considerations, you can begin to construct well-paced stories that are filled with your best shots and that avoid embarrassing mistakes.

When you go to the movies or see a pop video, and the names of the film, actors, and director flash onto the screen, you can feel your anticipation mount. Titles can give your video that same professional look and impart some information. By keeping your viewer waiting for a few seconds as you introduce the story, you raise expectations.

Video equipment magazines would have you believe that you need the latest in elec-

- **Creating titles and credits without additional equipment**

Handmade titles

tronic character generators, image scanners and computers in order to produce good titles. Nothing is further from the truth. Imaginative and informative titles can be made with only the basic video equipment. Some of the very best titles are the simplest to make.

Titles usually serve two purposes: to credit those involved in making the production and to prepare the audience by setting the atmosphere for the film. The style of the titles should suit the subject of the film and should be simple.

TITLING MEDIA There are several ways of producing titles. Rub-down lettering can be used to very good effect, particularly if it is applied to postcards, photographs, and pictures, and it can be used in different colours. Three-dimensional plastic lettering has also long been popular for homemade titles. This can be bought from video shops, although it is becoming harder to find. The letters are attached to the background card with Velcro or magnets. Although difficult to position accurately, when lit by oblique light that casts shadows from the type they can look very effective.

Other methods of producing homemade titles include stencils, hand-lettering or painting, a collage of letters cut from magazines or newspapers, and typewritten copy. Once you have made your title cards, film them with a rostrum camera and insert them into the master tape during editing.

▲ **TITLES ON GLASS** *A simple way to superimpose titles over a background picture or scene is to put lettering on a sheet of glass and record it in front of your chosen background.*

Apply dry transfer lettering in a bold type face to a reasonably *sized sheet of glass. Then support this in an upright position between the camcorder and background. In the example shown here an African landscape was recorded live with the glass-mounted titles in front of a camcorder supported on a tripod.* *If your background is a still photograph, you can place the glass directly on top of the picture and record it as a rostrum shot.*

▶ **DRY TRANSFER LETTERING** *This needs to be applied with care. The top example shows titling that has not been properly spaced and aligned. The middle example is spaced much better. Most transfer lettering is provided with spacing guides to help you. It is also important to choose a legible type face that is in keeping with the words, as in the final example.*

▶ **LAYING OUT CREDITS** *For ease of reading, make sure that you leave enough space between the individual lines. In the first example, the credits look cramped and the ragged righthand margin makes the entire screen look untidy. The second example is far more legible because there is plenty of space between the lines. Also the lines are justified left and right which adds to the overall impression of clarity and order. Since the cast list was too long to be shown in one shot, the fade button was used as a transition between title shots.*

Paris in the springtime

Paris in the springtime

Paris in the springtime

CAST
Bob....Richard Brown
Douglas....David Eames
Cheryl....Chrissy Taylor
Diana....June Summer
Colin....Jim Davies
Leo....James Barraclough
Shirley....Louise Potter

CAST
..............
Bob............Richard Brown
Douglas.........David Eames
Cheryl.........Chrissy Taylor
Diana...........June Summer
Colin.................Jim Davies
Leo.......James Barraclough
Shirley...............Louise Potter

TIPS *Draw up an accurate layout before producing the title card.*

● *Allow a good margin all around, so that none of the lettering is cut off when it appears on screen.*

● *If there is a lot of text, use upper and lower case letters, not just capitals – these can be difficult to read.*

● *White lettering on a black background is easiest to read.*

If you're going to San Francisco...

UNUSUAL TITLING IDEAS

● *At least one famous movie had its main title drawn in the sand at the tideline on a beach. Add a bucket and spade and children's footprints and you have a title tailor-made for a video about a vacation at the seaside.*
● *A close-up of the front page of a mountain hotel's brochure placed beside a ski in the snow provides an appropriate opening for a video of your skiing vacation.*
● *A close-up of a cake with "Happy Birthday..." sets the scene for a child's birthday party.*
● *A view through the window of an airplane, the porthole of a boat, or glasses on a restaurant table all produce interesting backgrounds.*

Over the last few years, a wide range of electronic titling equipment has appeared. Since most video enthusiasts and all professionals prefer to add titles at the editing stage, a considerable range of postproduction titling equipment has been developed. But for people with tight budgets, or who do not want to become involved in editing, clip-on character generators will produce reasonable, if not particularly exciting, titles.

- **Simultaneous and postproduction equipment**

Electronic and computer titling

SIMULTANEOUS TITLING Character generators have an alpha-numerical keyboard on which you type the words of your title. You then clip the character generator onto the shoe attachment of the camcorder and plug its lead into the relevant socket – though some newer camcorders have built-in character generators. At the appropriate time during filming, you push a button and the preprogrammed titles scroll across the picture. Text such as captions can also be inserted in the middle of the film by the same method.

Most character generators have the capacity for several pages of type and offer two or three different type sizes. Some allow coloured lettering, although the majority have white only. If you use coloured lettering, the colour should contrast with the background so that it stands out clearly. Some generators also allow an outline or drop-shadow around each letter so that it will stand out from a background of a similar colour. Titles on a character generator take quite a long time to compose, but it is a relatively inexpensive way of getting titles to roll over the moving pictures at the beginning or end of a film.

Many machines require you to scroll through the alphabet for each letter of each word, which can be a tiresome process. For this reason, try to assemble and enter the titles into the memory of the generator before you go out filming. Then it is just a matter of pushing a button when they are required.

TEXT ORIGINATING PROGRAMS
These allow you to create titles in a wide range of type faces and sizes to suit the character of the production. Either the words appear on screen after being faded in, or they scroll from the top to the bottom of the screen (or vice versa). You can also place subtitles at the bottom of the screen.

Credits at the end of a video look effective when scrolled across the screen and you can do this even with a basic character generator. The appearance of titling is often improved by the use of a "drop-shadow" effect that makes the words stand out against the background (as in the example above). You need to be careful in your choice of colors, though. It is worthwhile experimenting with different options before making your final choice.

◄ CHARACTER GENERATOR TITLES *To get the best results it is important to take care in pre-planning your titling. Position the titles against a suitably contrasting background to make them stand out. The spacing and placement in the frame should complement the overall composition of the scene.*

PAINT PROGRAMS *Paint programs allow you to draw graphic pictures, charts, and the like. The results can be extremely sophisticated or very basic, depending on the operator's skill and the time available. Some paint programs also have text origination facilities, thus providing versatile titles. If you want to superimpose drawings, pie-charts, titles, and so on over video footage, you will need an extra piece of equipment called a genlock. This allows you to mix in computer-generated pictures or superimpose computer-generated titles over video pictures.*

Additional equipment useful in producing video titles includes scanners, which you can pass over a photograph or piece of artwork to give you a graphic reproduction of the original, although most scanners can only accommodate small photographs or pieces of artwork. You can then add or subtract different colours to adapt the artwork. One major advantage is the scanner's ability to reproduce logos and pictures, not just text.

POSTPRODUCTION TITLES A wide range of job-specific postproduction home titlers have been designed. Some have built-in designer graphics – coloured stars, hearts, cakes, sports logos, and so on – to add to the titles. Sony has produced an innovative edit controller for use with their Video 8 and Hi-8 machines that also has a titling keyboard.

COMPUTER TITLING Computers are becoming more popular in postproduction video editing for supplying titles and other kinds of graphics. In theory, any model of domestic or business computer can be used, in practice, though, the RGB signal (red/green/blue) output by most computers is quite different from the composite video signal. This means that although a picture can be displayed on an RGB computer screen, such computers cannot be connected to a VCR without expensive add-on equipment. However, a computer specifically designed for use with video equipment can be connected to a VCR. Its output is recorded directly onto videotape – an obvious essential for titling. Operational directions are simplicity itself: bring the titles up on-screen (either by keying them in or by calling up ready-made ones) plug the computer into the VCR with a blank tape in it, run the titles program on the computer, and then press the VCR's record button to transfer the titles into the VCR. The final step is to insert-edit the titles into the master videotape.

Computer manufacturers have produced an array of programs that allow you to create titles easily. Even the cheapest produce good-looking titles.

Titling software can normally be purchased from video shops. It consists of one or more disks and a user's manual. Copy the master disks, then store them away safely. If the copies become damaged, you can always record another copy from the master.

The art of editing lies in deciding what shots to include, what to leave out, and how to position the edited sections, so that they relate to one another within the film. An editor must pay attention to the timing, pacing, and continuity of the edited segments.

Video editing is a process of copying. A source player and an editing recorder are required, together with a TV to monitor the edits. Provided that you are not going to use

AFTER THE SHOOTING IS OVER

Basic editing

your equipment too heavily, you can use the camcorder as the source machine and the VCR as the editing recorder. There are three main types of editing – in-camera editing (see facing page), assemble editing and insert editing.

ASSEMBLE EDITING Probably the most familiar form of editing, this method enables you to shoot the video in the most convenient manner. You can record several takes of a scene and choose the best at the editing stage. You can cut into the beginning or end of a shot to create better edit points, and intercut between different shot sizes and angles. In fact, it gives you complete creative control over the finished video. The drawback of assemble editing is that if you make a mistake, you have to go back and recopy the shot and all subsequent edited material.

INSERT EDITING Simple insert editing consists of recording new material over existing material, either directly or from a prerecorded tape on a camcorder or VCR that has an insert edit facility. You cannot change the order or length of shots with this method of editing, but you can replace a shot with another of the same length by recording over it.

A more sophisticated form of insert editing, is to copy the shots you want onto a blank, but prepared, tape. To understand how this form of editing works, you must be familiar with how the sync track controls the tape.

As well as recording the pictures and sound track, the tape records synchronizing signals

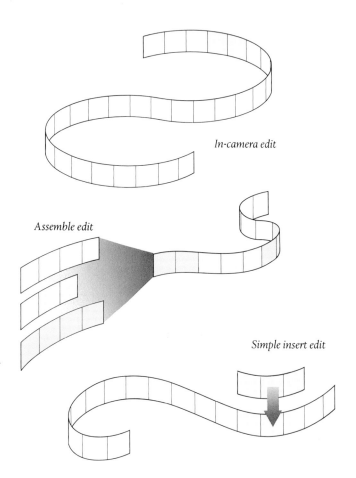

In-camera edit

Assemble edit

Simple insert edit

▲ **EDITING METHODS**
These diagrams show the three main types of video editing.
In-camera edit *Shots and shot lengths are decided at the time of recording. This technique requires no editing equipment.*
Assemble editing
Shots are copied onto a
new tape in the order you want – not necessarily the order in which they were shot. An editing VCR is needed.
Simple insert editing *New material is recorded over existing footage. Does not require extra equipment.*

▶ IN-CAMERA EDITING

Most people start by editing in camera but unless you consider your shots carefully, there is a risk that the finished tape will look incoherent.

Bear in mind that with in-camera editing you cannot retake a badly exposed or composed scene, or one in which you just miss the action. Planning, therefore, needs to be more meticulous. With one eye to the view-finder, you will have to have the other alert to what is about to enter the frame or looking for reaction cut-aways, and so on. Pay particular attention to avoiding jump cuts, as well. You will also have to develop some sort of internal clock so that you keep individual shots from becoming too long.

▲ **1** *These shots were taken in the order shown here. This opening image could last between 5 and 15 seconds, depending on any dialogue between the girls.*

▲ **2** *This scene shows the older girl in mid-shot. Her position to the left of the frame implies the position of the other. Being closer, this scene could be shorter than the establishing shot.*

▲ **3** *The camera cuts to a mid-shot of the younger girl. Her position is at the right-hand side of the frame, indicating she is looking toward the other girl on the left.*

▲ **4** *The scene cuts to a thoughtful close-up of the older girl as she listens to the other girl talking.*

TIP *When starting a new take, always change the type of shot and the angle. Otherwise, very similar shots will appear to jump at the edit point.*

(pulses) during recording. As you edit the video, separating out the sequences that you wish to copy from those that you do not, you also break up the continuity of the pulses on the sync track. This can result in jumping or rolling edit points. Newer VCRs are fitted with flying erase heads that are very tolerant of the edit-point sync problems. Nevertheless they still occasionally show bad edits. If your VCR has "insert edit" provided as a feature, however, it is possible to edit (insert) new pictures over old ones – or onto fresh tape – with complete freedom from bad joins in the sync track. This is because it copies pictures and/or sound, but not the sync track. However, this can only work if the tape you are recording on-to already has a sync track on to which the

new pictures and sound can lock. If there are pictures on the tape already, there must be a sync track there.

Brand-new tapes do not have sync tracks, and therefore have to be "blacked (or blanked) up" before they can be used for editing. To do this simply run a tape through a camcorder switched to on/record with the lens cap over the lens. Insert edit onto this tape and the strong, unbroken, first-generation sync track will accept the pictures and sound being copied onto it. This is notably better than recording a chain of broken, second-generation syncs, as happens with assemble editing. Once you have prepared the blacked-up tape, select and copy the shots you want, following the same procedure as for assemble editing.

AFTER THE SHOOTING IS OVER

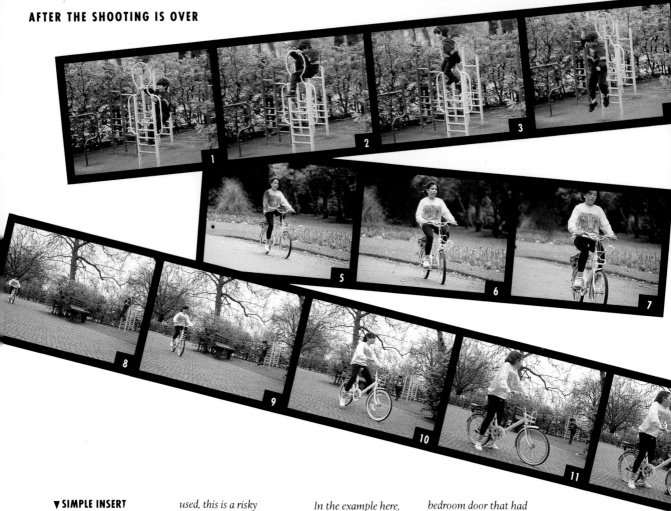

▼ SIMPLE INSERT EDITING Basic insert editing involves using the camcorder only and new material is recorded over previously recorded footage. Since the master tape is being used, this is a risky procedure. A safer method involves the use of a VCR with an insert-edit facility, and all editing procedures are then carried out on a copy tape.

In the example here, the original footage is shown in the bottom strip of images below. There was ample material of the child asleep, so a scene of the mother opening the bedroom door that had been shot earlier was inserted over the excess footage. You can see how these work in the edited version in the top strip below.

◄► **ASSEMBLE EDITING** *Comparing the two sequences of images here (left and right) illustrates how assemble editing can change the look of a tape. Some superfluous scenes have been removed (3, 5, and 7), but also two different activities and camera angles have been intercut to make the sequence more dynamic. This did involve careful planning, though. The boy on the frame, for example, had to climb through the hoop and jump off the frame twice — one version was recorded in close-up, and the other in wide shot with the cyclist coming into view. Intercutting between the two achieves the type of results more usually seen in movies.*

▲ **Shot 6** *A wide shot of a girl cycling through the park.*

▲ **Shot 1** *Cut to a little boy playing on a climbing frame.*

▲ **Shot 2** *This scene follows on from the previous one.*

▲ **Shot 8** *Back to the girl cyclist. The same scene from a different angle.*

▲ **Shot 9** *The boy jumps off the frame in the background.*

▲ **Shot 4** *Close-up of the boy jumping off the frame.*

▲ **Shots 10, 11, 12** *These three scenes have been left in* *their original running order. The boy runs over to meet the* *cyclist. The editing here was carried out in-camera.*

At its most basic, editing is simply a question of removing unsuccessful shots or reducing certain sequences to produce a tape of manageable length. However, you can take editing a step further, using it to add polish, impact and watchability to your video.

ELIMINATING EXCESS FOOTAGE The most common error is to show too much for too long. Most viewers become bored by endless shots – for example, in a holiday video, of your family

Creative editing

sunbathing on the beach. It would be better to cut these down to allow more time for action shots, or for sequences featuring interesting architecture and landscapes.

When you have finished recording, take a critical look at your completed tape; ask yourself whether each sequence really earns its keep. If in doubt, try cutting it and see whether this improves the pace of the video. Remember – the original sequence will still be on your master tape if you change your mind.

IMPROVING THE NARRATIVE Editing is your opportunity to reorder the sequence of scenes. You may want to do this to correct continuity problems or to insert buffer shots that will reduce the effect of mistakes such as jump cuts.

Reordering certain sequences may also be necessary for other reasons. Circumstances may dictate that you must record scenes in a different order from that which you plan for the final version. This is likely to be the case if you have been trying your hand at shooting a feature film. You will probably have shot all the footage for each location at the same time, regardless of the place of each scene in the story. The editing stage is the time for you to reassemble the scenes in your intended order. It is also your chance to experiment with creating the most impact and tension from shot order. This can apply as much to a wedding video as to a thriller. For example, you could assess the effect produced by cutting from scenes of the bride putting the final touches to

● Editing for impact

VERSION 1: THE WINNER *On these two pages, and the two that follow, there is a progression of shots taken from a short video of a tennis match. In this first version, the video has been edited to show a chosen player winning the match; in the next version, this same player is seen, after re-editing the tape, losing the match. In virtually any type of video context, the same footage can be edited to tell a variety of different stories.*

▲ **4** *Here there is a cut to a different angle as play continues.*

▲ **8** *This theme is carried on here with a cut to an off-court take showing our player apparently despairing of the situation.*

▲ **1** *This "conceal" shot has been used as the establishing shot.*

▲ **2, 3** *As the camcorder pulls out a longer shot we see the main character. The aim of the editing is to create a "point of view" of* the chosen player, favoring him over his opponent. So only shots from his side of the court have been used.

▲ **5** *This is a cut to a close-up that was part of a previous take some minutes prior to the last image. The effect of the close up is to keep the viewer involved with the chosen player.*

▲ **6** *This shot of a ball landing out of court was chosen to add a little drama and to show the game going against our chosen player.*

▲ **7** *To signify his intense frustration, and to build the dramatic tension, this shot of the player throwing up his hands to his head was selected for this part of the tape.*

▲ **9** *Now the cut is to the match in progress once more, with our player beginning to regain his confidence.*

▲ **10** *This is the last of the actual playing shots and here we see him being a lot more forceful and aggressive in his playing.*

▲ **11** *This is the most important shot in this edit, and we see him obviously having gained a victory although no actual winning action was shown.*

her appearance to shots of the groom and best man waiting nervously for her arrival. Even though, in reality, the time scale was rather different, the compression and juxtaposition of events makes for a better narrative.

ADDING TITLES, PICTURE WIPES, AND OTHER EFFECTS
Simple titles and scene transitions can be produced as you record. However, certain effects can only be produced at the editing stage. Titles that you have created and recorded separately will need to be inserted as appropriate. Obviously any electronic titling must also be added at this stage.

Most of the myriad of picture wipes and other special effects can only be inserted at editing. These are discussed in more detail under Scene transitions, page 88.

EDITING ERRORS
After shaky camerawork, of all the mistakes that you can make, a misjudged jump cut is probably the most distracting to the viewer. Imagine that you are filming a member of your family standing by the front door of your home. You set up your camera on a tripod and film the scene minus the person. You then film your relative and again move him out of the shot for another take of the house. Replay the tape and you will find the person pops in and out of the shot as if by magic. This is an extreme example of a bad jump cut.

If you do have an awkward sequence in your footage, it can be disguised by inserting a cutaway shot.

TIPS Use cut-ins and cutaways to break up jump cuts or to conceal bad camera work.

● Editing can easily compress time by cutting out superfluous shots, but it is difficult to expand time unless considerable spare footage is available. This is an argument for shooting plenty of extra footage.

● Sloppy camera work that has been shot with the attitude "It can be fixed in the editing" usually escapes correction, so shoot with care.

VERSION 2: THE LOSER *The sequence of images on these two pages shows our featured player having apparently lost the tennis match (see pages 84-5 for Version 1, in which he won). The video editor is helped in this process by the audience's instinctive belief in the truth of the video image. Here, exactly the same images have been used as before, but in a different order, to tell a very different story.*

▲ **4** *This interposed shot of our player giving a very positive gesture reinforces the confidence of the previous shots, and so conditions the audience's responses to those that follow.*

▲ **8** *This is a simple filler shot to smooth the passage between cuts.*

EDITING POINTS

● *Camera angle – should change from one shot to the next.*

● *Shot size – should change significantly from one shot to the next.*

● *Eyelines – make sure that eyelines are compatible throughout a scene.*

● *Action lines – make sure that action lines are compatible, unless you can insert a neutral bridging shot.*

● *Cutaways – these should always be to an appropriate and relevant subject, or be used to give dramatic impact.*

● *Continuity – look out for continuity of props, expression, background, sound, etc.*

▲ **1, 2** *This version of the tennis match opens with a wide establishing shot and continues with the serve. This leads the viewer into the frame. Note also the use of the rule of thirds (page 56). The low camera angle includes a lot of sky.*

▲ **3** *The insertion of a low-level shot here during the editing process, increases the pace and tension.*

▲ **5** *Editing in this close-up contributes to turning this camcorder shoot into a fast-paced and varied product that looks as if it has used several camcorders.*

▲ **6** *Although close-ups are important and tend to make a video look sharper overall, the inclusion of wide-angle shots like this allow the audience to regain its orientation every so often.*

▲ **7** *Cut to a close-up again. This time showing the tension on our player's face. This shot conveys a change from the triumphal shot in frame 4.*

▲ **9** *This is a continuation of the last shot, used to make up some space between the last close-up and the one that is to follow. It also avoids a jump cut and shows some more of the action.*

▲ **10** *This is a reaction shot to the last playing sequence. This image is important to show our player's frustration and to signify that he has lost the match to his opponent.*

▲ **11** *The final shot shows our player in despair with his head in his arms. It effectively reinforces the last shot, and is a suitable point at which to conclude Version 2.*

I f you are a truly enthusiastic video editor, you will soon find the simple video editing setup of a source machine and VCR too limiting, particularly as an increasing variety of ancillary equipment is coming within reach.

The current range of postproduction editing equipment offers opportunities that one can hardly ignore. Options extend from a simple, inexpensive picture fader to a fully-specified vision mixer. In the last few years,

Scene transitions

video manufacturers have released a dazzling array of sophisticated yet relatively inexpensive apparatus for creating a variety of scene transitions and special effects.

FROM CUT TO FADE The most popular scene transition is the "cut", in which one scene is instantly matched with another. You can realize this effect without additional equipment. However, there are several other scene transitions that you can elect to use to produce very different effects.

After the cut, probably the most commonly used transition is the dissolve, or mix. The first picture dissolves or blends into the following one before fading out. A dissolve is used to produce a slow, gentle type of changeover. It often indicates a major shift in time or location. Faster dissolves are occasionally used simply to make the transitions flow more smoothly. The dissolve is possible only using a three-machine setup (page 90-1).

A major change of time or location is usually indicated by the fade. Many camcorders have a built-in fade control and many editing accessories incorporate a fade function. However, many amateur videomakers tend to use the fade too much. Clearly, fading up the picture at the beginning of the recording is fine, as is a fade-out at the very end, but fading at any other time should always be approached with some caution.

WAYS OF USING THE WIPE Another familiar form of scene transition is the wipe. There are

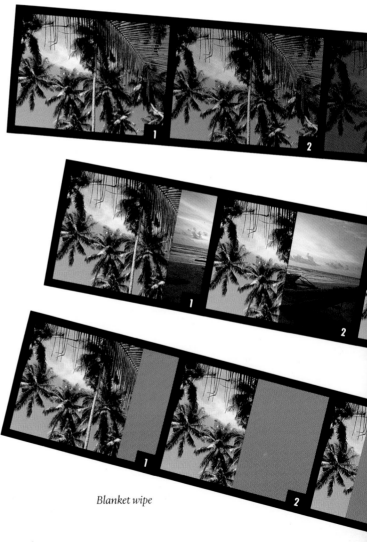

Blanket wipe

Cut

Dissolve

Fade

◄ TYPES OF SCENE TRANSITION *Here the cut from a shot of palm trees to a beach at sunset is shown using each of the main types of scene transition. From top to bottom they are: cut, dissolve, fade (shown at the end of the sequence), picture wipe, blanket wipe.*

two kinds, the picture wipe and the blanket wipe. Blanket wipes are very popular. This is largely due not only to the fact that they can be produced using a basic editing setup, but also that the machine designed specifically to produce them – called a blanket wipe generator – is also quite cheap. In simple terms, the technique uses a wash, or blanket, of colour to wipe one picture from the screen, replacing it immediately with another image that obliterates the colour.

The three types of picture wipe – the push, the reveal, and the conceal – present complications, since all of them require a three-machine editing system. In all the variations, a picture immediately replaces an earlier one on the screen. While the push – in which the old images move across the screen, pushed off by the new one – requires a professional vision mixer, both the reveal and the conceal can be completed on a domestic vision mixer. The former allows the earlier shot to be erased from the screen to reveal the newer one; conversely the conceal hides the older picture behind the incoming one. The way in which the wipe masks its replacement can take one of a myriad of shapes: a circle, square, oblong, curtain, diagonal, and so on. However, during editing, the synchronization of the two source tapes can unfortunately be difficult, time-consuming, and involve a good deal of trial and error.

Picture wipe

Three-machine editing is the summit of post-production sophistication. When you become involved with the intricacies of this process, you are talking serious filmmaking and serious money. It entails editing from two source tapes on separate VCRs. These are linked to a vision mixer to produce the edited master. The process allows you to dissolve, mix, or wipe between the two incoming picture sources at your edit points, adding a real

• Extending your editing options

Three-machine editing

gloss to your video recording. Used intelligently, it should make the whole story-telling exercise clearer and more effective.

If you have a single tape that you want to edit using a three-machine setup, you will need to create a copy of your tape for use in the second source machine. The use of two copies of the same tape for three-machine editing is known as A and B roll editing, the A tape being the original and the B tape the copy. The copying process involves some loss of quality on the B roll but, because you use it only briefly at the edit point before reverting back to the A roll as soon as the transition is complete, it should not matter. In any case the overlap itself conceals loss of image quality to some extent.

► **VISION MIXER** *This slots in between the source VCRs and the editing VCR. Connections are from the VIDEO OUT and AUDIO OUT ports on the two source VCRs, to the VIDEO IN and AUDIO IN ports on the vision mixer.*

Editing VCR

Source monitor

► **FINAL SOURCE MONITOR** *This monitors the edited results. You can use a dedicated video monitor or a TV. Connections are from the VIDEO OUT and AUDIO OUT terminals on the editing VCR, to the VIDEO IN and AUDIO IN on the monitor, or via an RF lead.*

▲ **EDITING VCR** *This holds the master tape on which you are creating the edited version. It should have insert edit and audio dub facilities.*

Connections are from VIDEO OUT and AUDIO OUT on the vision mixer, to VIDEO IN on the editing VCR.

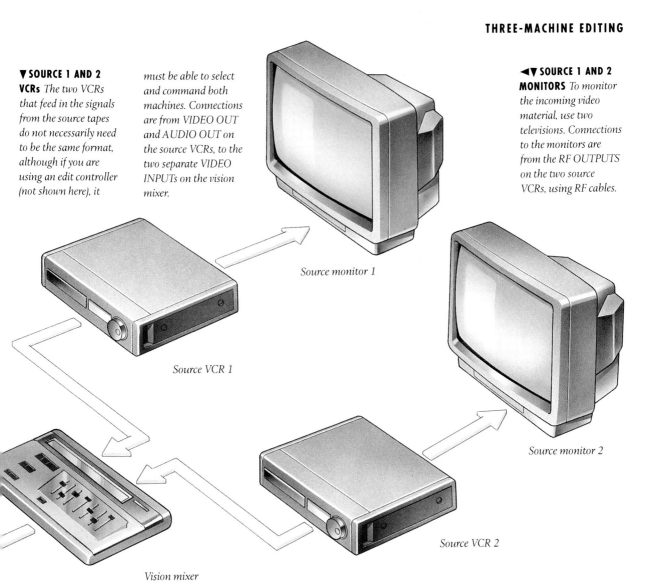

▼ **SOURCE 1 AND 2**
VCRs *The two VCRs that feed in the signals from the source tapes do not necessarily need to be the same format, although if you are using an edit controller (not shown here), it* *must be able to select and command both machines. Connections are from VIDEO OUT and AUDIO OUT on the source VCRs, to the two separate VIDEO INPUTs on the vision mixer.*

◀▼ **SOURCE 1 AND 2 MONITORS** *To monitor the incoming video material, use two televisions. Connections to the monitors are from the RF OUTPUTS on the two source VCRs, using RF cables.*

Source monitor 1

Source VCR 1

Source monitor 2

Source VCR 2

Vision mixer

THE SYNC TRACK As well as recording pictures and sound, a videotape also records a stream of synchronizing pulses. The sync track controls "tracking", the speed and regularity of the videotape as it rolls across the playback heads. If the drive motors of the playback recorder are faster or slower than those of the originating camcorder, mistracking will occur. As a result, the picture will exhibit a diagonal noise bar across the screen and, if the mistracking is particularly bad, the image will roll and break up. Many modern camcorders and VCRs have automatic digital tracking and are therefore self-adjusting. Older models, however, rely on a manual tracking control that operates by means of a thumb-wheel or button.

The sync track becomes vitally important when you want to perform a three-machine edit because the incoming pulses from the two source tapes invariably conflict. Modern home vision mixers easily align the sync pulses from two separate source tapes, slowing down one to match the other.

Not only does the quality of the resultant picture vary between vision mixers of different price ranges, but the range of functions each performs is also greatly affected. The more expensive vision mixers available allow you to use dozens of different wipes and picture-in-picture facilities, as well as enabling you to strobe, colorize, and grab still frames from both incoming sources.

TIP *Make a copy of your single-camera shoot and occasionally mix to and from the copy to give your production a two-camera look. Use the copy only during the fleeting transitions, and your audience will never notice the momentary loss of picture quality.*

Competent editing demands a sensitive ear. You need to be aware of conversations, background noise such as distant music or traffic, and other sounds of normal life to make sure that there are no jump cuts in the sound-track. When the subjects are distant from the camera or facing away from it, and no direct speech is observable, lip sync is unimportant. In such situations, it is quite feasible not to use any live sound, but to

Editing sound

replace it with a sound-track recorded on another occasion.

During editing, it is as important to hear the effects you are producing on your final tape as it is to monitor the sounds on your prerecorded track. You have three options: you can listen with your television speaker or, for more accurate or stereo sound, attach headphones or an amplifier and two speakers. **SOUND MIXERS** There are two main types of sound mixers. The so-called microphone mixer allows you to add live sound, such as a commentary from one or more microphones. This type is not suitable for post-production sound editing. A true sound mixer allows you to add prerecorded sound from various sources – such as an audiocassette player or another videotape – as well as live sound from a microphone at the editing stage. The number of input channels available varies with the type of machine. Many sound mixers incorporate a graphic equalizer (see Accessories and equipment, pages 162-9) and a reverb unit. **ADDING SOUND** The simplest way of adding sound to a video recording is to tape a new sound-track, using the audio-dubbing facility if your camcorder or VCR has one. Audio-dubs can be used to cover jump cuts in the sound at edit points and to substitute background sound for unwanted noise. They can also be used to add music or a commentary. If you wish to edit new sound onto a tape using a mono VCR, you will automatically lose what-

Feed machine

► **VCR 1 (FEED) MACHINE** *The feed machine can take the form of the camcorder or a VCR. If the camcorder on which the sound-track was recorded has hi-fi, and the feed machine does not, hi-fi will be lost. Connections are from the feed machine's OUTPUT to the mixer's INPUT.*

Monitor headphones

► **HEADPHONES** *Should be used to monitor the edited sound track.*

BASIC AUDIO DUBBING *This illustration shows a basic sound-editing suite. If space and budget allow, you could also add a graphic equalizer between the sound mixer and the master VCR. Before starting, you will need*

to decide which sounds to add and whether or not you will re-record the original sound completely, or only partially. You will also need to decide in advance what, if any, sound you will want to dub onto the edited tape. When choosing a

VCR to use as the master record machine, make sure that the audio dub function allows you to add to the sound track, rather than simply replacing it with another.

SIMPLE AUDIO-DUBBING PROCEDURE

1 *Check that the dub is the correct length.*
2 *Connect the tape- or cassette-recorder into the audio-in socket of the VCR or camcorder containing the master videotape.*
3 *Record the sound onto the videotape.*

▼ VCR 2 (MASTER VCR)
The AUDIO OUT lead from the sound mixer is connected to the AUDIO IN port on the master VCR.

Monitor

Master VCR

Sound mixer

▲ MONITOR *At the end of the audio-dubbing chain is a monitor television, connected to the master VCR.*

◄ SOUND MIXER *Slot the sound mixer between the source and the master VCR. Connections are from the source's OUTPUT to the mixer's INPUT, and from the mixer's OUTPUT to the master VCR's INPUT.*

Microphone

◄ NEW SOUND SOURCES *Microphones (for adding commentary) or music players (audio cassette, record, or CD) are fed into the additional INPUT socket on the mixer.*

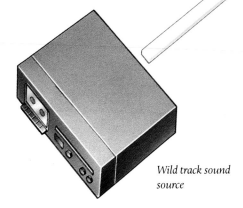

Wild track sound source

ever sound is already on the tape. In many cases this is an insurmountable problem. Stereo equipment allows you to over-record only one of the two tracks, so that existing sound is left untouched on the other.

You can audio-dub either by recording directly into the camcorder – to add a commentary, for example – or by feeding in a prerecorded tape on a cassette, or tape recorder plugged into the audio-in socket on the camcorder or VCR. Alternatively, you can build up a sound-track using sound from two different sources. This can be done either by recording a premixed tape on a tape- or cassette-recorder and by dubbing it onto the videotape, or dubbing two sound tapes onto the videotape simultaneously using a sound mixer. If you want to add commentary and music, record the commentary onto a tape or cassette first, carefully timed and cued, and then feed the commentary and music separately into a sound mixer to dub them onto the videotape.

To add sound to a prerecorded sound-track without losing the original sound, feed the original sound from the audio-out on the camcorder into the sound mixer at the same time as the additional sound. The mixed track will be dubbed onto the videotape.

93

Tricks and special effects fall into two main categories: those that you produce while video filming; those that you produce while editing. Within this second category are two sub-categories: a) tricks produced by editing VCR and b) tricks produced by ancillary or editing accessories. The special effects produced during filming can be both fun and easy to achieve. They can add atmosphere and, if you want, even supernatural elements to your

- **Creating extra interest**
- **In-camera effects**
- **Editing effects**

Tricks and special effects

video production. Effects of this kind include the use of smoke, special lighting, makeup, and glass shots.

SMOKE EFFECTS Smoke is most often used in the production of pop videos and atmospheric dramas (see Mini feature film, page 124), and is produced in two different ways.

Genuine smoke can be produced by using a smoke machine. This burns small quantities of paraffin or a similar oil. Such machines are part and parcel of a disco entertainer's kit. They can also be rented. Alternatively, small smoke pellets can be purchased from theatrical suppliers. These are usually small lozenge-like cakes that can be set alight with a match to produce a short but very dense billow of smoke. Both machine and pellets are unsatisfactory because they pollute the air quite quickly, especially if used indoors, as well as giving off a quantity of soot.

Dry ice is much favoured by musicians as an alternative to fire smoke. But it is more expensive and can form a dense mist that hangs low over the floor and does not disperse easily. This low-lying cloud can sometimes be manipulated to great effect – for instance, to obliterate a stage or scene to knee-level. But more often than not this murky ground cover creates a problem. Dry ice can also be dangerous because its intensely low temperature causes it to stick if it comes in contact with human skin. It must therefore be handled carefully.

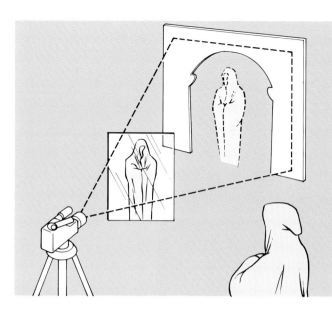

PEPPER'S GHOST

This is an old movie technique for creating ghosts and other effects such as fire.

You need a thinly silvered mirror that allows some light to pass through it. Set this up at an angle of about 45° to the camcorder in front of the scene on which you want the "ghost" to appear. Position the ghost out of shot so that its image *is reflected in the mirror. Make sure the ghost is as well lit as the background over which it is to appear. The camcorder will record both the reflected ghost image and the scene behind the mirror.*

◄ ARTIFICIAL MIST AND FOG *These effects are the great mainstay of "atmospheric" scenes. Smoke, mist, and fog immediately imply mystery and often suspense. For this shot taken from the mini feature (pages 124-7) an oil-burning smoke machine was used to generate the mist that was such a vital element in building the sense of menace associated with this character.*

APPARITIONS AND SUPERIMPOSED MATERIAL

The illusion called Pepper's Ghost is achieved by using a semi-silvered mirror. This allows some of the light directed at the mirror to travel through it, while at the same time reflecting light from a second subject. The second subject appears wraith-like or semi-transparent.

Images that the videomaker wishes to superimpose on a scene can be painted or collaged onto a sheet of glass. This sheet is placed behind, or in front of, the main subject and simply melts into the picture. Such traditional glass shots are a stock item in the repertoire of home moviemakers' special effects. But they usually require skillful painting and careful control of the depth of field.

IN-CAMERA EFFECTS Some video camcorders have built-in features that allow you to manipulate images while filming. They can produce effects like colour casts, posterization and mosaics, digital pictures, strobe movement, recordable still frames, and other options. However, the main disadvantage of these in-camera effects is that once they are recorded onto your master tape, they cannot be removed. For this reason, most videographers prefer to introduce effects when editing rather than while filming, allowing wider choice and experimentation.

EDITING EFFECTS If you wish to introduce effects as you edit, you will need several pieces of equipment. To begin with, an editing recor-

REFLECTIONS FROM WATER *The effect of sunlight reflected from water onto your subject can be relatively easily faked. Simply place a mirror or alternatively a sheet of aluminium foil in the bottom of a shallow tray filled with water. Shine a strong light into the water at an angle that reflects the light back onto your subject's face. Finally disturb the water to make ripples to create the impression that your subject is washed with reflected sunlight.*

▲ NEGATIVE EFFECT
Up-market vision mixers provide this option which converts colours to their complementaries – that is, blue to orange, red to green, etc. You can use it to create weird atmospheric shots, as here, or on a more practical level, to record colour negatives placed on a light box or in a slide converter in their "true colours".

◄ COMPUTER EFFECTS
A straight shot of a boat in a fjord (1) has been processed using some of the special effects functions that are available on vision mixers.

The first effect (2) was created by mixing a pink background colour with the image. This effect can be used to alter the mood of a scene or as a crude method of colour correction.

Posterization (3), sometimes referred to a Paint effect, simplifies the tonal values to provide a graphic effect that could be suitable as a background for titles or in a pop video.

Next (4), a "soft circle" wipe effect is combined with the Paint effect to focus attention on the boat.

The mosaic effect (5) is another possibility for an opening shot. It divides the image into small squares. The size of the squares can be selected to suit the image you want. The effect can be seen in detail in picture 6.

der with one or more trick heads is advantageous. Additional trick heads allow specialized functions such as slow motion and noise-free recordable freeze-frames. (Noise-free refers to the lack of interference bars across the screen when the tape is held in pause.) For more elaborate electronic effects, a Special Effects Generator (SEG) – or optimally, a true Vision Mixer – is required.

Adjustable speed strobes offer another option. These produce a jerky kind of slow motion, in which the mixer grabs a frame and repeats it for an adjustable number of frames before grabbing a new frame and likewise repeating it. Strobes differ from slow motion in that they have a pronounced jerkiness – this can often be used to good effect. However, the major advantage of strobe effects over slow motion is that while the action *appears* to be retarded, it actually works in real-time so that the sound track remains normal and constant, and is not also slowed down as it would be with true slow motion.

Posterization, in which the colours and tones are simplified to achieve a graphic effect – mosaic – in which the picture, or a portion of it, appears to be made up of different-coloured small rectangles, and negative/positive, in which the lighter tints appear dark and vice versa, are all sophisticated effects that make the most of the colour opportunities offered by modern video recordings.

FAKE BACKGROUND *Any enthusiastic videomaker can use the technique of painting on glass to produce convincing backgrounds for videos. A useful tip for those who are not confident of their artistic skills is to use a real background that approximates to that which you are aiming for and to use a painted glass screen to adapt only those parts that do not meet your requirements.*

In the example illustrated here, an intact cityscape was selected as the basis for

the scene. A sheet of glass was supported in front of the camcorder and acrylic paint that matched the colour of the sky was applied to the glass to block out the tops of the buildings, creating the illusion of ruins. A small colour monitor allowed the success of the effects to be judged on screen.

▲ VISUAL FEEDBACK
This technique can be used to produce spectacular endings to your production. You need a camcorder and character generator. Set the camcorder on a tripod or other firm surface facing your TV set at a slight angle. Connect the camcorder to the TV and key in display the words you want to appear on screen. As you record, you will notice the words create a tunnel-like effect on screen. Watch how the shape of the lettering alters if you change the camcorder position.

Even if you don't

have a character generator, you can try this effect by applying lettering – either hand-painted or dry transfer – directly to the TV screen. You will need to check that whatever lettering you use can be easily removed later.

Making
4
a
video

Making a video

The best way to learn any new skill is by practice. Nearly everybody reading this book knows this from their own experience – perhaps from learning to use a computer, play a musical instrument, or drive a car. The theory is fine, but you never really come to terms with it until you are actually hands-on.

By using your camcorder and accessories immediately you will start to gain valuable experience and confidence. It is only by setting and then using the controls that your video-making will start to become automatic and reflexive. Once you have reached this point, you can begin to take more notice of the creative possibilities inherent in the locations and places in which you are taping. The particular applications to which you might want to put the camcorder largely depend on your own interests and activities. Although different subject areas will present different challenges, and may require different skills and approaches, most of the applications described here have more in common with each other than you might initially realize – at least from a video-making point of view.

To illustrate this point, the camcorder user who keeps a lively, well-presented video diary of special family events – or just ordinary day-to-day activities – is learning skills that might well be used at some later date for a very different type of project, such as a mini-feature or even a documentary. In this chapter you will find a project dealing with creating your own video diary. In this the rostrum camera techniques used to record old family photographs are exactly the same as those used for, say, taping a map for an insert in a documentary. The research, pre-planning, and approach required for these projects are, of course, very different, but many of the video skills are common.

In order to broaden the appeal and make the learning exercise relevant to every camcorder user, the projects in this chapter deal with such family areas as taping a child's birthday party, a wedding, and making a family diary. For those who travel a lot, there is a travelogue video project; while if your interest lies in natural history subjects, then there is a specific wildlife topic. Should you wish to try your hand at creating and scripting a mini-feature or documentary, then these too are covered, as is recording a stage play. For the aspiring musician, a video of your band may help you to reach a wider audience, and will also certainly be a great deal of fun to make. If you are a sports enthusiast, you may well consider recording a key event or even try using a video recording to help improve your own technique. Last but not least, video is ideally suited to many business applications, and for some of you a well-crafted video may serve to promote your own business in a style that would be the envy of a professional public relations firm.

▶ **PUTTING THEORY INTO PRACTICE** *Videos have become such a regular feature of our everyday lives that it's now as hard to imagine a wedding without a videographer as one without a still photographer. Many other events provide potentially fertile ground for video recording: sport, travel, wildlife and business are a few examples.*

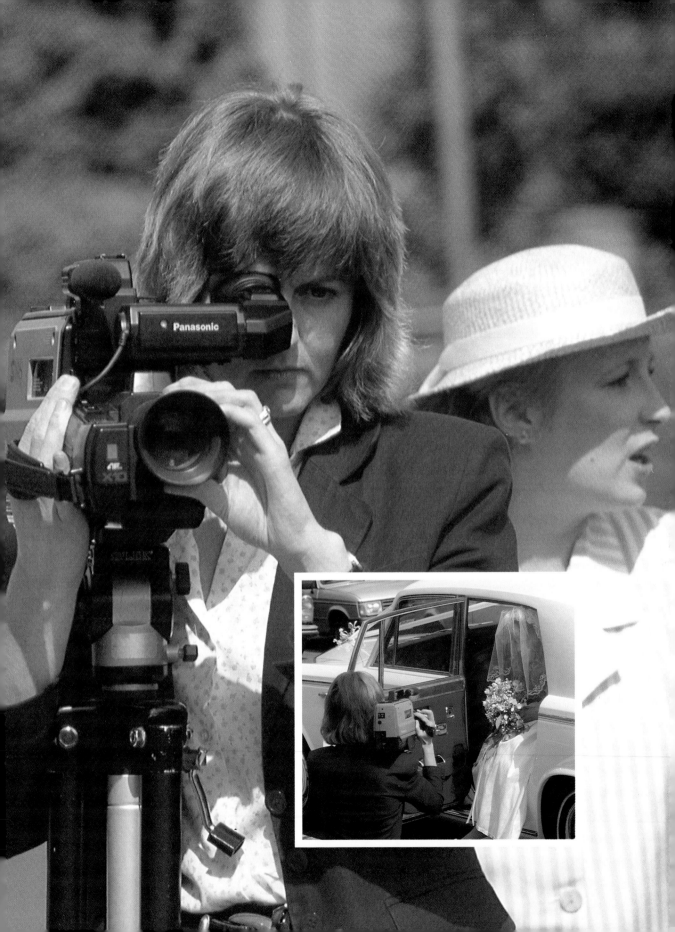

Perhaps one of the most enjoyable uses to which you can put the camcorder is making an ongoing record of your family. You can include all sorts of activities, depending on what you like to do as a family. In this way you will also build up a permanent record of your children as they grow and develop over the years.

If you have acquired a camcorder only recently, but your family is already growing up,

- **Filming the family album**
- **Rostrum work**
- **Indicating the passage of time**

Family video diary

don't feel that your record need somehow be incomplete. There is no problem in transferring cine footage to videotape, for example, and you can produce a retrospective tape encompassing not only the present generation but also old footage of when you and your partner were children growing up with your own parents.

Even if cine film is not available, why not record still photographs from the family album and slide images too? These can be transferred to tape just as easily. If the image quality is good, you will be able to move into a big close-up on a photograph and let the camera move and explore the image, gradually revealing it to the audience.

TITLES The dates and events you are taping now are fresh in your mind, but as time goes by you will forget when such and such happened, or if it is your child's fifth or sixth birthday party you are watching. It is essential to use titles for each episode. You could do this with your camcorder's caption generator, but there are more imaginative approaches. You could, for example, zoom in on a handwritten, dated caption under a photograph, a shot of a party invitation, or ticket stubs.

THE PROJECT This project is in two parts. The first shows one family's approach to using nonvideo pictures from their family archive on video. The second part of the project includes some scenes from another family's current video diary.

TYPES OF IMAGERY
A family video diary should record family events and experiences over the years to build up a catalogue of memories. As well as the quiet, intimate moments of family life, you will also want to record many of the fun things you all did together, such as days out at the beach or in the country, going on family vacations, or, as in the image shown above, a family trip to Canada to visit Expo '87.

▲ **1** *On this page and the two that follow, a camcorder has been used to record a family photograph album. The titles are shot over a background of scattered pictures.*

▲ **2** *The image dissolves to a piece of artwork showing the date of Isabelle's (the videographer) parents' wedding. A sound track of the Wedding March might be appropriate.*

▲ **3** *The parents' wedding photograph is introduced with a close-up of the bride's head and shoulders, slowly pulling out to reveal the whole picture.*

▲ **4** *Using the zoom, the whole picture is revealed. A zoom out from the previous close-up and a pan to the right reveals the bridegroom on the bride's left.*

▲ **5** *The couple's first child, Isabelle, is seen in this next shot.*

▲ **6** *There was a gap in the album covering Isabelle's early childhood, and so newspapers of the period were mounted on a spinning turntable to signify time passing.*

▲ **7** *A photograph of Isabelle as a 6-year-old framed as a wide shot. Slowly the lens zooms in tighter, panning slightly to the left to keep Isabelle center-frame, until we see her face in close-up.*

▲ **8** *This image shows a dissolve from a close-up of the 6-year-old Isabelle to the 16-year-old Isabelle.*

▲ **9** *As the dissolve finishes, the teenage Isabelle is seen seated with a group of her friends at a café table.*

▲ **10** *Using the same photograph as the last, we now cut to a mid-shot of Isabelle framed so that she is positioned according to the rule of thirds to give emphasis.*

▲ **11** *This frame showing a college prospectus indicates the next stage in Isabelle's life.*

▲ **12** *This photograph is of the college at which Isabelle studied. The sound track is of music she enjoyed at this time.*

▲ **16** *No wedding record would be complete without a shot of the wedding cake. So here the rostrum camera set-up was used to record this photograph onto tape.*

▲ **17** *A map shot has been included here with a dot marking the spot in Portugal where the couple spent their honeymoon.*

▲ **18** *The map image dissolves into a photograph taken in Portugal, showing Isabelle and her husband walking along a beach.*

▲ **22, 23** *The picture material available from their trip is in slide form. The slide was projected onto a screen and the camcorder mounted normally on a tripod. The sequence starts with a close-up of a*

mountain, and then the camera pans across to reveal Isabelle and her daughter, now older, in the foreground.

▲ **24** *A gentle dissolve forms the transition to a shot of the family in front of a magnificent waterfall, and the camcorder slowly zooms in on the child.*

▲ **13** *A head-and-shoulders shot of a photograph introduces Isabelle's future husband. The continuation of the music helps forge the link between them in the viewer's mind.*

▲ **14** *Things are moving on quickly now. The next image is the invitations to Isabelle's wedding.*

▲ **15** *A black-and-white photograph shows the wedding ceremony.*

▲ **19** *A fade from black suggests the passing of time, and mother and new baby appear on the screen.*

▲ **20** *Never ones for settling down too long, the family decide on a trip of a lifetime. A map of South America sets the scene.*

▲ **21** *A straight cut brings up an image of a map detail showing us their first destination.*

▲ **25** *The close-up in the previous shot dissolves into another close-up of the child, this time in a street market. The lens zooms out to reveal the whole scene.*

▲ **26** *Back to rostrum techniques to show a map of the family's final destination – Rio de Janeiro. Arrows have been added to show the flight path from their previous location.*

▲ **27** *The final image in this part of the diary is again taped from a projected slide and shows an aerial view of Rio taken from the plane.*

LOOKING BACK
*Richard
growing up*

1

2

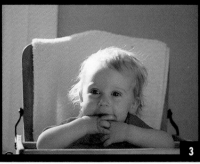

3

▲ **1** *A family video diary does not need to have a beginning, middle, and end. It will probably consist mostly of snatches of memories, which will have more coherence if each is preceded by a short caption card.*

▲ **2** *The first footage of Richard was recorded when he was 3 weeks old. This early footage was originally recorded on cine but has been transferred to video.*

▲ **3, 4** *Richard, now aged 18 months, sitting in his high chair. These head-and-shoulders scenes give a good feeling of his personality, character, and boundless energy.*

7

8

9

video relied on background music only. So, to ease the transition, it was best to fade in the live sound gradually.

▲ **8, 9** *The tape jumps forward a few years to a sequence taken on Richard's first holiday overseas, in France. A wide shot*

introduces us to the country before cutting to a more detailed shot of the holiday "pension."

WHAT TO SHOOT

One of the joys of a family video diary is that it captures all the small changes that children undergo as they grow up. But to give your footage a real period feel, try to include lots of contemporary details: fashions and fads that will inevitably become fascinating, as well as amusing, to look back on. Include store windows, posters, price tags, store signs, and so on. It can be great fun to be reminded of past style. The photograph shown here is a still shot taken in the 1950s. It makes the point perfectly, though, showing a brother and sister all dressed up in the "latest" fashions posed in front of the family's new car.

▲ **5, 6, 7** *The family has now acquired a camcorder! Some early experiments with the new camera feature Richard in the local playground. The scene starts in wide-* *shot and slowly zooms in to a close-up head-and-shoulders shot. With the camcorder also came the ability to record live sound. Up to this point, however, the*

▲ **10** *Now we return to Richard framed as a mid-shot. As you can see, he was very aware of the camcorder. The background clearly shows the setting.*

▲ **11** *Scenery will probably feature heavily in most footage of foreign travel. It only takes a second or two to frame an image to produce a pleasing shot such as this.*

▲ **12** *If you want to prevent a child playing up to the camera, then give them a distraction. A simple scene of a young boy eating ice-cream can bring back a flood of memories in years to come.*

▲ **13** *If you are finding unselfconscious images of your children difficult to capture, try taping them when they are asleep. It might be the only time they look this angelic.*

▲ **14, 15** *Gradually the tape is moving away from featuring Richard by himself. Here, there is some good, natural footage of him playing in the garden with the family's dog. Like the ice-cream in the earlier frame, the dog acts as a distraction and takes his mind off the camcorder.*

Another thing to bear in mind is that video footage of things such as the family dog might not seem significant while it is still alive and with you. When you look back at this tape in perhaps 20 years, images of a much-loved family pet may be far more precious than you can imagine right now.

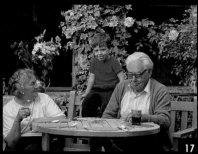

▲ **16** *This sequence ends with a low-angle shot that conveys the child's viewpoint.*

▲ **17, 18** *We cut now to another garden scene, but this time showing Richard's grandparents. The camcorder has been left running to record their conversation. Sequences of relatives and friends form an* important element in any family video diary.

▲ **22** *A zoom out reveals her standing by his side pointing out something in the musical score.*

▲ **23, 24** *The theme of hobbies continues, but now featuring Richard's mother, Sarah, working on a portrait. Video is an ideal medium for showing, in an abbreviated form, the different stages of* something like a painting being created. A cut to a close-up of Sarah's hands shows her putting the finishing touches to her picture.

▲ **28** *As the music continues, the scene changes to show Sarah involved in another traditional Christmas pursuit – decorating the tree.*

▲ **29, 30** *Back to Richard now, to reveal him in mid-shot doing his share of the preparations – writing out his Christmas cards. After a cut in on a detail of one of* the cards, the image cuts to a tighter shot of him sealing the envelope.

▲ **19, 20** *Hobbies are a favourite subject for the camcorder, and here Richard wrestles with the intricacies of the scales on his recorder. Because continuous sound is important for this type of material, and* it is vital that finger movements match the music, the whole sequence was recorded continuously. The scene starts from a wide shot and then slowly zooms in on a mid-shot that concentrates on his hands.

▲ **21** *At a convenient break in the music session, the camcorder was moved to look over Richard's shoulder at the sheet music in front of him. The hand pointing to the music is that of Richard's mother.*

▲ **25** *The next stage, the mounting process, has been recorded in mid-shot, which shows enough of the general subject and of the detail for it all to make sense to the viewer.*

▲ **26** *Sarah is obviously pleased with the end result, as you can see from the smile on her face.*

▲ **27** *A change of scene now, and the beginning of the Christmas season is heralded by a shot of a traditional advent calendar. Snippets of Christmas music can be heard.*

SOUND ADVICE *Most situations can be accommodated by an on-camera mike. If you wanted to feature a lot of conversation, however, then it might be a better idea to use a directional mike mounted on a stand.*

For footage of, say, a sports event, you might want to take a separate cassette recorder to record wild track sound that can later be dubbed over your edited footage.

Apart from live sound, you might want to mix in some music appropriate to the visuals – Christmas carols for Christmas shots, the Wedding March when showing wedding photographs, and so on. Make sure you gently fade the music in and out as required.

One further sound possibility is the addition of a commentary. This should always complement the pictures, not overpower them.

Black-and-white blurs and even scrapbooks full of colour photographs are a thing of the past. Today's happy couple *must* have video souvenirs of that special day. But how you should tackle a wedding video depends on whether you are asked to be the main photographer or you are simply one of the guests trying to grab some entertaining footage.

As one of the guests, you can concentrate on the more lighthearted aspects of the day –

- **Scouting for camera positions**
- **Organizing permissions**

Wedding

telling shots of the bride and groom, or the guests, in less guarded moments. If you want to try for material during the ceremony itself, check to make sure camcorders are allowed.

Even if the tape is just for fun, it is still a good idea to record the set pieces, such as throwing the confetti and cutting the cake at the reception. This type of shot does require a fair amount of organization, however. A simple way around this is to tag along with the official still photographer. Once everybody is arranged for the shot, you will have a perfect chance to shoot some tape from the sidelines.

THE PRO APPROACH If you are taking on the role of main photographer, then bear in mind that the finished tape needs to contain all the elements the bridal couple think are important. And the only way to find this out is by talking it over with them beforehand. After your meeting, draw up a suggested shot list and make sure they see it in plenty of time to make any amendments.

Other vital information you will need is the address of the ceremony and the reception. Make a careful note of the starting times of both, and try to look over the sites prior to the wedding to preplan shots and lighting.

THE PROJECT The coverage of this traditional white wedding began with the arrival at the church. The reception was held at a different location under the cover of a large marquee. The tape ends with the couple's departure in the afternoon for their honeymoon.

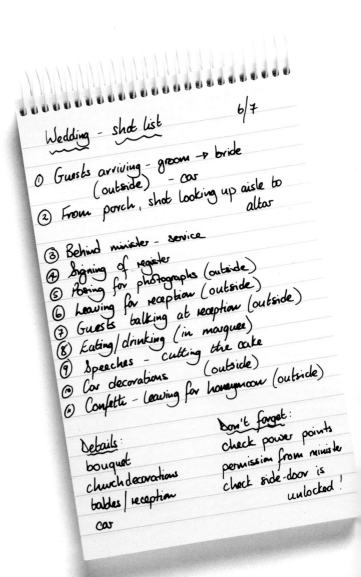

Wedding - shot list 6/7

① Guests arriving - groom → bride
 (outside) - car
② From porch, shot looking up aisle to altar
③ Behind minister - service
④ Signing of register
⑤ Posing for photographs (outside)
⑥ Leaving for reception (outside)
⑦ Guests talking at reception (outside)
⑧ Eating/drinking (in marquee)
⑨ Speeches - cutting the cake
⑩ Car decorations (outside)
⑪ Confetti - leaving for honeymoon (outside)

Details:
bouquet
church decorations
tables/reception
car

Don't forget:
check power points
permission from minister
check side-door is
 unlocked!

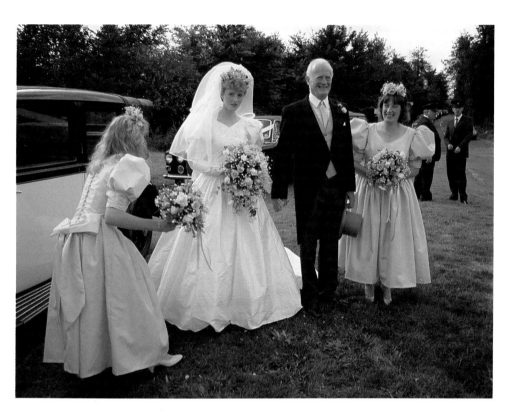

WEDDING DO'S AND DONT'S *This is probably one of the most important days in the life of the bridal couple. Your tape should reflect the happiness of the occasion and over all the major highlights of the ceremony and reception in a relaxed and unobtrusive fashion.*

● *Do make sure you have spare video tape and battery packs.*

● *Do make sure you have a spare video light bulb.*

● *Do allow plenty of travelling time.*

● *Do interfere with the proceedings as little as possible and keep your footage natural.*

● *Do get as many shots of people laughing as possible.*

● *Don't move around inside the church during the service.*

● *Don't get in the way of the official photographer during any of the set pieces.*

● *Don't position an off-camera microphone where it may be brushed against or kicked.*

● *Don't forget to draw up a list of all the key shots you want to record.*

◄ ► **PLANNING THE EVENT** *Make careful notes of both the equipment you plan to use and the sequence of events. If you have been able to visit the wedding locations before the big day it should be possible to make some preliminary decisions on the best positions from which to shoot.*

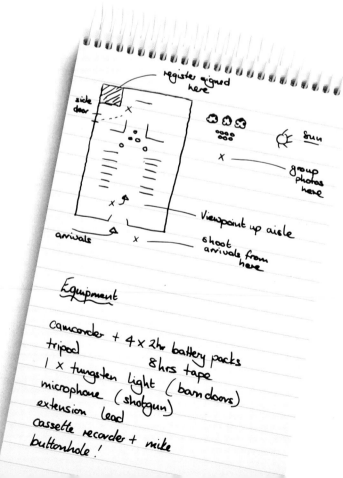

register signed here

side door

group photos here

sun

Viewpoint up aisle

arrivals

shoot arrivals from here

Equipment

Camcorder + 4 x 2hr battery packs
tripod 8hrs tape
1 x tungsten light (barn doors)
microphone (shotgun)
extension lead
cassette recorder + mike
buttonhole!

Our Wedding

MICHELLE COLE
SIMON BROWN

July 15 1992

▲1 *The titles could include an engagement photograph, or an invitation card filmed in close-up.*

▲2 *The bridal bouquet or floral decorations inside the church can make a very successful background for scrolling or static genlocked titles. If you don't have access to a computer, use rub-down lettering over a photograph.*

▲3 *The arrival of the key players is an important element. Here, the groom, best man, and ushers are seen in wide shot arriving at the church.*

CAMERA POSITIONS *If you want to get the set pieces just right, then try to scout the location before the wedding day. For the shots of this wedding, the most important camera positions are noted on the diagram.*

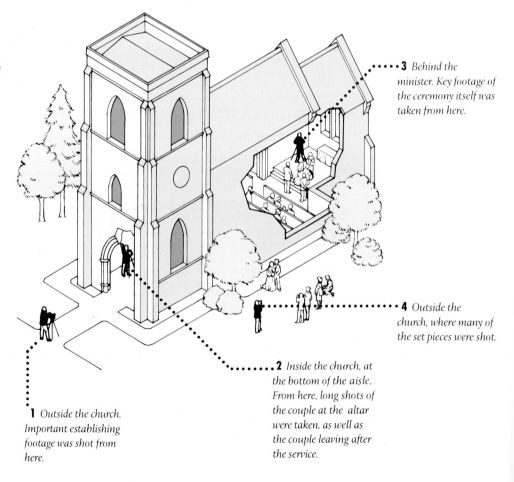

3 *Behind the minister. Key footage of the ceremony itself was taken from here.*

4 *Outside the church, where many of the set pieces were shot.*

2 *Inside the church, at the bottom of the aisle. From here, long shots of the couple at the altar were taken, as well as the couple leaving after the service.*

1 *Outside the church. Important establishing footage was shot from here.*

112

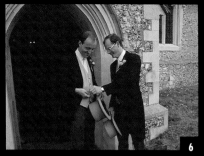

▲ **4** *In this shot, the camera was in fact static. Visual variety has been created simply by allowing the party to grow larger in the frame as they approach and then pass the camera position.*

▲ **5, 6** *This type of scene is great if you can record it. We all realize that the wedding day is a nerve-racking affair, so images of the groom and best man checking their watches are excellent. The camcorder was*

reasonably close to the pair and was shot with the zoom on moderate telephoto. This allowed the camera-mounted mike to pick up their comments to each other.

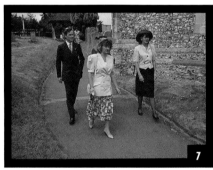

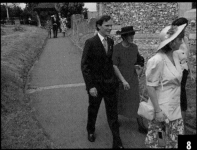

▲ **7, 8** *To maintain the visual flow and continuity from the last shot, the camera was kept rolling outdoors to record the arrival of some of the guests. The object was to include members of both the*

bride and groom's family arriving before the service. Note the camcorder position and angle here is the same as that used for the arrival of the groom earlier on.

▲ **9** *A cut here to an establishing shot of the interior of the church provides a means of conveying the passage of time while we wait for the ceremony to start.*

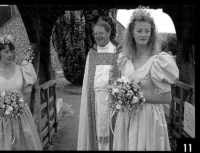

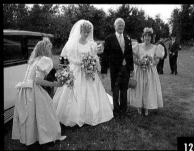

▲ **10** *When the bridal car is as spectacular as this, make sure it features in the coverage.*

▲ **11** *A quick cut to the minister and bridesmaids waiting for the bride to emerge heightens the sense of expectancy.*

▲ **12** *The bride finally appears. Linger a little while on this key shot.*

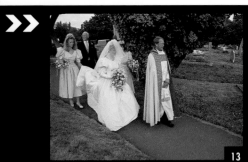

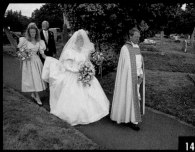

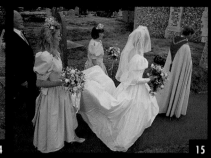

▲ **13-15** *These three shots show the bride, her father and bridesmaids, and the minister processing into the church. The camera pans to keep them in shot. Note* *that they enter the frame at the extreme left, but the pan lags behind just a little as the shot develops so that they exit at the extreme right of the frame.*

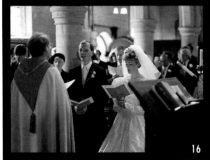

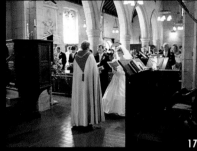

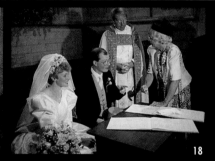

▲ **16, 17** *The church had been well surveyed before the wedding day to select this position – looking over the minister's shoulder at the couple's faces as they recite their vows. Zooming back partway* *through the shots helps to open out the image. Before attempting to shoot from an angle like this, make sure you get permission from the minister and the bridal couple. Try not to be obtrusive.*

▲ **18, 19** *By the time it came to signing the register, much of the tension of the occasion had been dispelled, and there was more flexibility to move around looking for the best angles. With the minister's*

▲ **22, 23** *To give variety of shots and framing, the larger groups framed in mid and long shot were inter-mingled with close-ups of smiling and laughing guests.*

▲ **24-6** *A panned sequence of family and close friends with the newly-weds centre stage is always a popular shot. Pans like this need to be smooth and slow so that every person is on screen long enough to be recognizable and be seen to be reacting. Everybody was roughly the same distance*

SOUND ADVICE *Sound from an on-camera mike can often be less than satisfactory when heard on playback. Because of this, it makes good sense to use an off-camera mike during the actual service and, later, at the reception for the speeches from the head table. A hand-held mike is also useful to encourage some of the guests to talk directly to camera.*

As well as the microphone itself, you will need around 18-20 feet of microphone cable, a small microphone stand, and a set of earphones (cans). However, unless you intend to monitor the sound quality, an off-camera microphone may not be worth the effort. If it is a windy day, consider using a microphone muff to reduce unwanted noise.

permission, a camcorder-mounted video light was used here to boost light levels. An important part of this coverage was a well-posed composition of the couple with the register.

▲ **20** *Before cutting to the first of the posed shots outside the church, the videographer included some candid coverage of the guests waiting, cameras in hand.*

▲ **21** *If your coverage is from a guest's point of view, then you won't want to copy the same camera positions as those of the official still photographer .*

 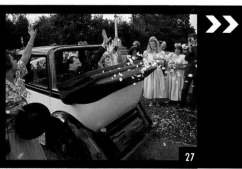

from the camcorder to prevent the autofocus from shifting focus position partway through the camcorder movement, which is always a distraction.

▲ **27** *This was a key linking shot between coverage at the church and that to follow at the reception. The camcorder was kept rolling to capture the confetti raining down and the cheering guests added a noisy and appropriate sound track.*

▲ **28-30** *After the formalities at the church, the informal, candid coverage at the reception made a welcome change of pace. Lots of smiling guests, drinks in hand, helped to establish the mood and there was plenty of opportunity to show the bride and groom relaxed and mingling with family and friends.*

▲ **31-33** *Once all the guests were seated ready for their meal, it was possible to carry out a slow pan. Not only did this help to ensure everybody was seen somewhere on the tape, it helped to give a feel for the size and atmosphere in the marquee.*

SHOOTING FOR EDITING *Editing can be a time-consuming affair. If you bear this in mind while you are recording, and edit in camera as much as you can (see Basic editing, page 80), you will save yourself a lot of post-production headaches.*

Do remember to shoot some footage that will make a suitable background for titles — the establishing shot of the location, for example. Be sure to monitor the sound carefully as it is recorded so that you don't have to overcome too many problems of sound continuity as part of the editing process.

Develop a rhythm to the length of your candid shots: look for smiles, ignore the ordinary, and try to notice what is happening in every direction at once. To save editing time, if you have recorded some footage you are certain you do not want to keep — perhaps you pressed the record button by mistake — rewind to the beginning of that scene and record over it again.

LIGHTING *Lighting can be a real problem. A manual iris, or at least a backlight-compensation control, is a great advantage. During the ceremony it is usually not possible to set up additional lights and your choice of position may be limited. Your only option might be the iris control, and if this is not enough, then you might have to accept the couple appearing in silhouette. During the reception speeches, if the subject is framed by a bright window, you may need to open up the iris as well as close the curtains. You may also decide to use additional lighting to bring out detail in the faces.*

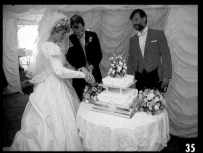

▲ **34** *With only a minor change of position, it was possible to zoom in to the top table for the speeches. Framing both the bride and her father allowed the inclusion of charming reaction footage.*

▲ **35, 36** *At the reception there are some aspects you simply can't omit – and cutting the cake is definitely one of them. It is best to arrange with the couple to give you a bit of notice so that you can get into position in advance. Here the shot opens with a wide shot, with the bride and groom holding the knife poised and ready to cut. Next, the shot zooms in to a close-up so you can see clearly both hands on the knife.*

▲ **37-39** *As well as the solemnity of the church service, a wedding tape needs to show the fun of the occasion. One of the traditional finales to the reception is decorating the car and the final throwing of confetti as the couple leave on their honeymoon. In order to ensure proper coverage at this point, the camcorder was hand-held. This maximized the opportunities for the last shots of the couple. Using a tripod here would have meant keeping the guests away for a clear shot of the couple, and this would have been unpopular with everybody. If the camcorder is jostled a bit at this stage, it really doesn't matter all that much.*

Birthday parties are potentially chaotic, with lots of noise, activity, and unpredictable behaviour. Unless you simply want to produce something resembling a movie scrapbook - a collection of unconnected snatches of sound and vision - preplanning is vital.

The first thing to decide is the running length of the finished tape. There are no rules here, but if you think in terms of a film between 12 and 15 minutes long, you won't be

- ● **Low level viewpoints**
- ● **Looking for the unexpected**
- ● **Continuity of sound track**

MAKING A VIDEO 4

Children's party

far off. For many projects, a storyboard would be your next step, but this implies a degree of intervention not appropriate here. But don't despair - a shot list will serve your purposes (see Pre-production planning, page 51).

In many ways, filming children is easier than working with adults because children are likely to be less self-conscious. Make sure you tape spontaneous action. Set your lights in advance. Then you can move about freely with your camcorder without encountering deep pockets of shadow or blinding highlights. Wherever you decide to place your lights, they should be suitable for the angles from which you want to shoot the set pieces, such as the cake cutting or the present opening. To suit both requirements in an average-size room, you should install the largest-sized bulbs your ceiling and side lights will accept without exceeding the maker's recommendations. If you have 500-watt photofloods, then use these angled at the ceiling, so that they reflect an overall, even lighting effect.

THE PROJECT For this tape of an eight-year-old girl's birthday party, it was decided to begin with the arrival of the first guests. A clown was there to entertain the children, which provided plenty of opportunity for good reaction shots. The setting in a conservatory offered some technical problems because of the reflective windows all around and the possibility of mixed lighting sources (see Adding light, pages 30-3).

PRE-PLANNING
Decide on the key events of the party from guests arriving to their departure. Include also notes on camera angles, lighting and sound. Also be sure to make a list of the equipment you intend to use including lights, spare batteries, tripods, etc.

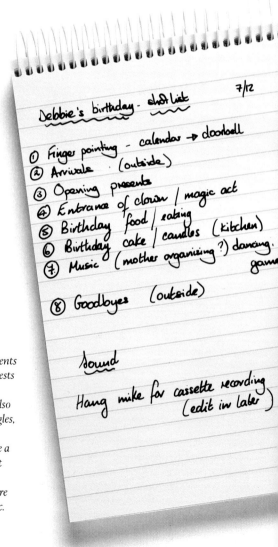

Debbie's birthday - shot list 7/12

① Finger pointing - calendar → doorbell
② Arrivals (outside)
③ Opening presents
④ Entrance of clown / magic act
⑤ Birthday food / eating
⑥ Birthday cake / candles (kitchen)
⑦ Music (mother organising?) dancing. game
⑧ Goodbyes (outside)

<u>Sound</u>

Hang mike for cassette recording (edit in later)

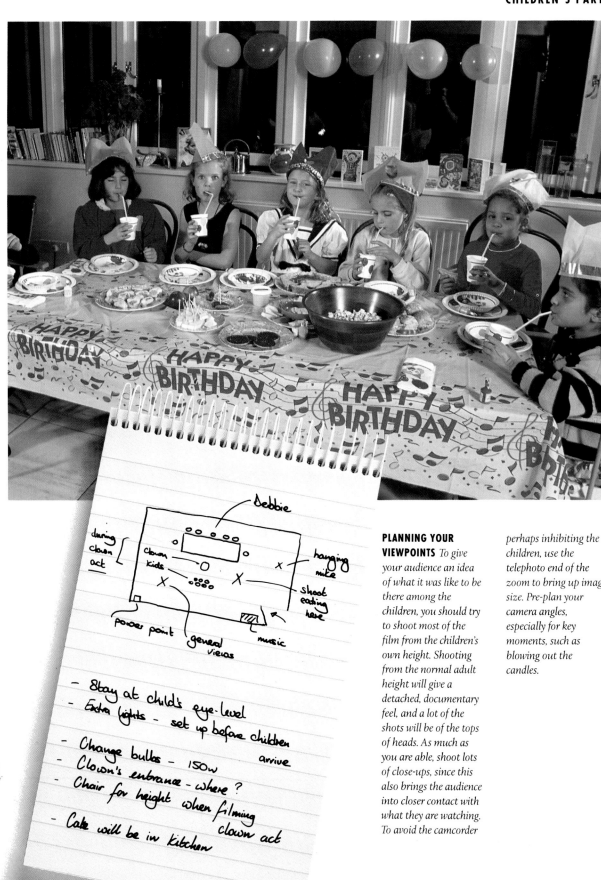

PLANNING YOUR VIEWPOINTS *To give your audience an idea of what it was like to be there among the children, you should try to shoot most of the film from the children's own height. Shooting from the normal adult height will give a detached, documentary feel, and a lot of the shots will be of the tops of heads. As much as you are able, shoot lots of close-ups, since this also brings the audience into closer contact with what they are watching. To avoid the camcorder perhaps inhibiting the children, use the telephoto end of the zoom to bring up image size. Pre-plan your camera angles, especially for key moments, such as blowing out the candles.*

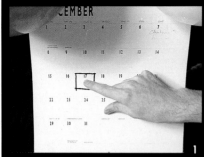

▲ **1, 2** *These two images were chosen because the hand on the bell closely matches the size, direction, and placement of the finger pointing to the calendar. The*

intention was to surprise the audience, as one dissolved into the other.

▲ **3** *The birthday girl opened the door in response to the bell. An on-camera mike picked up greetings. The decorations in shot open the story without need for dialogue.*

▲ **8** *A reaction shot such as this could be held for about 5 seconds, if the expression is natural. When framing a close-up, remember to allow for looking space (see Composition, page 56).*

▲ **9** *This close-up of three children was designed to record their excitement, although at this stage the film's audience doesn't know what the cause of it might be.*

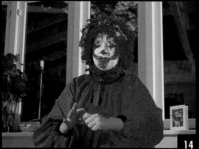

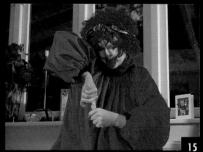

▲ **13** *The intercutting between the entertainer and the children's faces, as well as the changes in shot size, move the story along and create visual variety and interest.*

▲ **14** *With the focus now on the entertainer, it is important that the audience can see what she is doing, so this was shot in close-up to show a trick being performed.*

▲ **15** *Not too close, however. If this shot had zoomed in any tighter, it might have been too revealing of how the trick was achieved and spoiled the magic of the illusion.*

▲ 4 *A zoom was used for a medium close-up of the girl's reactions. A cut would have chopped out some of the live dialogue being recorded.*

▲ 5-7 *With the camcorder indoors, it became possible to pick out groups of children before things became too crowded.*

▲ 10 *All is revealed – the entrance of the entertainer. The zoom-in adds impact to her entrance, though the zoom movement is less obvious because there is movement in the frame.*

▲ 11 *After the entertainer's entrance, this reaction shot was demanded as part of the narrative.*

▲ 12 *This shot is a matching reverse shot showing the entertainer from the children's point of view.*

▲ 16 *A zoom out and then back in again was used here to imply some eavesdropping on a conversation between the entertainer and child.*

▲ 17 *A change of shot size here is designed to create a sense of expectation about what is going to happen. And the change in angle heralds a new trick.*

▲ 18 *This cut to a two-shot shows the trick in just the right amount of detail. The sound of applause signals that the performance is finished.*

▲ **19** *This image acts as an establishing shot showing the children seated around the table and ready for their birthday food.*

▲ **20, 21** *This cut is a closer shot to show the children on the right of the table…followed by a similar cut to show*

those on the left. Cutting between shots is usually better than panning or dollying, as long as sound continuity is not important.

▲ **25** *This scene was vital, since it captures one of the highlights of the occasion – the candles on the birthday cake being lit.*

▲ **26, 27** *The camcorder moves in closer…and closer still to show the girl preparing to blow out the candles. It is tempting to move into a big close-up for a scene such as this. But by holding back a little, the other children and their reactions*

are also in shot. The sound accompanying the visuals is the children singing Happy Birthday.

SOUND ADVICE *You can treat such sounds as the door chimes and the noise of wrapping paper as sound effects. Record them before the party and dub them on later. If you record them live, position the microphone close-up so that the sound is clear and does not become lost in the general background clutter of noise.*

Record important background sounds such as music separately. Not only will this give cleaner reproduction, but you will avoid the problem of the music being discontinuous when you cut from one shot to another, or stop taping for any reason. Conversation is best recorded directly onto the videotape, however,

since this avoids lip-synchronization problems.

▲ **22-24** *These cuts between a series of close-ups and two-shots show the children enjoying themselves (and the food). At the editing stage, these can be intercut with longer sequences, if that is preferred.*

▲ **28** *This shot marks another change. One of the parents is seen selecting a record, which means that the party is entering a new phase.*

▲ **29, 30** *This long lead-in shot in the conservatory shows the children responding to the music and now the action is all to do with games and dancing. Shorter takes*

from a variety of angles convey the sense of activity and increase the pace of the film as the party builds toward its end.

▲ **31** *Stay alert for spontaneous footage, such as here – the birthday girl dancing. A shot like this easily rates as a key shot in the tape.*

▲ **32** *Now there is a complete change of pace and scene. This signals in every way that the party is over.*

▲ **33** *A nice visual trick here as the camcorder pulls back to reveal the birthday girl waving goodbye to her friends. The perfect concluding sequence.*

Many camcorder owners try their hand at producing a piece of pure fiction – a mini-drama of some sort. This is great, since it is an excellent way of putting into practice many of the disciplines and techniques dealt with in this book.

DEVELOPMENT Once you have worked on the basic concept of the drama, the next step is to make a detailed storyboard. This will show you how the action is meant to develop and

- **Making a storyboard**
- **Working on location**
- **Telling a story**

Woman, kids, bike wave goodbye avoid foliage away - woman view. Sound

shot to cor with mug standing

4 MAKING A VIDEO

Mini feature film

give a good indication of shooting angles, as well as indicating the personnel involved, including technicians and actors.

After the storyboard stage comes the shooting script which helps you to organize production efficiently. With a shooting script, you will be able to schedule consecutively all the scenes involving the same people in shot, no matter where the scenes will be edited into the final tape.

Once you have come this far, it is essential to have a dry run. Go through the scenes a few at a time before shooting, to work out the best way for the actors to approach their roles, where they will stand, and the positions they will move to. The last two points enable focus to be determined, lights set, and microphones positioned. At this stage, discuss any dialogue and make sure everybody feels happy with what they will be doing.

THE PROJECT Our feature has a simple plot: a woman out for a walk has her handbag stolen. Although only a short, four-minute mini-drama, the piece is well-paced, with plenty of variety in framing and rapid cutting from shot to shot. To increase the tension, deliberately exaggerated shooting angles have been employed, and to keep organization simple, only five actors were involved. Everything was shot at the same location. There was a camcorder operator, a combined lighting-and-sound person, and a director.

RESEARCHING YOUR LOCATION

- *Keep in mind lighting conditions during different parts of the day. Make allowances for the movement of the sun and the varying shadows it casts.*

- *Find out if your location is less busy at certain times of the day/week.*

- *Are there likely to be any inherent sound problems with the location — airplane flightpath, for example.*

- *Have an alternate location in mind if bad weather forces you to abandon the location for the day.*

- *Do actors require changing facilities?*

- *Do you need mains power?*

- *Is the owner's permission necessary before filming at the location (this includes in public parks)?*

- *If there will be noise or smoke associated with the filming, gain the co-operation of those who will be affected.*

Bench. Woman reads – compose shot. rule of thirds. Calm and peaceful.

W. S. up steps. Dolly up? Hill Garden. Woman's footsteps – her point of view. show plaque.

M.S. dark undergrowth. Mugger behind tree – rustling sounds. She walks past – tension.

Woman on bench – looks at watch. Worried. Zoom to C.U. of watch.

Mugger enters right, she turns, they struggle, he grabs purse. Sound footsteps, scuffle, scream.

Top of stairs looking down on kids, mugger runs down, passing them.

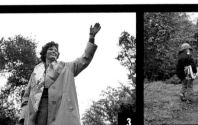
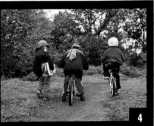

C.U. foot on skateboard – Crash!

Kids run down + sit on him. woman follows. picks up purse. END.

◄ **MINI FEATURE STORYBOARD** *When planning a mini feature of this type, it is not necessary to create a complex storyboard. Use it to develop a rough outline of the action, and to make notes on sound track and camera angles.*

▲ 1 *The opening wide shot is set up to give an indication of the location, and it also introduces some of the players.*

▲ 2 *Cut to mid-shot of kids starting to turn away and cycle off. The sound of their voices is increased here to enhance the normality of the scene.*

▲ 3 *The long angle of this shot of the woman waving good-bye to her children shows her against the sky.*

▲ 4 *The kids are now seen from the woman's point of view, as they ride off. The soundtrack quietens as they become smaller in the frame.*

THE HILL GARDEN

▲ 5 *A wide shot shows more of the deserted park. Little by little, the sound of birdsong is increased to indicate a peaceful, pleasant atmosphere.*

▲ 6 *Don't keep the main character out of shot for too long. Here, she is reading in mid-shot. She is framed according to the rule of thirds.*

▲ 7 *A change of scene. A low angle, looking up a flight of stairs. The sound track is of the woman's footsteps.*

▲ 8 *This close-up indicates that she is starting to explore other parts of the park. The birdsong has now stopped.*

9

10

11

12

▲ 9 Not only are the woman's footsteps heard coming closer as she walks up the steps, she can now also be seen. The line of her movement runs diagonally, thus continuing the visual flow of the previous shot.

▲ 10 The cut to a medium shot shows a tangle of trees and undergrowth, and a fleeting figure is glimpsed. The sound track is of the woman's steps and an ominous rustle of leaves.

▲ 11 The previous, darkly lit scene contrasts well with this one, with the woman shot in mid-shot framed against the sky, moving left to right.

▲ 12 We cut back to a dark scene of the stranger peering out from behind the trees. The woman's footsteps are growing fainter as the man starts to move decisively.

17

18

19

20

▲ 17 Cut for impact to a close-up of her watch. This indicates there is a note of urgency about the lateness of the hour.

▲ 18 Cut back to a wider shot of the woman's head and shoulders in profile as she turns to call for the kids. She is still at the extreme right of the frame with plenty of space to indicate the size of the park.

▲ 19 A close-up of the mugger. This telephoto shot has knocked the background out of focus, concentrating attention on the face. The sound track is of the woman calling the kids.

▲ 20 A quick cut to an extreme close-up, taken from exactly the same angle as the last. His intentions are unmistakable as his eye stares out of the screen.

25

26

27

28

▲ 25 The camera tracks the action toward the left, where we see the purse wrenched from the woman's hand. The sound track has her screaming accompanied by the noise of feet scuffling.

▲ 26 A cut to a wide shot of the children coming up the stairs. The sound of screaming can still be heard, together with racing footsteps. The children's faces show alarm.

▲ 27 The mugger races past the camera and starts down the steps, where he pushes into the group of children. The scene ends with the mugger seen stepping on the discarded skateboard.

▲ 28 A quick cut to a close-up of the mugger's foot on the moving skateboard. The line of movement is top right to bottom left.

▲ **13** *He has now moved out of the undergrowth and is creeping along the path. Only the right half of his face is lit, showing that he is staring at the woman (out of shot).*

▲ **14** *This shot is important since it is the first showing the man and his intended victim at the same time. Dynamic diagonals lead the eye to the woman.*

▲ **15** *The next shot shows our main character sitting reading a magazine, with a well-framed view of the park as background. Framing the shot with the columns makes a strong composition.*

▲ **16** *She pauses in her reading to check her watch. Her frown indicates that she has now become concerned about the time.*

▲ **21** *The cut to the woman's handbag in the context of the previous shot leaves the audience in no doubt that it is this that he is staring at so intently.*

▲ **22** *An extreme low angle has the mugger appearing strong and menacing.*

▲ **23** *The woman is now standing by the column where she was previously seated, looking for the kids. Behind her in the misty background the mugger draws nearer and starts to break into a run.*

▲ **24** *As the mugger's footsteps become louder the woman starts to turn towards the noise. The assailant now grabs her handbag.*

▲ **29** *A wide shot of the attacker losing his balance and falling (movement still right to left). The clatter of the skateboard on the stone steps and the mugger's cries of alarm reinforce the drama.*

▲ **30** *This mid-shot of the body of the fallen thief forms a triangle that echoes the composition of the remainder of the final scenes. The stolen purse is prominently featured.*

▲ **31** *A slightly higher and wider viewpoint shows the group of children pouncing on the mugger. The woman victim makes an entrance at the apex of the triangle and retrieves her handbag.*

▲ **32** *Relief is expressed in the children's voices as well as in their happy faces. The urgency of the woman's pose in the foreground indicates that she wants them out of the way of the fallen, but still potentially dangerous mugger.*

At first glance, taping a stage drama seems pretty straightforward. After all, the action is confined to the small area of the stage and all you need to do is point and shoot. Well, this is only partly true.

Perhaps the biggest problem is lighting. Stage lighting, while adequate for our very adaptable eyes, usually is a mixture of bright pools of light and deep shadows. A camcorder confronted with this high-contrast scene will

MAKING A VIDEO

Stage play

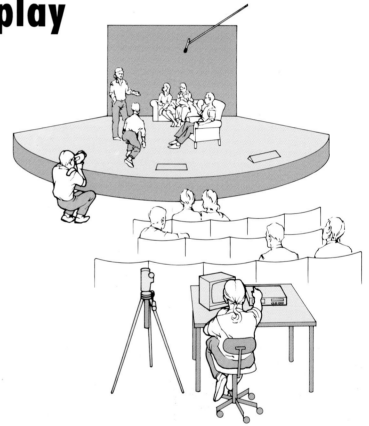

cause the highlights to burn out and shadows to become dense and featureless. Once you move into close-up – on an actor's face, for example – the camera's autoexposure should be better able to cope, but when in mid- or long-shot you will have to put up with less-than-perfect exposures.

USING TWO CAMERAS While you can make a perfectly adequate recording using one camera, a much better result becomes possible by working together with somebody else who can video from a different viewpoint.

A two-camera shoot does not entail too many problems when taping a stage play. It helps if you and the other operator have seen the play so that you can preplan which shots each will concentrate on.

The major potential hazard is that of crossing the imaginary line dividing the stage. What you cannot do is position one camera to the left and the other to the right of the stage. If you do, when you cut between them, action moving left to right (or an eyeline looking left to right) will reverse itself. The way around this is to set up one camera centre stage at the rear of the theatre, so that it is taping virtually on the line.

THE PROJECT The production shown here is a contemporary play, with a very spartan set. The interest relies heavily on the storyline and acting of the cast. Without impressive sets to look at, viewers have only the action to draw their attention and engage their imagination.

CAMCORDER POSITIONS

In a two camcorder shoot of a stage play, one camcorder should be in a fixed position at the rear of the theatre so that it takes in virtually all of the stage. If the action moves out of shot, it can pan left or right slightly to *follow it. The second camcorder is mobile, taping close-ups and mid-shots from either side of the stage. Action missed by this camcorder as it changes position, or potentially confusing footage recorded from the left and then from the right of the stage, will be* *covered by footage from the first. The fixed camcorder can be linked to a small monitor, which will make checking focus and framing easier than concentrating on the viewfinder for the length of an entire performance.*

▲ 1 *The video opens with an establishing shot taken by the central, main camcorder (camcorder 1). The foreground character is slightly overlit, but this is something you cannot control in these circumstances.*

▲ 2 *In this scene, camcorder 1 zoomed in tighter on the action. The ghosts of the main character's dead family have stepped down from the rostrums, become real, and confront him.*

▲ 3 *Camcorder 1 zoomed in to its maximum magnification to bring a sense of intimacy. In this telephoto shot, the operator had to be careful to control the tripod head so as not to introduce any wobble to the image.*

▲ 4 *This somewhat indecisive pull-back is not different enough from the last frame and runs the risk of drawing attention to itself.*

▲ 5 *In this first show from camcorder 2, the operator crouched down at the front of the auditorium. The medium close-up conceals the fact that the main character is leaving the table and another has sat down.*

▲ 6 *Back to camcorder 1 to re-establish the three players and to confirm the geography of the set. Since there is interaction between all three players, it was best to have them all in the frame.*

▲ 7 *Camcorder 2 taped a scene here of the main character's grandparents arguing about him as they take their places on the rostrums.*

▲ 8 *Camcorder 1 recorded the character's father, dramatically lit by a spotlight. The scene was kept to this single-character framing to keep attention concentrated on the speech he was delivering.*

▲ 9 *The cut here to camcorder 2 is for a close-up two-shot of the son and his mother. Framed in close-up like this, the shot contributed to the emotional intensity of the scene.*

▲ 10 *This is the same shot as before, but zoomed back to become a three-shot and show the father's changed position on the stage. If the viewer cannot see people moving about, characters will appear to materialize out of thin air.*

▲ 11 *This cut to a wide shot from camcorder 1 was dictated by the need to include dialogue between all of the characters.*

▲ 12 *The final shot is from camcorder 2, as the operator crouched down once more at the front of the auditorium. The character is talking directly to the audience bringing the play to an end.*

A video of the sights and sounds of a family holiday can preserve all those fabulous memories, so that they can be relived and enjoyed time and time again. And one of the best things about taping in a new city, town, or countryside is that your eye is fresh. You are so acutely aware of being somewhere else that you become aware of a variety of interesting new shooting angles, all bathed in a quality of light very different from that back home.

- **Using a tilt shot**
- **Picking out landmarks**
- **Using filters**

MAKING A VIDEO 4

Travelogue

COHERENT RECORD You will not want your time dominated by the need to shoot videotape, but it takes surprisingly little effort to produce short sequences that sum up the flavour of a location. Shoot just a few well-planned sequences rather than a lengthy tape of snippets without coherence or a story to tell.

When you come across a scene you want to record, take a few minutes to look around you. Plan your video coverage. For example, if there is a panoramic view to be shot, determine where you want the camera to start and to finish, to avoid unsightly images. If the pan takes in objects at different distances from the camera, switch to manual focus. This will stop the autofocus system adjusting the focus throughout the shot, ruining the scene.

After you arrive at your destination, walk around the general area in which you wish to film. Find the positions that best capture the particular charm and personal appeal of the place. Keep alert to unusual shooting angles. And so your audience knows exactly where you are, look out for visual icons that are associated with your location - shots of the Opera House in Sydney or the Statue of Liberty in New York.

THE PROJECT This project starts with a record of a trip down the West Coast from Oregon to California. There then follows a sequence showing a visit to Venice, Italy, and finally Sydney, Australia. The challenge is to produce an entertaining video of basically static subjects.

CHOOSING YOUR VIEWPOINT
Look for viewpoints that add impact to your subjects, angles that make the audience sit up and take notice. In this shot of New York's Statue of Liberty, a low camera position looking up at the statue utilizes a trick of perspective known as converging verticals, in which lines seem to come together as they recede into the distance. Another compositional device used in this shot is the rule of thirds. This states that objects positioned one-third in from the frame edges have added impact.

.U.S.A.
WEST COAST RUN
Route 101

▲ 1 *Titles shot using a rostrum camera. They could also include a map of the route taken, before dissolving into the opening shot.*

▲ 2 *For this spectacular opening shot, the camcorder was positioned at a point overlooking a bend in the River Umpqua, Oregon, which leads the viewer's eye into the landscape.*

▲ 3 *From the opening high angles, the camcorder has descended into the valley. This was framed as a wide shot and shows elk grazing peacefully.*

▲ 4 *This is the opening image from a classic tilt shot. The figure standing at the base of a giant redwood is important to lend scale.*

▲ 5, 6 *The tilt continues, slowly revealing, frame by frame, the towering height of these ancient and mighty trees. Having reached the top of the tree canopy, the shot is held for a few seconds to let the size sink*

into the audience before ending the recording.

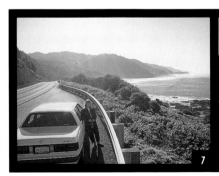

▲ 7 *To signal the change from one location to another, a car and travelling companion image was used.*

▲ 8 *A polarizing filter was used to darken the blue of the sky and sea. Avoid zooming when using a polarizer, since the lens turns during the zoom and affects the orientation of the filter.*

▲ 9 *This atmospheric shot was carefully framed so that the horizon didn't cut the image in half. It started as a wide shot followed by a very slow zoom.*

VENEZIA

▲ **1** *This title was accompanied by operatic music to set the scene of a trip to historic Venice.*

▲ **2** *A high viewpoint from a tall building was chosen for the opening scene. The shot is initially tightly framed, using the telephoto end of the zoom.*

▲ **3** *This shot progresses as the lens is zoomed out slowly, gradually showing more of the building.*

▲ **4** *While the zoom continues, a slow pan to the right commences. In this way, one camera movement is masked by the other and does not draw too much attention to itself.*

▲ **9-11** *This cut was justified by the last scene. The tilt starts off at the top of the Bell Tower and slowly travels down to its base to bring us into St Mark's Square itself.*

▲ **12-14** *Now begins a visual exploration of this most famous square. Very gently and smoothly, the camcorder begins to pan and zoom in on the colonnaded façades that line St Mark's.*

▲ **17** *A wide shot reconnects the scene to St Mark's Square, where sailors are lined up to have their picture taken. This supplies a good thematic link to the next scene.*

▲ **18** *On the waterfront, a sign proclaims that gondolas are for hire, setting the scene for a canal journey.*

▲ **19** *The footage from this point is all taken from aboard a gondola as it moves along the Grand Canal.*

▲ **20** *Here the videographer was lucky to witness several gondolas in a race. For extra stability, the camcorder was mounted on a shoulder pod.*

▲ **5, 6** *As the pan continues across the lagoon, more and more of the distant outline of the city is revealed.*

▲ **7, 8** *The pan finishes with a famous landmark of Venice centrally framed – the Bell Tower of St Mark's Square and, to its right, the Doges' Palace.*

This shot was held for a few seconds before a slow zoom concentrating on the Bell Tower as the Palace slips off the right of the screen.

▲ **15, 16** *Cut to a scene of children feeding pigeons. After the long series of wide shots, a well-composed close-up such as this is about due. It is also good to see people featuring in the imagery once more.*

▲ **21** *The gondola with the camcorder was moving in the same direction as the racing boats, making a smooth tracking shot possible.*

▲ **22** *With lens fully zoomed, the race sequence concludes with a close-up of the front boat showing three gondoliers in action.*

▲ **23** *As the journey continues, the camcorder is turned to the side to bring into view some of the ornate buildings lining the waterway.*

▲ **24** *This shot was framed with the bow of the gondola projecting into the frame, to remind the viewers of the mode of transport.*

▲ **25** *Another famous landmark, the Rialto Bridge, comes into view, lying dead ahead.*

▲ **26, 27** *As the gondola nears the bridge, it is possible to show a much more detailed shot without having to zoom too much. This makes for a stable image.*

▲ **28** *The final shot is a dramatic sunset scene continuing the gondola theme.*

◄ **MAKING THE MOST OF A TILT** *For travelogues where large scale architectural and landscape features are bound to form a recurring element, the tilt is a key shot. In this sequence, a detail shot of the gondola provided a link to this scene, taken leaning from a bridge and showing the canal below. Following the movement of the camcorder from the bottom picture to the top, the viewer's attention is gradually led up from the canal to the view of the bridge and surrounding buildings.*

LIGHTING EFFECTS

Sydney Opera House and Harbour Bridge were shot at different times of day to produce different lighting effects.

▶ **1, 2** *The serene early morning establishing shot dissolves into a longer shot of the harbour.*

▶ **3, 4** *Strong late morning light is enhanced using a polarizing filter. A pan gives a view of the harbour.*

▶ **5** *The pan comes to rest on the Opera House again, completing the panorama.*

▶ **6** *The Opera House in the early evening, shot from sea level.*

▶ **7, 8** *There is a striking change in light between early evening and full night. Frame 7 was shot using a filter to produce an interesting colour change.*

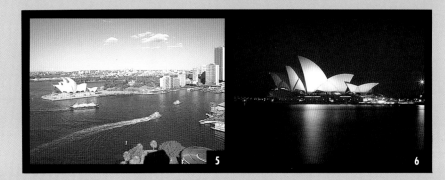

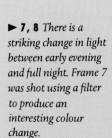

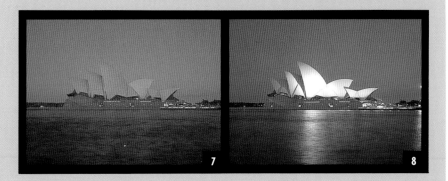

M any companies, big and small, even one-man bands, would like to produce some sort of promotional video to help raise the public profile of their activities. The purpose of this type of video is to get a message across to potential customers. Research is of course unnecessary if you are producing a video about your own business. If you are an outsider, you will need to speak to someone in the company who knows it inside and out. You should ask

- **Preparing a storyboard**
- **Using video graphics**
- **Fly-on-the-wall technique**

MAKING A VIDEO 4

Business promotion

general background questions and find out specific details. Take plenty of notes.

Other topics to discuss at this stage are how long the edited video should run and how much money it might cost to produce.

Next, meet the people who will be featured in the video – the ones who do the job you will be taping. Take your camcorder along and run off some test material. If faces are going to be important, you will need to make sure they have the right look also.

Once you have a good idea of both the processes and the people involved, work out a likely shooting schedule. If, for example, a promotional video is to run for 20 minutes, you should plan for a shooting ratio of 6:1 – that is, shoot at least six times the amount of material you will eventually screen. This gives you the luxury during editing of using only the best footage – a promotional video must present the company at its best.

THE PROJECT A medium-size catering company has asked for a video to be made to promote its services. Taping took place over two days and covered both food preparation and presentation. Continuity was a potential problem, since key personnel had to be available on both days. Sound was partly live – the staff were talking to camera and among themselves – and was mixed with sound effects and music. As a linking device, to tell the story to the audience, one of the company directors read a scripted voice-over.

NEW QUEBEC QUISINE

Opening music. Show company logo.

Head of company talking in general. Show still of banquet in background.

Start of the narrative section – a typical day. Company kitchens – a banquet being prepared. Focus on Alfred as a character?

QUEBEC QUISINE

The food is ready for transportation to ven Show company logo c van.

▲ **1** *In the opening sequence the company's logo features – formal and corporate. In the background, an appropriate music track has been added.*

▲ **2** *One of the company directors is seen here talking about the business. She was carefully framed to the right of the screen to allow the eye to travel to the banquet table behind.*

▲ **3** *This shot continues the theme of quality and clearly indicates the attention to detail of presentation.*

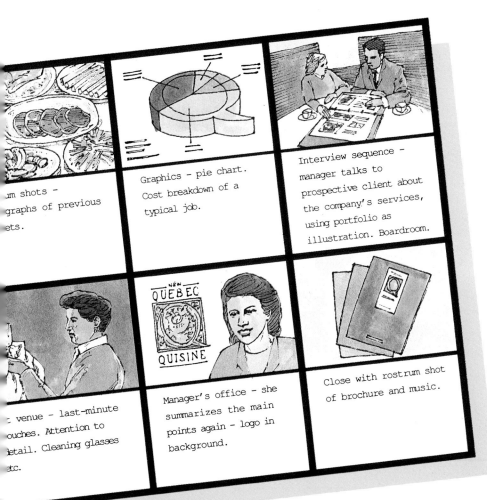

...um shots – ...graphs of previous ...ets.

Graphics – pie chart. Cost breakdown of a typical job.

Interview sequence – manager talks to prospective client about the company's services, using portfolio as illustration. Boardroom.

...e venue – last-minute ...ouches. Attention to ...etail. Cleaning glasses ...tc.

Manager's office – she summarizes the main points again – logo in background.

Close with rostrum shot of brochure and music.

PREPARING THE STORYBOARD

For a business promotional video you could regard a storyboard as essential. During the making of the video, you will probably be using a variety of locations (or sites within the same location) and a number of people will appear on screen. In order to plan the production — so that all shots at one location or site involving the same personnel can be taped at the same time, no matter where they will finally appear in the tape — requires the type of previsualizing for which a storyboard is perfectly suited. A storyboard also helps you plan camera angles and framing, so that on the day each scene can be shot with a minimum of disruption.

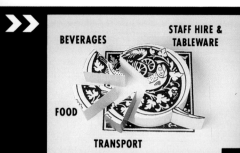

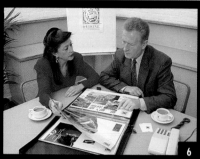

▲ 4 *This graphics sequence showing the cost breakdown of a particular job was worked out in discussion earlier on with management.*

▲ 5 *A close-up of the company brochures and menus introduces a sequence in which a potential client is shown the range of the company's services.*

▲ 6 *This was a set-up shot using a "fly-on-the-wall" technique to produce an establishing shot, in which the director can be seen showing the company portfolio to the client.*

▲ 10 *The image of a lone chef was decided on to symbolize the start of preparations for the day. The pace at this point seems leisurely, and background voices can be heard.*

VIDEO GRAPHICS *The idea behind a tape of this sort is to make the goods or services the company has to offer attractive to potential customers. To achieve this, don't ignore the impact of graphics. As an opening sequence for this catering business video, a graphics sequence could include the logos of clients that use the company, or taped letters of recommendation from former customers. Other graphics sequences could involve rostrum shots of a range of menus clients can choose from. The graphic above gives some useful background, showing the growth of the company in an imaginative and appropriate way.*

USING MUSIC *Although the law is different in detail in different countries, bear in mind that it may be unlawful to use popular recorded music without a licence. The music copyright belongs to the composer, musicians, and recording company, and you may need permission to use it in your production. Licences don't necessarily cost a lot to obtain, however. Alternatively you can use copyright-free music, usually available as audio cassettes. The music you choose should match the visual subject matter, and the rhythm, tempo, and pacing should harmonize with the action.*

▲ **7** *Maintaining visual continuity, here we have a close-up shot of the director explaining the company's approach to the client.*

▲ **8** *A reaction shot of the client looking satisfied with what he has heard rounds off the sequence.*

▲ **9** *To herald a change of location, the image faded in on this big close-up of the company name embroidered on Alfred's, the chief chef, white jacket. A scripted voiceover is the main sound track.*

▲ **11** *This cut to a close-up shows the care and attention that goes into the preparation of the dishes.*

▲ **12** *The sequence continues with a change of camera angle and framing. This is the only point in the video to show a dish being prepared from start to finish.*

▲ **13** *The finished food on a plate, shot in close-up.*

▲ **14** *The takes from now on start to become shorter and the cuts more frequent. Activity is increasing as the day develops. Here, a different member of the kitchen staff is introduced.*

▲ **15** *A change of angle and framing reveals another member of staff. Background kitchen noises are now slightly louder.*

▲ **16** *Another quick cut shows Alfred intently watching the activities, insuring that everything is just as it should be. The voiceover continues throughout these cuts.*

▲ **17** *This sequence was speeded up slightly for humorous effect, but the visuals are still very serious and show Alfred making slight adjustments to the arrangement.*

▲ **18** *The speeded-up sequence ends with this close-up of the result of all that activity, and now the food is almost ready for packing.*

▲ **19** *Dissolve to a shot of the dishes being wrapped for safety and hygiene before leaving the kitchen.*

 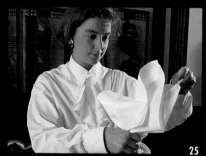

▲ **23** *A cut to a new location – the boardroom that is to be the setting for the lunch. It is now 10.05am.*

▲ **24** *This footage mirrors that earlier in the kitchen. Here, one of the serving staff is seen polishing a glass, again emphasizing the company's policy of care and attention to detail. The pace is slow and careful.*

▲ **25** *Lots of detail shots consistently reinforce the company's image. Background music accompanies the voiceover.*

▲ **29** *The boardroom has been transformed into a setting fit for the beautiful food.*

▲ **30** *Dissolve to the director, who now sums up the company's philosophy and the range of services to suit all pockets, stressing that they never compromise on quality.*

▲ **31** *Her voice can still be heard as the scene cuts to one of Quebec Cuisine's brochures being held as she makes her final point. Voice fades out as music fades in.*

▲ **20** *The food is now crated up and is about to leave for the waiting van outside.*

▲ **21** *A hand-held camera follows the kitchen hand out through the kitchen. Every detail shows gleaming surfaces and spotless surroundings.*

▲ **22** *This cut is to the delivery van. It starts off in a close-up of the company logo before zooming out.*

▲ **26** *Alfred has now arrived and is making last-minute adjustments in the small kitchen adjoining the boardroom. It is now 11.35am.*

▲ **27** *The director is seen taking a personal interest in the preparations, checking the plates of food against the menu descriptions and making sure that presentation is up to standard.*

▲ **28** *The food has passed muster and the chef proudly displays the dishes to the camera.*

ADDING IMPACT

Paying attention to detail during shooting pays dividends when it comes to editing. The use of close-ups, for example, intercut with sequences of long or medium shots, will help to make the video look sharper and more professional. Opening the aperture just slightly (if your camcorder allows it) will make a scene look cleaner and brighter by showing the subject more sharply focused than the surroundings. Throwing an unwanted background completely out of focus when shooting can save you a great deal of time in editing, otherwise you would need to search for a cutaway shot to replace the original.

Use big close-ups, different scene transitions – blanket-wipes, curtain break-outs, reveals, conceals – as well as subtitles, captions, and graphics to add interest and supplement your straight video footage. The visual images can be reinforced by good sync and wild track sound and additional sound effects.

● *For relaxed viewing, takes should be longer and edits fewer.*

● *To build up tension or expectancy, shorten the takes and speed up the cuts.*

● *Match your cuts to the beats of the background music (if applicable).*

● *Keep in mind the elements of pictorial continuity as well as audio timings, and match them whenever you can.*

Because we are so familiar with the animal, bird, and insect life around us, even in cities and large towns, it is easy to overlook or dismiss them as wildlife subjects. It is true that the superb wildlife videos screened on television are made by skilled professionals, but you don't have to be an expert, spend months on location, or use expensive equipment to produce a short tape on a subject that awakens your interest.

- **Time lapse video**
- **Anticipating action**
- **Filming in close-up**

4 MAKING A VIDEO

Wildlife

RESEARCH For some subjects, a little research can help. If, while on holiday at home or abroad, you wanted to make a tape about local bird life, then a little money spent on a good bird watcher's handbook would provide valuable background on habitat and feeding and nesting habits. Bird and animal sanctuaries and game parks are not uncommon in many countries. A lot of these cater to the needs of photographers, providing hides and special observation points where you can set up your camcorder without disturbance to animals.

EQUIPMENT You will need to sit comfortably and quietly for long periods with the camcorder mounted securely on a tripod or other firm surface. Binoculars are also very useful.

With a normal zoom, even fully extended, any distant animal would be too small in the frame to create an interesting picture. If your camcorder allows other lenses to be fitted, then you could buy or rent an extreme telephoto. More than likely, though, you will have to use focal length extenders. For shots of insects, you could use your built-in macro facility but, once engaged, it puts the zoom out of action. A better bet are close-up lenses you screw onto the front of the lens.

THE PROJECT The wildlife projects shown here demonstrate the variety of subjects and approaches included in this topic. They include footage from an African game reserve as well as underwater, macro and time-lapse examples.

FILMING UNDERWATER
Taping underwater can be a rewarding activity. You will, of course, need a special protective housing for the camcorder. The main problem you will encounter underwater is an extremely low level of illumination. Even in the cleanest waters, *light just 5-10 feet below the surface may be only half that topside. Particles in the water tend to scatter light, so be prepared for some radical shifts in the quality of light. You will need a high-power, portable battery light — housed in its own special casing — plugged into the* *camcorder. Sound is not too much of a problem, since even if the microphone were operating, all you would hear would be the bubbles escaping from your aqualung or snorkel.*

FILMING CLOSE UP *Most close-up enthusiasts prefer to attach supplementary close-up lenses to their camcorders rather than engage the macro facility found on most modern models, because the macro disengages the zoom and you are left with a fixed-focal-length lens. The spotted longhorn beetle at rest on a common dog rose (below), and the beautiful Madagascan butterfly were both filmed using the lens's macro facility, however. They were chance finds, and no close-up lenses were available. When you are this close, you will need to watch that your own shadow does not get in the way. A little water sprayed onto the foliage adds an attractive dewiness, and the water droplets may reflect back as little sparkles of light to brighten the image.*

▲ **1** *Titles could dissolve to a wide location shot to set the scene.*

▲ **2** *These sable antelope were filmed from the open top of a safari bus with the zoom on maximum magnification.*

▲ **3** *From an elevated vantage point, the videographer saw a predator approaching from the left, and was able to anticipate the direction of the antelope's flight.*

▲ **4** *This kudu approached a waterhole very warily. It was obviously aware of the presence of onlookers.*

▲ **5** *When it finally felt at ease, the kudu lowered its head to drink.*

▲ **6** *This was taken as a sign by the other kudu, which had been hanging back, and shortly after it was possible to capture footage of the herd at the water hole.*

▲ **7** *A huge flock of cattle egrets gathering in a field was a spectacular sight. Resist the urge to pan the camera to follow their movement.*

▲ **8** *Once the birds appeared to be ready to take off, the videographer started a slow pan combined with a zoom out of long shot to gradually increase image size.*

▲ **9** *This is a cut to a different location, although the type of bird is the same. The viewer will assume, however, that this is now simply a close-up of the same flock as the preceding shot.*

▲ **10, 11, 12** *With such animated animals as these meerkats, it would be easy to allow too much camera movement to creep into your coverage. It required* *restraint to keep the camera still to allow the action to unfold in the frame. The slightly out-of-focus dried grass in the foreground, caused by a wide aperture and* *the resulting shallow depth of field, has, like the shadows on the ground, imparted a sense of distance to the pictures.*

TIME LAPSE VIDEO *Very few non-specialized camcorders have a built-in time-lapse facility. With patience, however, you will be able to record some good results using an ordinary model. For this egg-hatching sequence, periodic bursts of tape were shot over a period of a few hours — in fact, any time there was any movement from the egg at all. The camcorder was mounted on a tripod so that framing was consistent throughout the sequence. During editing, you can trim down the segments to form a smooth and regular unfolding of the action. Without a special time-lapse facility, choose a subject to tape whose movement takes place over a matter of hours rather than days.*

Sports is one of those subject areas in which, as an amateur videomaker, you have almost as much chance as a professional to grab some first-class action coverage. But there is one golden rule to remember – know your subject! No matter what type of sporting activity you want to tape, if you are familiar with the rules and the flow of play, you will be better able to anticipate where the most promising camera position is likely to be.

- **Following the action**
- **Planing your coverage**
- **Framing the subject**

4 MAKING A VIDEO Sport

TYPES OF SHOT At some sporting events, such as football, you will be confined during the actual play to one spot in the spectators' stand. So before the match begins, concentrate on recording some broad establishing footage while you can still move around freely without getting in anybody's way. Often, too, the action off the field can be just as entertaining as that in the arena. Keep an eye out for good crowd scenes. Also, try to zoom in on some interesting faces reacting to the play.

At other types of sporting events, however, you won't be nearly as limited in your choice of shot. At many motor or bike race circuits, for example, you will be able to move around the perimeter of the course freely and have a chance at some excellent close-ups on the corners, where the cars or bikes slow down. Keeping the subjects in the frame for any length of time is a problem, however, and you will have to pan the camera to keep up with them. Again, it is best if you can anticipate the line they will take through the bend in order to carry the camera movement off.

THE PROJECTS Our main project is a local marathon. This is a good race for the camcorder, since you can cover the start, grab sequences throughout its 26-mile duration, and still get to the finish in time for the triumphant breaking of the tape. Other, smaller projects deal with a football match, how to set the camcorder up to tape your own golfing technique, and following a horse and rider.

THE GOLF SWING
Many sporting activities require precise timing, consistent technique, and good physical co-ordination. To achieve these aims, you need to be able to see what you are not doing right. This is where using your camcorder to tape a sporting activity — such as a golf swing (see right) — can be a great help. If you are taping your own swing, you will have to set the camera up on a tripod and prefocus and frame the action so that the viewfinder image takes in the part of the technique you want to record. It might be the grip and follow through, for example, as here. In this situation, set the lens so that its angle of view is broad enough to record that part of the action right through the swing.

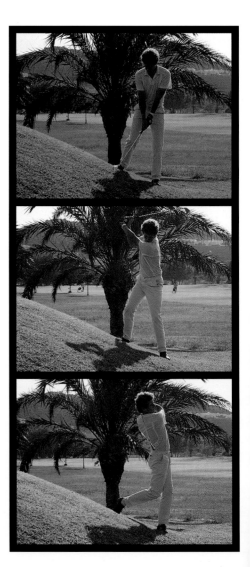

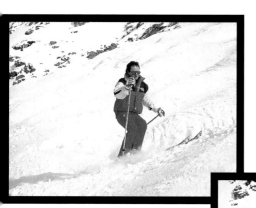

FRAMING THE SUBJECT

Skiing is one of those sporting activities where it is easier to frame an experienced or professional run than that of an amateur. This is because the line taken by a professional over any given course will be more predictable, being governed strictly by the conditions of the course. Watch a few pro skiers tackling the same run and you will see that they all take pretty well the same line. An amateur skier is likely to go anywhere, making anticipation difficult. In these shots the skier enters the frame at the extreme left, moving toward centre frame, and then being held there pretty steadily throughout. This is good – nothing draws attention to the camera more than inconsistent framing, with the subject constantly fluctuating between the left and right of the screen.

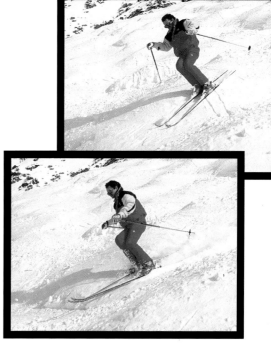

PLANNING *The key to successful video sports coverage is anticipation. Most sporting activities take place at speed, and unless you have a sufficient knowledge of the rules and the likely flow of the action, you will find that most of your scenes are of competitors moving out of shot, and none of them moving in. If possible, visit the site of the activity before the day of the shoot so that you can get a feel for the location and scout out some likely camera positions. Of course, the sporting ground might be one you know well, especially if you are making a tape of your own home team.*

Equipment checklist

- *Camcorder*
- *Spare batteries*
- *Spare tape*
- *Camera-mounted microphone*
- *Monopod, tripod, shoulder harness, or chest brace*
- *Camcorder cleaning equipment*
- *UV or skylight lens filter*
- *Notebook and pen*
- *Umbrella (for rain or to act as a shade)*

▲ **1** *The essential opening shot for any race video is the starting line. The large numbers of competitors in a marathon take a long time to sort out before the start, so you could hold this shot long enough to run a titles sequence over it.*

▲ **2** *This shot is only a few hundred yards down the road, but the videographer had to scramble to get there in time to frame the runners, still well bunched, with the start banner in shot.*

▲ **3-5** *In the next three frames the sequence continues with the same framing. The camera was kept stationary, since all the action here consists of runners growing larger and larger, obscuring more and*

▲ **7-9** *Here we have the start of a slow pan. The operator swung round so that the audience's view of the action moved through a 180° turn. The scene that started with a frontal view of the runners*

approaching, finished with a rear view of them pounding by. It was important not to start the pan too soon since, when the camera movement ended, the frame needed to be full of runners. Note, that the angle

of the pan begins from about waist high. This helps to emphasize the effort of the runners.

▲ **13** *After filming the first half of the runners, the camcorder was switched to pause and swung around to begin filming the rest of the field. Amusing shots such as this group of rollerskaters helps to add variety to the video.*

▲ **14** *A cut here to show the audience that the race is drawing to a conclusion — at least for the front runners.*

▲ **15** *At any stage during the race, include plenty of coverage of the crowd cheering the runners by. Later, these can be edited in wherever they are considered necessary.*

more of the banner, accompanied by the sound of their pounding footsteps becoming louder as they approach.

▲ 6 *Still from the same position as before, the operator held the shot until scores of runners had passed the camera position.*

▲ 10-12 *Recording a pan such as this, with subjects at many different distances from the camcorder, it is a good idea to switch the autofocus off to stop it shifting* focus position continually. By reducing the aperture instead, you can count on the wide depth of field to keep enough of the scene in critically sharp focus.

▲ 16 *The videographer made certain to include the triumphant raising of the arm as the first athlete approaches the finish.*

▲ 17 *After the race, the camera operator moved among the exhausted athletes. The idea here was just to grab cameo shots of them, some close to collapse, as they received their finishers' medals.*

▲ 18 *An emotional shot of an exhausted but triumphant competitor being greeted at the finish provides a fitting end to this record of a grueling test of stamina.*

▲ FOLLOWING THE BALL

This sequence of shots of a football game in progress illustrates football video at its best. From a good seat at the front of the spectators' stand, the camcorder has captured a fast-moving and exciting short piece of action.

With ball sports, the rule is to follow the ball relentlessly with the camcorder. Wherever the ball is, there you will find the major action. If possible, make sure the depth of field is narrow enough to keep only the players in focus. This will cut out the background, and focus the viewer's attention on the action.

If you are planning to film a game in the daytime, check out the position of your seat in relation to the sun. Try to avoid being in a position where you have to spend half the game shooting into the sun, or into deep midday shadows. Also, try to position yourself as close to ground-level as possible – this will minimize the distracting visual effect of the players' shadows on the ground.

CROSS-COUNTRY RIDING

▲ 1-3 In these shots of a horse and rider taking a low wall in a cross-country course, the subject was initially framed in long shot. The camera remained stationary throughout, simply zooming in slightly toward the end of the scene in anticipation of the horse clearing the obstacle. The autofocus was turned off for the shot and the lens prefocused. This prevents the camcorder constantly looking for the best focus position.

SOUND ADVICE It is generally true that an off-camera microphone delivers better-quality sound than a camera-mounted one. At a sporting event, however, you may have to react quickly to the flow of the action, in which case a camera-mounted mike will prove to be more convenient.

Be sure to record plenty of additional "atmos" sound track — the crowd cheering and clapping, for example, or revving engines — for use as possible wallpapering during editing.

If the game is being broadcast, you may wish to have a friend record the commentary for use as inspiration when you come to write your own voiceover.

You may find it difficult to produce a good live sound track for some sports events — especially those that involve intermittent loud noises that reverberate, such as rifle shooting or ice-hockey. In these cases you may have to make do with a sound track made up of music and commentary.

▲ **4-6** The camcorder has picked up the same rider at another obstacle — a series of steep downhill steps. This sequence shows a pan as the camera follows the horse's successful descent, and finishes with it galloping off. The key to the successful framing of the shot was anticipation of the direction of the horse's movement during and after the jump. This sequence, as well as the other, benefits from strong directional lighting, which gives the scenes depth as well as adding texture and form to the subjects.

The word *documentary* has rather a serious sound to it. The examples we see on television tend to deal with matters of local, national, or international concern. But documentary simply means a factual film. So the documentary format lends itself to most subjects that might interest you; anything from the activities of a local sports club, school, or the work of a charity, to something more exotic discovered on holiday.

- **Structuring a documentary**
- **Adding commentary**
- **Working in difficult conditions**

4 MAKING A VIDEO

Documentary

STRUCTURE An ideal length for an amateur documentary is between four and ten minutes. This should be long enough to give your audience an insight into whatever it is the tape is about, yet short enough to tape sufficient good material in a relatively short time – maybe even within three or four hours. But in order to communicate properly, a tape as short as this needs a tight structure, something that can be achieved only if *you* understand the subject matter. Without this, the tape could lack coherence and the story become muddled.

When thinking about structure, don't ignore the different ways your tape can tell its story. The visuals, of course, are the backbone, but they need fleshing out with sound. You could produce an interesting sound track by, for example, introducing the tape yourself, talking directly to the camera. The visuals then cut to the main subject of the tape, as your voice carries over the cut in the form of a voice-over. Live sound is also vital. It helps give the visuals a three-dimensional quality.

THE PROJECTS The processes involved in both the projects here - fabric dyeing in India and cheese-making in France - take place over an extended period of time, far too long a time to tape step by step. However, both these processes are carried out on a continuous basis, with every stage of completion available to be taped at any one time. If this had not been the case, many visits over a period of days or months would have been necessary.

PLANNING THE SHOOT
When you have only limited time to get the shots you need, careful scheduling is vital. In a hot country such as India, plan to start early to benefit from the cool part of the day.

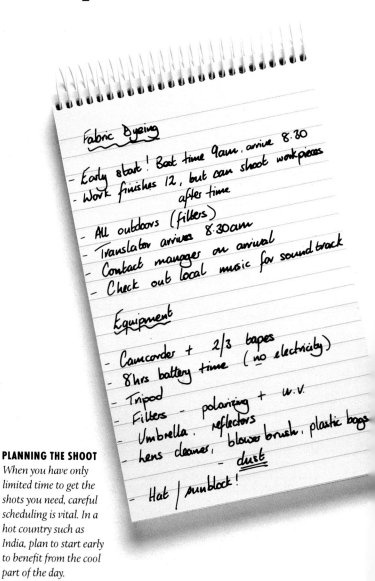

Fabric Dyeing

- Early start! Best time 9am. arrive 8.30
- Work finishes 12, but can shoot workpieces after time

- All outdoors (filters)
- Translator arrives 8.30am
- Contact manager on arrival
- Check out local music for sound track

Equipment

- Camcorder + 2/3 tapes
- 8hrs battery time (no electricity)
- Tripod
- Filters - polarizing + u.v.
- Umbrella. reflectors
- lens cleaner, blower brush, plastic bags
 - dust

- Hat / sunblock!

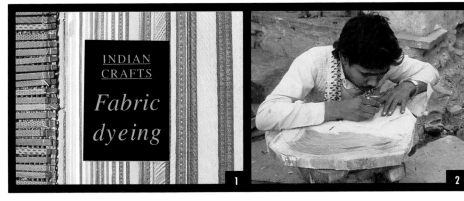

INDIAN
CRAFTS
*Fabric
dyeing*

▲ **1** *Isolated in close-up, the bright colours and straight lines of the dyed and printed fabric make an ideal background for opening titles and an end sequence.*

▲ **2** *The medium close-up used here excludes distracting detail and helps the viewer concentrate on the work of creating the design of the printing block.*

▲ **3** *This shot is important to the documentary because it establishes the setting and introduces several members of the community.*

▲ **4** *A change of pace here into a big close-up of an intricately carved printing block. On purpose, no scale is provided – yet.*

▲ **5** *From this image, we can now see the true size of the printing block used by one of the women.*

▲ **6** *A radical change in lighting as we move out into full sun. The composition is punchy – the eye reads left to right and comes to rest on the figure at the end.*

TIP *Like any type of story-telling, a documentary is only as good as the knowledge of the videographer. The finished tape has to entertain, but if it is to give its audience an insight into the subject matter, you need to do some basic research into the subject. Without an understanding yourself of the processes that you intend to tape, the finished product could be muddled. Books, magazines, asking people knowledgeable in the subject area, even tourist guides and brochures, all can be used to give you important background information.*

▲ 1 *This is the establishing shot of the farmhouse where the cheese is made. As we approached by car, the camcorder was zoomed back to hold the shot. This allows time for a voice-over or titles.*

▲ 2 *It is important to see where the raw material for the cheese comes from – hence the cows. The strongly patterned animals intersected by the horizontal lines of the gate also make a powerful image.*

▲ 3 *Here we see two of the cheese-makers. An on-camera light was used for the shot, and the near subject is a bit overlit – a risk with this type of light.*

▲ 7 *A static shot of these cheese moulds was planned here to allow space for the voice-over to explain some of the cheese-making process. Make sure to choose an image with strong form to hold the viewers' attention.*

▲ 8 *This transition was achieved by dissolving from the previous shot. This is the stage when the cheese is allowed to ripen and is explained by the narration.*

▲ 9 *Many of the steps in making the two types of cheese shown in this project are similar, so here the camcorder lingers on this shot while the voice-over summarizes the differences.*

LIGHTING TIPS *If the location of the documentary shoot is near your home, you will be able to transport all the equipment you need and put into practice many of the lighting skills described in this book. Mostly, however, you will be restricted to using a single, battery-powered light as the main source of illumination. But remember that you can often lift the brightness level in a dimly lit room simply by changing the light bulbs to a higher wattage. Where possible, utilize found reflectors, such as mirrors, or use sheets of white cardboard positioned strategically out of shot. In a confined area, this might be all the extra lift to lighting you need.*

▲ **4** *The imagery of every shot adds to the overall feel of the tape. Isolating these utensils works in context here because the audience will later see them in use.*

▲ **5** *Shooting with the lens set to macro is excellent for raising a question in the audience's mind: "What is it?" The voiceover supplies the answer, of course.*

▲ **6** *Pulling back into a medium shot reveals not only the cheese-maker ladling the curds, but it also emphasizes the "old world" feel of the location.*

▲ **10** *Don't exclude people from the documentary for too long – activity and movement are important parts of the audience's expectations.*

▲ **11** *This was a complicated sequence that needed rehearsing. Starting with a zoom back, it required the camcorder to "crab" slightly to the left in order to force the right-hand rack of cheeses into shot.*

▲ **12** *A typical product shot, one entirely appropriate in the context of this documentary. It is also ideal as the background for the end credits.*

ADDING A COMMENTARY

When writing a commentary don't describe simply what the viewer can already see in the film itself. Any commentary that does not give additional information will rapidly turn the audience off.

Timing the commentary to the visuals is vitally important – the voice-over must be relevant to the part of the documentary on screen at that point. To achieve this, use a stopwatch to time every scene in the documentary, and log these times and a description of the shot. Next, write the script, scene-by-scene. Then talk it through, adding or cutting information as necessary, until the script is the right length. Remember to take into account where you will be adding sound recorded during the shoot.

When recording a commentary:

● Use a cardioid microphone and record in a quiet, soft room.

● Insert each page of the script into a plastic envelope, so that there is no rustle as you turn the papers.

● Prop up the script in front of you so that you do not have to look down.

● Do not let your voice drop at the end of sentences.

● Record the script in short sections.

Pop music is more than just the instrumental or the lyric: the right look is every bit as important as the right sound.

The aim of this video is to be eye-catching. And to achieve this, most of the do's and don'ts of good video practice can be turned on their heads. Whip pans, crash zooms, impossible camera angles, filter effects, jump cuts, crossing the line – all of these can be employed as well as very professional-looking post-

- **Gaining inspiration**
- **Filters for special effects**
- **Creative editing**

MAKING A VIDEO

Pop Video

production effects, such as fades, dissolves, wipes and posterization.

LAYING DOWN THE VISUALS Basically, you need numerous takes of the band miming complete versions of their song (playing in the background on an ordinary audiocassette). At this stage the sound is not important. Tape the band in long shot, medium shot, and then in close-up, concentrating on individual band members. Include details such as faces or hands on the guitar fret board or the drummer's stick striking the cymbals. For each take, emphasize a different effect – a starburst or prism filter, perhaps, shooting with the camera tilted, or whatever suits the music. Don't forget to shoot plenty of noneffects footage.

POST–PRODUCTION Begin by assembling a balanced tape of straight footage from different takes of the song, intercut with special effects. Since all the takes contain the complete song, you will be certain that if, for example, you want a close-up of the lead singer miming a particular part of the song with a starburst of light coming from the rear, it will definitely be there. Once the tape is assembled, you can replace the live sound track containing the cassette playing in the background with a final recording of the song.

THE PROJECT In this pop video, all of the material was shot in a single location, although you may want to use two or even three and edit them together. About 12 takes of the song were recorded to ensure plenty of scope for editing.

DEVELOPING A CONCEPT
Most pop videos are non-narrative — in other words, they don't tell a story. This gives you tremendous freedom of choice to use all manner of lights, filters, backgrounds, effects and angles as part of your visual approach. Let your imagination run riot. Unlike most other types of video presentation, in a pop promotion tape the sound should be the dominant element, with the visuals acting in a supporting role.

To develop your own concept for a pop video, consider the following suggestions:

● *Watch as many pop videos of famous bands as you can, in order to gain an insight into the techniques used.*

● *Either choose a location that acts to reinforce the concept behind the song, or one that positively contrasts, and so introduces an element of incongruity.*

● *Record more takes of the band performing the song*

than you think you will need. Most of the work that goes into a pop video happens during the editing stage, and you will want to have plenty of material to choose from.

▲ **1** *These guitars were set up almost like a still-life composition, forming a static shot for the opening titles. The same shot could be used at the conclusion of the tape for the end credits.*

▲ **2** *This high-angle shot looks effective, and it was achieved by standing in a shopping cart.*

▲ **3** *Breaking the "rules" of film making, a music video is reliant on constantly changing camera angles, achieved here by pushing the cart along for a dolly shot.*

◄ **TITLES**
Pop videos do not usually bother with elaborate titles; possibly because of the creative nature of the content itself. However, if you have the equipment, there is no reason why you should not have the band's name on screen preceding the song and present the musicians' names as end credits.

✸ **TIP** *Over a period of time, build up a library of unassociated footage for possible use in later projects — such as in a pop video. It's amazing how often unrelated scenes can be inserted creatively in a way totally impossible to forecast.*

◄ **VIDEOS AS INSPIRATION**
Professionally-produced videos, such as the two examples on the left, represent the best source of inspiration for any budding pop producer. Obviously money has been lavished on their production; but look beyond the locations, extras, lighting rigs, and all the rest of the things that eat up resources. Notice instead the angles, framing, tracks, pans, and tilts, as well as the more achievable special effects that have been used both during filming and in post-production.

▲ **4** *This cut to a close-up of the singer's face has great impact value following on after the previous visuals, and the cut is timed to coincide with the start of the lyric.*

▲ **5** *Uplighting the guitarist's face is a simple effect, and it gives him an almost macabre appearance. His features are further distorted by the use of a wide-angle lens attachment close to the subject.*

▲ **6** *A tilt from the previous shot ends by holding a shot of the neck of the guitar.*

FILTERS FOR SPECIAL EFFECTS *Filters for special effects are most often associated with still photography, but there is no reason why these same filters cannot be used on a camcorder. Filters are either circular pieces of glass with a threaded mount that screws directly onto the front of the lens, or they are square pieces of gelatine that slip into a special holder attached to the front of the lens.*

Of the wide variety of filters available, the following are only examples of the ones you may find most generally useful:

● **Repeating-image** *Either a half or full filter with fine lines engraved in its surface that repeat any part of the subject within its focus.*

● **Fog** *A slightly grey-coloured filter that gives the impression of filming through heavy haze. Definition is lessened, but not too badly.*

● **Centre spot** *A coloured or fog filter with a clear central spot.*

● **Graduated colour** *Filters that are half coloured, graduating in strength to become half clear glass. This type of filter is available in many different colours and can be used to tint dramatically the appearance of, say, the sky, while leaving the ground unchanged. The filter can be oriented so that the coloured half aligns with any part of the subject you wish.*

● **Prism** *A filter with four faceted faces that repeat the subject in the centre of the frame.*

▲ *Special effects filter, such as the one used here, repeats the main image a set number of times. Different filters give you a choice of different patterns of the repeated image.*

● **Starburst** *A filter that turns any point sources of light into brilliant stars. Very effective with city-scapes at night, bright highlights off water, car headlights, and so on. Image definition is slightly reduced.*

● **Day for night** *A blue-coloured filter often used to give daylit scenes the appearance of being shot at night. The use of the filter is usually evident, but it is accepted mostly by the audience as a visual cliché.*

▲ **7** *The camera tracked round here for a front on shot. Since both the guitarist and his guitar are now farther away, the distorting effect of the lens has disappeared.*

▲ **8** *The previous scenes were very monochromatic, but here a rainbow filter was used to introduce an impressive splash of colour.*

▲ **9** *Cut to a close-up of a guitar, this time without a filter. The overall reddish colour cast was achieved by setting the white balance to outdoor.*

▲ **10** *Introducing another of the personnel here – the band's female guitarist.*

▲ **11** *To coincide with the song's chorus, this shot was framed to accommodate a group shot. The angled framing also adds variety.*

▲ **12** *The camcorder has crabbed from the left side of the stage to the centre and gradually tilted from right to left.*

▲ **13** *The left tilt continues here in a mid-shot framed from well below the guitarist. His face has been deliberately overexposed to add visual impact.*

▲ **14** *A cut with the music justified this shot, made more effective by the use of a starburst filter on the camcorder's lens. The camcorder has crossed the line.*

▲ **15** *A wide-angle attachment was used again to obtain this close-up of the guitarist playing a solo.*

SOUND AND SYNC PROBLEMS

Unless extremely sophisticated sound equipment is used, recording bands live is usually not very successful. The camcorder's microphone is not of sufficient quality for the job, and the reproduction through the band's PA system, although acceptable when heard live, is poor when heard as part of a recording. Nearly all pop promotional videos are made using a pre-recorded audio tape as the sound track. The audio tape is copied onto a blank video tape that has been "blacked". During the filming itself, the band mime to a duplicate audio tape. The visuals are then inserted onto the blacked tape.

Although the sound recorded on the camcorder's master tape is not going to be subsequently used, it does play an important part during editing as a guide track in achieving lip sync. This is done by pausing the editing recorder while observing the singer's mouth or watching the drumstick hit the drumskin. The source tape is halted exactly on the word or drumbeat, and the edit performed. This technique requires practice, so don't be downhearted if you do not get it right first time.

▲ 16 *This shot of the guitarist using a wow-wow pedal reinforces the sound effects it produces.*

▲ 17 *A repeating-image (or multi-parallel) filter, left a comet trail of images behind the guitarist as he moved.*

▲ 18 *For a cooler effect, the white balance was re-set for indoor use and some very bright halogen lights were introduced.*

▲ 22 *Now for the drum solo. The low angle makes a powerful, dynamic composition with the drums emphasized in the foreground.*

▲ 23 *The camcorder crabbed clockwise around the drummer and was tilted to the left to catch the lines in the background at an energetic angle.*

▲ 24 *The camcorder was mounted on a tripod for this shot, and zoom used to limit depth of field. The drummer and cymbals are in focus, but the other band members to the rear have dissolved into a colourful blur.*

SPECIAL EDITING TRICKS *Editing a pop video gives you the opportunity for real creativity that is not possible with many other types of video production. It is possible to repeat a drumbeat or a close-up of a guitar chord several times, for example, without the audience being aware of it — provided there is some reasonable spacing between the repeats. The electronic "stammer" that has been a popular video trick for some time now, is easy to achieve by chain-repeating a few frames over and over again. And if you want a black and white effect, then all you need do is switch the source video-recorder to b & w at the back of the machine while recording. Add a little horizontal over-enhancement using an accessory picture enhancer and you will achieve a 1930s look. While filming, a few smoke macaroons, available from theatrical suppliers, will give you plenty of smoke effects, and the macaroons are safer and cheaper than using dry ice. Coloured lighting effects can be achieved simply and inexpensively by placing sheets of coloured acetates in front of ordinary lights. With a pop video, experimentation and imagination are what count.*

▲ **19** *During post-production, the scene was strobed to make the most of the performer's wild movements.*

▲ **20** *This moody, dark shot provides a complete change of atmosphere, as we switched to the girl guitarist.*

▲ **21** *The camcorder follows the girl's movement forward which results in an even darker shot as her head hides the bright spotlight in the background.*

▲ **25** *Cut to shot looking straight up from the ground. This unusual viewpoint has vital impact. Note, too, the distortion caused by the steep perspective.*

▲ **26** *This cut is startling simply because it is neutral, coming as it does after the distorted perspective in the previous image.*

▲ **27** *The solarized effect has been strengthened for the song's finale — shot of the lead singer and guitarist. As the song concludes, the image is freeze-framed as the last bars of the music carry on.*

Equipment and accessories

The range of equipment and accessories available for videocamcorders is not as extensive as that for still cameras, and so a full shooting kit is easy to assemble. It is probably better to assemble a collection of equipment little by little, as the need for each piece arises, rather than all at once – it is easier on the pocket, and reduces the probability of buying items that you will never need to use. The following is an outline of some of the most commonly available accessories. The order in which the items are listed broadly reflects the likelihood of their being needed by the average videomaker.

CASES AND BAGS *Camcorders are bought with their own moulded plastic cases. These are strong and tailored to fit the camera exactly, but there may not be sufficient room for the numerous extras we all find useful when shooting. A case like this also draws attention to the camcorder and may invite theft. You will probably find it more convenient to buy a larger bag that has room for such things as spare tape, batteries, filters, cables, microphone, lens tissues, and headphones, as well as the camcorder. Ideally it should be made out of a tough material such as canvas and have plenty of adjustable internal dividers to keep your equipment organized and readily accessible. A rigid case provides more protection for your camcorder but many people prefer a soft bag such as that illustrated on pages 168-9. A "rain jacket" is a useful accessory for those who plan to do lots of outdoor work.*

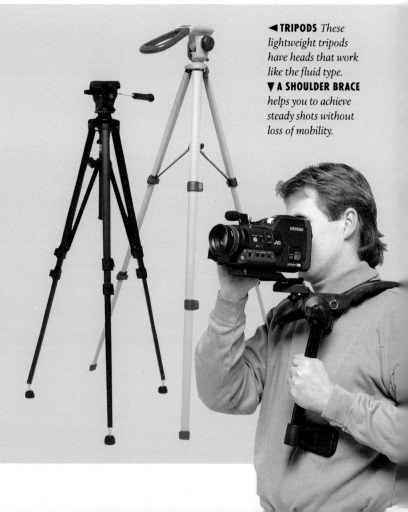

TRIPODS *If you want rock-steady, professional-looking images, then a tripod is an essential piece of equipment. Tripods are available in a range of sizes and specifications, but those designed for still cameras are not suitable, because the platform on which the camera sits is often not large enough for a camcorder.*

When choosing a tripod, go for the best your budget will stretch to – basically the heavier its construction the steadier your images will be. The legs will be independently adjustable to allow for uneven terrain, and for extra rigidity the legs should have bracing struts connecting them to the central column. This column is also adjustable to allow you to vary the height.

Without doubt, however, the most vital part of a tripod is the head, which should allow you to pan and tilt smoothly and easily. There are three different types of head: friction, fluid, and geared. A friction head is the cheapest option – twisting the pan-and-tilt arm locks or releases the head, allowing you to move the camcorder freely. They do have a tendency to stick, however. A much better option, and a lot more expensive, is a fluid-filled head. Geared heads are the most expensive, and are used with heavy cameras.

◄**TRIPODS** *These lightweight tripods have heads that work like the fluid type.*
▼ **A SHOULDER BRACE** *helps you to achieve steady shots without loss of mobility.*

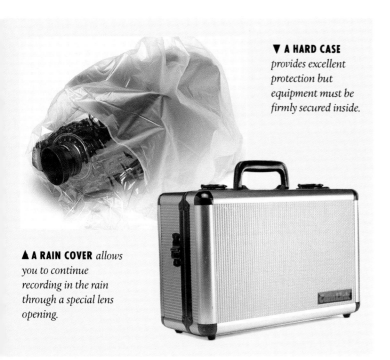

▼ A HARD CASE *provides excellent protection but equipment must be firmly secured inside.*

▲ A RAIN COVER *allows you to continue recording in the rain through a special lens opening.*

VCRs *Home video cassette recorders, apart from being the usual playback device for a finished videotape, are also used extensively during the tape editing and sound track stages of a production. If you intend to edit your videotapes, an insert edit facility is almost a must.*

Your VCR will be set to play back tapes compatible with the television standard of the country in which it was bought. There are three such standards used around the world today. NTSC is used in the US, PAL in the UK and SECAM in France. Camcorders are also adapted to record tapes compatible with the local TV standard. You will therefore be unable to play back, for example, a tape recorded on an American camcorder on a European VCR.

At some stage you are bound to want to carry out a tracking shot, something made far easier with a tripod mounted on a set of wheels. These wheels are available as an accessory, but check before buying that the tripod in which you are interested is suitable.

If space is tight where you are filming, you might want to consider a monopod – a one-legged support. This is not nearly as effective as even a cheap tripod, but it is often better than hand-holding the camera, especially if you might be jostled.

It is also possible to buy a motor-driven tripod attachment that will pan the head by remote control – handy if you intend to do a lot of landscape filming. It will rotate the head through 360 degrees if required, for completely smooth panoramas.

There will be times when you need complete freedom of movement with the camcorder, making use of a tripod or monopod impractical. For these situations, you could use a shoulder brace or chest harness to steady the camera. The ultimate in this type of camera support is the Steadicam. The junior version is now available and its series of fluid-filled joints makes it possible for you to run while filming and still bring home near-steady images.

LENSES *If you are more used to thinking of lenses by their focal lengths, as with still cameras, then the usual 6× or 8× descriptions given to camcorder zoom lenses can be a little vague. The truth is, however, that no camcorder zoom lens offers more than a very moderate wide-angle view. To get around this problem, wide-angle converters are available that attach to the prime lens. A 0.5× converter, for example, will halve the focal length of any lens it is attached to, allowing a table full of people all to be included in the frame when filmed from reasonably close up. As a side effect, a wide-angle converter increases depth of field at every aperture, which can make manual focusing easier in dim lighting. At the opposite end of the scale, teleconverters can turn the camcorder's lens into a powerful telescope, increasing its focal length to deliver large images of small, distant subjects. However, as focal length increases so depth of field decreases, and any camera movement is also magnified, thus making the use of a tripod a prerequisite for steady images at long focal lengths.*

▼ A WIDE-ANGLE AND A TELEPHOTO LENS *increase the variety of shots you can achieve.*

163

FILTERS *The best value for money accessory you can buy is an ultraviolet (UV) filter. This screws onto the front of the lens and protects its delicate surface from dirt, dust, and grit. The filter itself appears colourless and is made of optical-quality glass that can be cleaned in the normal way using lens tissue or soft, lint-free cloth. Overcleaning of the lens's front element, on the other hand, could easily damage its fine lacquer coating, which is designed to help improve the colour rendition of the final image. As well as protecting the lens, the UV filter also helps to filter out excessive UV light, which is responsible for the slight blue haze often noticeable in distant scenes.*

A vast range of special effects filters are also available, including starbursts, centre spot, graduated colour, fog, and haze. Of more general practical use, however, are the following: neutral density, for use to cut down light in very bright conditions; polarizing filter to cut out glare and improve colour quality in bright conditions; amber, to add warmth and improve skin tones; blue to make a scene cooler; and magenta to cut out the green light cast by fluorescent lights.

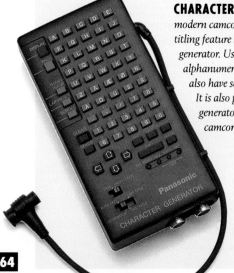

CHARACTER GENERATORS *Many modern camcorders incorporate a very useful titling feature known as a character generator. Using a keypad you can add alphanumeric characters on screen, and some also have scroll and wipe effects as well.*

It is also possible to buy add-on character generators that clip to the top of the camcorder.

◄ AN ACCESSORY CHARACTER GENERATOR *like this is a way of extending your titling options if your camcorder does not have one built in.*

COMPUTERS *Home or business computers can be used to generate titles for video. However, such equipment may not be compatible with a video setup without the purchase of often expensive add-ons. A better alternative may be to purchase a computer designed for use with video equipment. Check with a supplier for details of alternatives, and for information on dedicated video-titling software, including the different paint and text programes currently on the market.*

Vision mixers, previously within reach only of professionals, are now coming into the home video market. They allow mixing of sound and images from different sources and enable you to create special effects.

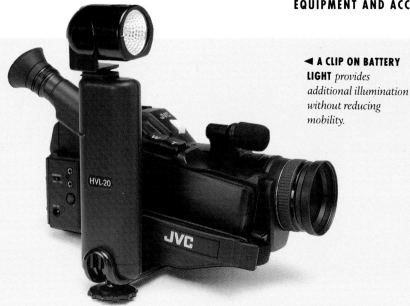

◄ **FILTERS** *provide an economical way of producing certain special effects. Some common filter effects are show here.*
1a *Without diffuser filter.*
1b *With diffuser. Creates a "soft" image.*
2a *Without polarizing filter.*
2b *With polarizing filter. Enhances colour and cuts down unwanted reflections.*
3 *With sepia filter. Creates an "archive" effect.*
4 *With fog filter. The image is partly covered by a graduated fog effect.*
5 *With blue filter and starburst combined. Produces an overall blue cast plus starburst effect.*
6 *With multi-image filter. The image is repeated within the frame.*

◄ *A* **CLIP ON BATTERY LIGHT** *provides additional illumination without reducing mobility.*

LIGHTS *Lighting units fall into two distinct groups. The simplest type of accessory lights are the highly portable battery units. These can either be hand-held or fixed onto the accessory bracket on top of the camcorder. For most work, 50 to 100 watts is required, and the most useful battery-light units have a rechargeable, sealed lead-acid battery pack in a shoulder-strapped pouch to provide the current. Smaller, more compact models provide less light output as the price that is paid for their convenient size. All battery lights provide a bright, harsh, direct light that falls away in intensity very quickly, and so are suitable only for lighting small areas.*

The second type of lighting, useful if you are planning to video subjects where good-quality lighting is required over a large area, consists of more substantial lighting units. This equipment would be familiar to still photographers, and comprises broad-beamed floodlights and tighter-beamed spotlights. Used in conjunction with these lights are lighting stands, booms, and clamps to position the units precisely where they are most beneficial. As well, you can add reflectors, snoots, and barndoors to control accurately how the light falls on the subject, or any other part of the image.

MONITORS *The built-in viewfinders on camcorders display a black-and-white image, something that makes it difficult to assess the effects of colour within the frame. Separate add-on colour monitors are available, however. These consist of a small colour screen that plugs into the lighting bracket on the top of the camcorder. These screens make it possible to monitor colour while shooting, but the quality of the image is not particularly good, especially when lighting conditions are poor.*

▼ *A* **BATTERY-OPERATED MONITOR** *clips on to your camcorder and provides an LCD image.*

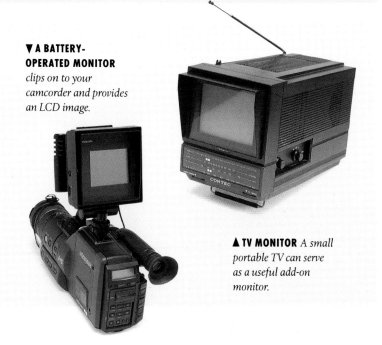

▲ **TV MONITOR** *A small portable TV can serve as a useful add-on monitor.*

165

MICROPHONES AND HEADPHONES

An additional accessory microphone, stand, and cable are essential for effective sound recording, and you can select the type that is best suited to the work you are doing (see Microphones, pages 38-9). The advantage of using an accessory microphone is that sound quality is invariably superior to that produced by the built-in mike found on all camcorders. And because it is not actually attached to the camcorder, the accessory mike is much less likely to pick up extraneous camera-handling sound. Both stereo and mono models are inexpensive and freely available.

As an alternative, you may perhaps want a radio microphone instead of a hard-wired type. Radio models are certainly more convenient, but their signals are prone to interference so often recording quality suffers as a result.

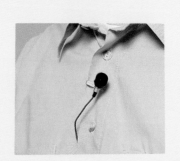

▼ **A CLIP-ON MIC** *is ideal for interviews.*

For monitoring sound, choose headphones that cut out as much background noise as possible. For this reason, large headphones that cover the ears are preferred to the earpiece-type headphones usually supplied with a camcorder, or small personal stereo headphones.

◄▼ **ADD-ON MICROPHONES AND STANDS** *allow you to pick up sound near to its source even if you want to record pictures at a distance.*

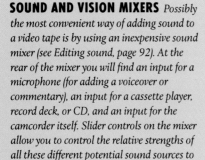

◄ **HEADPHONES**
Choose the larger type (far left) for best results.

SOUND AND VISION MIXERS

Possibly the most convenient way of adding sound to a video tape is by using an inexpensive sound mixer (see Editing sound, page 92). At the rear of the mixer you will find an input for a microphone (for adding a voiceover or commentary), an input for a cassette player, record deck, or CD, and an input for the camcorder itself. Slider controls on the mixer allow you to control the relative strengths of all these different potential sound sources to create the right balance and blend on the final version.

► **AV MIXER** *An upscale combined vision and sound mixer opens the door to a range of special effects and editing opportunities.*

◄ **BASIC AV MIXER**
Even simple mixers allow you to mix sound sources.

POWER SOURCES *Most camcorders are adaptable and can take their power supply from different sources, such as clip-on rechargeable batteries or from the electricity supply through an adaptor. Additionally, most camcorders can be powered by a battery belt or external battery of the correct voltage. Like all electrical equipment, the camcorder draws a current measured in amps, dependent upon its power consumption, measured in watts.*

With an electricity supply adaptor the camcorder can be used for as long as you wish. A battery belt makes the camcorder independent of the electricity supply and may work for up to several hours, depending on its rating. A car battery limits the camcorder's portability but supplies power for many hours. And a shoulder-carried battery pack designed for use with a 100-watt portable video light would power the camcorder for considerably longer than the camcorder's own battery.

When travelling abroad, you should ensure that you have the correct adaptors – a video equipment supplier will be able to advise.

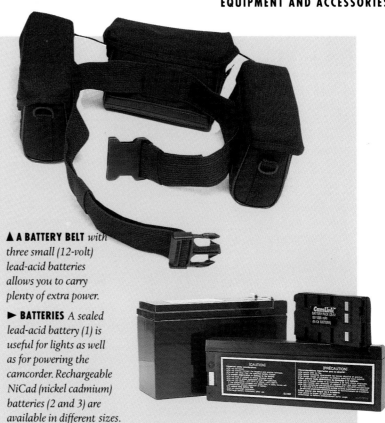

▲ **A BATTERY BELT** *with three small (12-volt) lead-acid batteries allows you to carry plenty of extra power.*

▶ **BATTERIES** *A sealed lead-acid battery (1) is useful for lights as well as for powering the camcorder. Rechargeable NiCad (nickel cadmium) batteries (2 and 3) are available in different sizes.*

REMOTE CONTROLS *Many different remote controls exist, some designed to operate the camcorder completely unattended, and others manually from a short distance. Some units, for example, consist of infra-red beams, which, when interrupted by, say, a bird flying through them or a person walking by, send control signals to the tripod-mounted camcorder. You can operate other types of remote controls manually from a distance simply by directing a radio beam at a receiver attached to the camcorder. Yet others will operate the camcorder at preset intervals for predetermined lengths of time. These are interval times which are used extensively for time-lapse sequences when you see, for example, a chick emerging from its egg in just a few seconds, or a flower opening at near lightning speed.*

SLIDE CONVERTER *As well as taking moving images, the camcorder can also be used to create a "photo album" of slides on video tape that can be viewed via your television set. To do this, you can buy a slide/video copier. It is basically a tub-like device that fits onto the front of the camcorder's lens, and it has a holder at the other end to accept a normal slide. An internal light source illuminates the slide and then it can simply be recorded onto tape. A certain amount of trial and error may be involved in getting the white balance of the camcorder set correctly, since the colour temperature emanating from the daylight-balanced slide image will be different to the low-powered (probably tungsten) light bulb illuminating it. You may also notice that the centre of the image is brighter (corresponding to the position of the bulb) than the edges.*

▶ **SLIDE AND CINE CONVERTER** *pictured here can convert both cine film and slides. Use your cine or slide projector to project the images onto the small screen on the side of the convertor. Place your camcorder at the other end of the convertor.*

TRAVEL KIT *It is quite vital when intending to travel to go through all the types of shots you are intending to produce so that you can make sure to take the appropriate equipment. While it is important to produce stable results, you may lose all interest in taking your equipment out of your hotel room if your tripod is too heavy. In this case a monopod or shoulder brace may be a good compromise. Always spend some time trying out any new equipment you have bought before travelling so that you can be sure of obtaining the results you want, rather than spoiling precious holiday footage.*

Some specialized types of shots require special equipment – for example, for underwater shots you need a watertight camera housing. If you are travelling to an area where you can expect a lot of rainfall, it would be a good idea to take a rain cover. Always make sure your provision for battery power is adequate and that you take the appropriate recharging units.

The amount of equipment you take also depends on your mode of transport and the country you are visiting. If you have to carry the equipment around with you most of the time, you would be well advised to keep it to an absolute minimum.

THE BAG *Every camcorder comes in its own case or bag, but this may not always be suitable for traveling. You will need a bag with plenty of room for accessories as well as the camcorder itself. A soft padded bag is probably most suitable with velcro partitioning inside. Outside straps that allow you to attach a tripod to its side are a useful feature as are outside pockets to take small, often used accessories like filters.*

TRIPOD AND SUPPORTS *If you plan to video a lot of architecture or telephoto wild life shots you cannot really do without a tripod. A monopod is lighter but does not eliminate camera shake completely.*

LENSES *A wide-angle lens is useful for architectural shots, especially interior shots where there may not be a lot of space. For the serious wildlife videographer a telephoto extender is almost a must.*

FILTERS *You should have a UV filter permanently attached to your lens for lens protection. Depending on what you intend to video other filters in your kit could include a* polarizing filter to eliminate reflections and enhance colour, and a neutral density filter if you intend to shoot in extremely bright light.

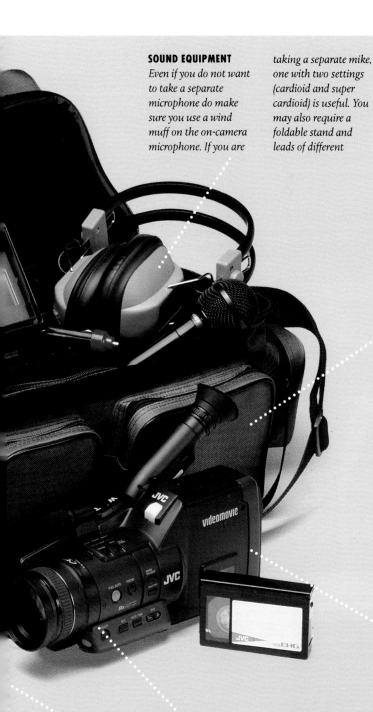

SOUND EQUIPMENT

Even if you do not want to take a separate microphone do make sure you use a wind muff on the on-camera microphone. If you are taking a separate mike, one with two settings (cardioid and super cardioid) is useful. You may also require a foldable stand and leads of different lengths to allow for different recording situations. Headphones to monitor the sound as you record are a must for any serious videomaker. You may also wish to take a small audio cassette recorder to record wild track sound on your travels.

IN THE POCKETS

Keeping your equipment clean is vital. You should protect it from dust and moisture. Plastic bags are useful and also small packets containing silica gel to absorb moisture. A plastic rain cover should fit into an outside pocket. Take a small blow brush for lens cleaning. A note book and pen come in handy for jotting down information that you will need to remember at the editing stage. A small screw driver, replacement fuses and a roll of sticky plastic tape may come in useful.

TRAVEL CHECK LIST

- *Bag*
- *Camcorder*
- *Tripod or other support*
- *Battery light*
- *Off camera mic, headphones, leads, and stand*
- *Wind muff*
- *Tape recorder*
- *Batteries for camcorder, light, microphone(s) and tape-recorder together with recharging units and mains adaptors*
- *Video tapes*
- *Audio tapes*
- *Wide-angle/ telephoto lens*
- *Close-up lens*
- *Selection of filters*
- *Polythene bags*
- *Raincover*
- *Blowbrush*
- *Sticky tape*
- *Screwdriver*
- *Fuses*

CAMCORDER LIGHTING

A battery-powered light that you can attach to the top of your camcorder is not too bulky or heavy to carry.

CAMCORDER

Most people who intend to take a camcorder on their travels will have selected a palmcorder because of its handy small size. Its size also allows you to be unobtrusive while shooting. However, a medium-sized camcorder provides steadier shots and may be the choice of those for whom this is important.

BATTERIES

Make sure you have sufficient batteries to cover the requirements of your equipment. Remember that your batteries give you a much reduced running time at low temperatures. If you are likely to spend entire days without the opportunity to recharge your camcorder batteries you may have to invest in a battery belt. Make sure you take the appropriate adaptors so that you can plug your recharging units for the camcorder and also your battery light into the electricity supply.

Glossary

ADDITIVE LIGHTING *Using additional lights to illuminate a scene.*

APERTURE *The adjustable opening that controls the amount of light passing through the lens onto the light sensor behind it. The aperture size is adjusted by a set of blades, controlled by the camcorder's in-built exposure meter.*

ASSEMBLE EDITING *Selecting the shots required from all those recorded on the master tape, and re-taping them onto a blank tape in the correct sequence.*

AUDIO DUB *To replace the original sound recorded on the videotape or add new sound to it, such as a commentary or music, without affecting the pictures.*

AVAILABLE LIGHT *The light in an indoor setting provided by domestic light sources.*

BACKGROUND SOUND *General background noise, which may or may not be wanted on the recording.*

BACKLIGHTING *A light source or strong reflective surface behind the subject. It can occur naturally - a window behind an interior subject, snow, etc. - or can be created in the studio.*

BACKLIGHT CONTROL *A switch on the camcorder that automatically increases the aperture when the subject is backlit, in order to prevent the subject being underexposed.*

BOUNCED LIGHT *The light sources are directed at a reflective area such as a ceiling or wall to create indirect, even illumination.*

BRIDGING SHOT *A shot taken from a neutral position along the eyeline or line of action, which is inserted between shots taken from different sides of these lines, to preserve continuity.*

CENTRE UP *To position the subject in the centre of the frame.*

CLOSE-UP *A shot that focuses on a person's face to reveal character or reaction, or on a detail in the scene.*

COLOUR CAST *The colour of the prevailing light, which can give a bluish (cool) or orange-yellow (warm) look to a scene. Fluorescent lighting gives a green cast.*

COLOUR TEMPERATURE *The measurement in Kelvin of the colour of light given off by a light source. Natural and artificial light sources have significantly different temperatures and therefore colours.*

COMPUTER TITLING *Use of a computer to generate text and graphics to add to a video at the post-production stage.*

CONTINUITY *The following-on of details of appearance, sound, positioning and so on from one shot to the next.*

CONTRAST *The brightness range from highlights to shadows in the scene being recorded.*

CRASH ZOOM *A very fast zoom in or out, which has a disconcerting effect on the audience.*

CROSSING THE LINE *Moving the camcorder across the eyeline/line of action.*

CUT-AWAY *A shot that is recorded separately and edited in to the master shot. It can add extra information, or be used to hide a jump-cut.*

DEAD RESPONSE *The effect created by an acoustically dead environment; one that absorbs sound so that no echo or other unwanted noises occur during sound recording.*

DEPTH OF FIELD *The distance between the nearest and furthest points in a scene that are in acceptably sharp focus. Depth of field is controlled by the focal length and aperture setting of the lens in use.*

DIFFERENTIAL FOCUS *Focusing on the foreground of a scene, and then shifting focus to another part of the scene, to guide the reader's eye to it.*

DIFFUSED LIGHT *Light that has been scattered by passing it through some form of diffuser, such as a thin wire screen or tracing paper, to create a soft effect.*

DISSOLVE *One image fades into another image.*

DOLLYING *The camcorder is moved towards (dollying in) or away (dollying out) from a stationary subject. It creates a more natural effect than zooming.*

DROP OUT *Horizontal silver line that appears in replay, due to metal particles being removed from the tape. Can be caused by keeping the tape in pause mode for too long.*

DUBBING *Recording sound from one tape to another or combining sound from several tapes onto one.*

ECHO *A sound is reflected more than once off the surrounding surfaces with an interval between each repeat.*

EDITING IN CAMERA *Selecting shots carefully before shooting them, and paying attention to transitions between shots, so that no editing is required later.*

ESTABLISHING SHOT *A shot that opens a sequence or new piece of action, and shows the whole area where the action will take place. It is usually a long or very long shot.*

EYELINE *An imaginary line drawn in the direction in which a person is looking. If the camcorder changes position during the scene, it should remain on the same side of the eyeline in order to maintain continuity.*

FADE *The picture fades in or out, usually to or from black or white, at the beginning or end of a scene. It can be used to indicate passing time or for visual effect. Sound can be treated in the same way.*

FILL-IN LIGHT *A light positioned to fill in the shadows created by the key (main) light, to make them less dense.*

FOLLOW FOCUS *To keep one person in focus as the subjects in a scene move about.*

FRAME *One picture, which is recorded on the videotape in a split second. When frames are viewed in succession, the pictures appear to move. A shot is therefore made up of a sequence of frames.*

FREQUENCY *The number of sound waves emitted from a sound source per second.*

GAIN-UP SWITCH *Amplifies the impulse received by the light sensor in order to improve image quality in poor light conditions.*

GRAY SCALE *A standardized scale measuring brightness in 10 steps, from solid black to brilliant white.*

HALO LIGHTING *The subject's head is lit around the edge from behind.*

HARD SOUND *Sound that has been reflected off the surrounding surfaces.*

HI-FI *A system of recording sound across the whole tape, giving improved quality.*

HIGHLIGHTS *The brightest points in the image, reflecting the maximum amount of light.*

INSERT EDITING *Recording new material over that already recorded, either directly or from a pre-recorded tape. One shot can be replaced by another in the middle of an already recorded tape. It can also be used to add titles and credits at the beginning and end of a video.*

JUMP-CUT *A cut from one shot to another that causes a break in continuity.*

KEY LIGHT *The main light source in an artificial lighting set-up.*

LINE OF ACTION *An imaginary line drawn through a scene following the direction of the action. The camcorder should only cross this line if a bridging shot is inserted.*

LINEAR SOUND *Sound is recorded onto a strip along the edge of the videotape, or in the case of stereo, onto two strips, one for each channel.*

LONG SHOT *A shot from a distance, showing the whole scene. It is used*

for establishing and master shots.

LUX *A standard scale for measuring illumination levels.*

MASTER SHOT *The main shot of a scene, covering all the action in the scene in one continuous take.*

MASTER TAPE *The videotape on which the original recording was made.*

MID-SHOT *A medium-length shot that keeps two or more people in view.*

MIXED LIGHTING *A mixture of natural and artificial light sources, as occurs in many indoor settings.*

PANNING *Swinging the camcorder horizontally from a fixed position across a scene during a take, in order to follow action or cover a scene that cannot be fitted into the frame.*

PICTURE NOISE *Graininess and poor colour on the videotape caused by shooting in very poor light.*

POINT-AND-SHOOT *Shooting as much material as possible, and editing afterwards.*

POLAR PATTERN *Describes the extent to which a microphone picks up sounds from different directions.*

POSTERIZATION *Manipulation of the colour and contrast of an image, using a vision mixer at the editing stage to create a poster effect.*

POST-PRODUCTION TITLES *Titles and graphics created by a titling machine and*

added to the video at the editing stage.

REACTION SHOT *A shot showing a character's reaction to something happening either on- or off-screen.*

REVERBERATION *Sound repeated in quick succession as it dies away. It can occur when recording in an environment with highly reflective surfaces. "Reverb" units are available that create the effect when sound is processed through them.*

RIM LIGHTING *Lighting is positioned behind the subject so that the subject is lit all around the edge.*

SHOOTING ANGLE *The angle at which the camcorder is placed in relation to the subject.*

SHOOTING SCHEDULE *A timetable giving the breakdown of the script into shooting sessions, with details of the time, place, people needed and shots planned for each session.*

SHOOTING SCRIPT/ SHOT LIST *The shots arranged in the order in which they are to be recorded.*

SHOT *The section of tape recorded in one take. Shots can vary in length and type.*

SILHOUETTE LIGHTING *The subject is lit from behind to create a silhouette effect.*

SIMULTANEOUS TITLING *Titles or captions are keyed in to a character generator, which is then attached to the camcorder. During recording, the titles can*

be scrolled across the picture at the right moment by pressing a button.

SOFT SOUND *Recorded sound that has been partly absorbed by the immediate environment.*

SPLIT FOCUS *Two subjects are kept as sharply in focus as possible when it is not possible to keep them both in very sharp focus.*

STORYBOARD *A sequence of drawings plotting out the video to be made.*

SUBTRACTIVE LIGHTING *The use of shade, diffusers and screens to reduce the amount of light falling on the subject.*

SYNC TRACK *The control track that is laid down on a videotape as material is recorded onto it.*

SYNCHRO-EDITING *By connecting two VCRs or a VCR and a camcorder with a synchro-edit lead, both are controlled by one machine. This enables more accurate editing than separate manual control.*

SYNCHRONIZED SOUND *The sound is recorded onto the videotape from a different sound source, but matches the visual material (e.g. lip synchronization).*

TAKE *One recording of a shot.*

THREE-LIGHT PROTOCOL *Three light sources are used to light the subject - key light, fill-in light and spotlight - giving*

control over the shadow detail and contrast range. It is also known as triangle lighting, because when used for portrait photography, the main light casts a triangular shadow across one side of the subject's face.

TILTING *Panning the camcorder vertically during a take in order to cover the subject, e.g. a tall building.*

TRACKING *Moving the camcorder parallel to the action.*

UNDER-LIGHTING *Lighting positioned below the subject's face and pointing upward, to create a dramatic or sinister effect.*

VOICEOVER *A commentary by someone who does not appear in the shot.*

WHIP PAN *A very fast pan that blurs the subject.*

WHITE BALANCE *A switch that is used to set the camcorder to match the prevailing light – either daylight or artificial light.*

WILD TRACK SOUND *Sound that is recorded separately and added to the videotape during editing (includes atmospheric sound and sound effects).*

WIPE *A new image moves across the frame replacing the previous image.*

ZOOMING *The focal length of the zoom lens is varied during a shot, allowing you to move in to and out from a scene, and making the subject larger or smaller in the frame.*

Index

Credits

Unless otherwise stated below, all photographs are copyright of Quarto Publishing plc.

Abbreviations:
t = top
b = below
l = left
r = right

p47tr Ian Howes.
p102 John Rutter.
p103-105 Michele Faram and Rachel Manning.
p106 (inset) Cathy Meeus; frames 1 and 5-15 Steve Wooster; frames 2-5 John Rutter.
p108-109 frames 16-19 Steve Wooster.
p135 Mike Tyler.
p142 Ron Williamson/Trip.
p143-144 Premaphotos.
p145 frames 10-12 Premaphotos; b Barnaby's Picture Library.
p150-151 Photo Stock Library.
p152-155 Jacqui Hurst.
p156 Picture Music International.

Quarto would like to extend thanks to the following individuals for their help with this book: Wedding: Lucinda and Robert Yelland and their family and friends. Children's Party: Elaine and Tabitha Becker, Caroline Baker, Eleanor Barr, Anna Chandwani, Chloe Faram, Stacy Gyoffry, Grace Jones, Claire-Louise Sloan, Oscar's Den and Belinda. Mini Feature: Matthew Manning, Edward Wooster, Samuel Amoako-Gyamtah, Jonathan Pring, Gary of Sound to Light Disco Hire. Business Promotion: Sharon Davy and the staff of New Quebec Quisine. Pop Video: Wilba Luff, Paul Hughes, Joel Morris, Bethan Williams, Paul Williams. Other sections: Kerry Davies, Rebecca Horsewood, Elaine Herraghty, Bruce Low, Sarah and Tom Harris, Trudie Joras, Janice Williams.

Equipment supplied by: Kobad Avari, Cokin, G2 Systems, Hama, Jessops, Johnsons Photopia, JVC (UK) Ltd, Kewmode International, Lamba Electronics Ltd, Optex Video Accessories, Panasonic Electronics, Sony (UK) Ltd.

the end